Calligraphy Workbook for Beginners

Calligraphy Workbook for Beginners

MAUREEN PETERS

STACKPOLE
BOOKS

celebrating **90** *years*

Guilford, Connecticut

Published by Stackpole Books
An imprint of Globe Pequot
Trade Division of The Rowman & Littlefield Publishing Group, Inc.
4501 Forbes Boulevard, Suite 200, Lanham, Maryland 20706
www.rowman.com

Distributed by
NATIONAL BOOK NETWORK
800-462-6420

Photographs by Deborah Bolton
Design and composition by TPC Ink, LLC

British Library Cataloguing in Publication Information Available
Library of Congress Cataloging-in-Publication Data Available

ISBN 978-0-8117-1995-7 (paperback)
ISBN 978-0-8117-6610-4 (e-book)

Printed in the United States of America

∞™ The paper used in this publication meets the minimum requirements of American National Standard for Information Sciences—Permanence of Paper for Printed Library Materials, ANSI/NISO Z39.48-1992

Contents

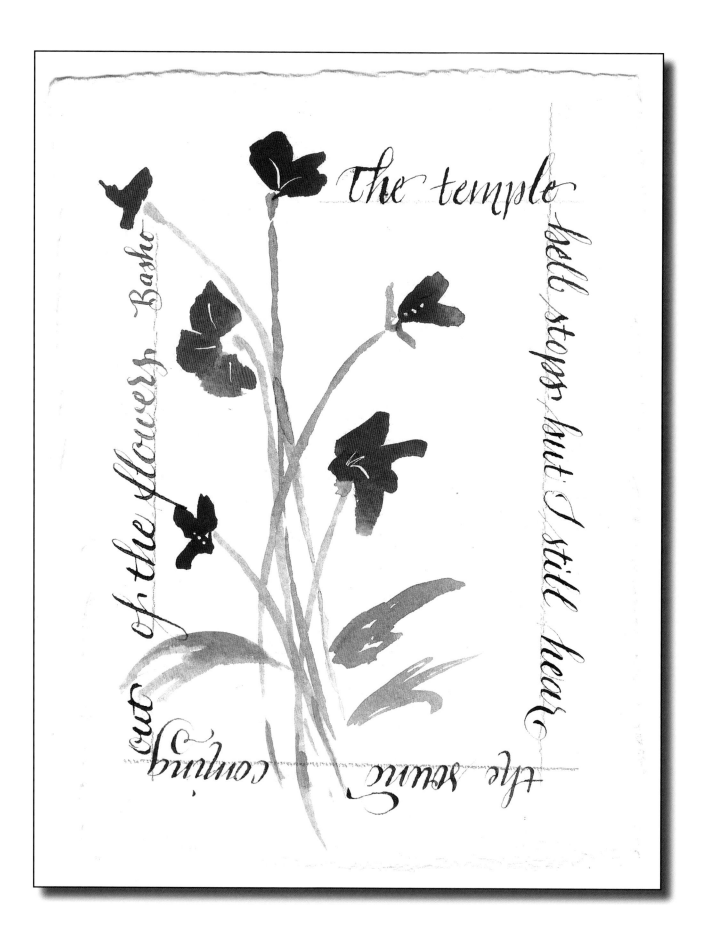

the temple bell stops but I still hear the sound coming out of the flowers Basho

Introduction

Everyone writes, makes letters. We calligraphers just make it fun and colorful! What better way to spend time than slowing down, remembering to breathe, and discovering the gentle ways of lettering. Perhaps we choose to write a quote that gives meaning to our lives or reinforces the good or reminds us to be kind to one another and ourselves. Perhaps we decide to create a one-of-a-kind card to share and give inspiration to someone's day.

Making art is a coping tool; it provides an escape from a sometimes harsh reality. Making art influences our state of mind, and can help us find a joyful emotional stability and take responsibility for how we feel. Creating art is a form of meditation; it allows us to free ourselves from daily worries and tensions and helps us connect to deeper parts of ourselves.

Calligraphy helps balance the body, fine-tune eye-hand motor skills, and create a peaceful mind by slowing our thoughts and hand. Making calligraphy, we can concentrate on positive words and thoughts. We can focus on touch, feel, sight, and sounds. We can improve our handwriting and improve our concentration and problem-solving skills. We can relax.

- Be aware of your thoughts while learning to create beautiful letters. Record them in a journal.
- While you're making calligraphy, be aware of your breathing. Breathe empty. The exhale is as important as the inhale. Empty the vessel that is the old you of resentments and disappointments and make room for new thoughts and ideas.
- Pause and absorb, and release and take in the inspiration of new work. Try not to stress out or overload. Find where your voice lives and grows, and then feed and nourish your creative side.

Everyone writes. Let's do it with new tools, fun colors, and relaxing thoughts.

A BRIEF HISTORY OF HANDS

Calligraphy comes from the Greek words *calli*, meaning "beautiful," and *graphein*, meaning "to write." Calligraphy means to write beautifully or beautifully written. It is thought the word was first used in the early seventeenth century, and it usually refers to beautifully formed letters written directly with pen or brush.

Roman Capitals or Classical Roman Monumental. These letters are all equal in height, upper case (majuscule) or capitals. These letters are modeled after inscriptional capitals from classical Rome. They were done with precision, drawn with tools and compasses.

Capitals Quadrata or square capitals are the pen-made version of the Roman Monumental capitals and are used for manuscripts (Latin *manes*, meaning "hand," and *scriptus*, meaning "to write"), documents, and books lettered by hand.

The Romans borrowed this alphabet from the Greeks. The standard Greek alphabet had twenty-four letters, the standard Roman alphabet twenty-three. From the standard Greek alphabet, the Romans took **A, B, H, I, K, M, N, O, T, X, Y,** and **Z**, with hardly any changes to the letters. The **B** went from a coarse version to a more rounded, softer letter. Remodeling other Greek letters, the Romans produced **C** and **G** and then **L, S, P, R, D,** and **V. F** and **Q** were taken from two old characters abandoned by the Greeks.

In the Greek alphabet, **Z** comes in the sixth position. When the Romans initially took over the Greek alphabet, they dropped the letter **Z** entirely. Once the Romans found they could not get along without the letter **Z**, they brought it back but exiled it to the end of the alphabet, where it has remained ever since.

In the Roman alphabet, there are three missing letters: **J, U,** and **W. W** was developed from **V** about a thousand

years ago, and **J** developed from the letter **I** about 500 years ago. **U** is a cursive form of **V** and has represented both vowel and consonant sounds since the Roman times and until the late medieval times, when the **U** was developed to represent the vowel. The letter **U** appeared as a separate entity in the 1800s.

Due to the type of writing instruments used, the Roman alphabet evolved into more flowing shapes. The precision drawing and inscription (carved into stone) became penned letters written on tables and reed pens used on parchment (animal skin).

As writing by hand became more popular, written forms developed. The **Roman "Square Capitals" Quadrata** was developed as a book hand because it was used primarily to produce handmade books. As writing came into general use, the need to write faster and produce more books turned the refining strokes and strokes requiring a separate stroke into one stroke. A new style was forming, and the rustic **A** lost a stroke altogether. To help keep the nibs from jamming and spitting ink, a change in pen position was needed. The letters became condensed and generally heavier and less vertical.

When Saint Patrick came to Ireland in the fifth century to educate the druids, he brought with him the **Roman rustic** style of lettering. With the increased demand for written form, a new style developed, **uncial (Roman uncial).** It was used for signs and announcements written about an inch high. *Uncus* is Latin meaning "crooked" because compared with the letters of the Trojan column these letters were crooked. The Roman uncial was still a majuscule (capital) and there were no coupling strokes.

The Irish scribes developed this style into **semi-uncial**. It was the first approach to small letter writing (minuscule). As these letters developed into a beautiful manuscript hand, **half uncial** became the common hand, a fusion of everyday handwriting. The regal uncial, which added regional Anglo-Saxon names, was developed by the natives of Scotland and England.

In the eighth century, Charlemagne, King of the Franks, invited a famous English scholar from York, Alcuin, to Tours. Charlemagne gave Alcuin the job of rewriting the church literature and editing and rewriting all the works that remained of the classical Greek and Roman authors. Alcuin knew the Anglo-Saxon style and developed a new style while at Tours. This style was named for Charlemagne and became known as **Caroline** or **Carolingian**.

This was a true small letter alphabet (minuscule). Alcuin made the letters so simple and its lines so free from any finishing frills, it could be written well by any scribe. The letters were joined for greater speed in writing, but each was clear and distinct. Carolingian was a clear, sharp, and readable script that could be written much faster than its predecessor—something Alcuin needed to accomplish the work he was brought to do.

As with the Roman letters, the Carolingian hand spread throughout the empire and changes were made by the scribes training. **Gothic** or **blackletter** became a distinct style of writing in northern Europe in the twelfth century, and in the thirteenth and fourteenth centuries, it developed into regionalized black letter. It took up less room on the page—a plus, as they were writing on vellum (animal skin), which was in great demand and costly. The Gothic style with its thick heavy lines made the page very dense, almost black, hence the name blackletter. This alphabet became very popular in Germany and the low countries, Holland and Belgium. This type of lettering style remained through current times and was used as the model for modern typefaces such as the one used in the Gutenberg Bible.

Italian round hand or cursive is based on the earlier Roman letters developed in the tenth century. The **Humanist hand** evolved in the late fourteenth century and is based on the formal classical Roman and Greek antiquity. A slanted, oval-shaped letter is easier to read than the **Gothic picket fence, rotunda,** and the **Batarde.**

Chancery cursive was officially adopted in the Papal Chancery by the Pontificate of Nicholas V (1447–51). **Italic handwriting** is the most cursive form of italic used for everyday writing and was first employed in the early Renaissance.

Tools & Materials

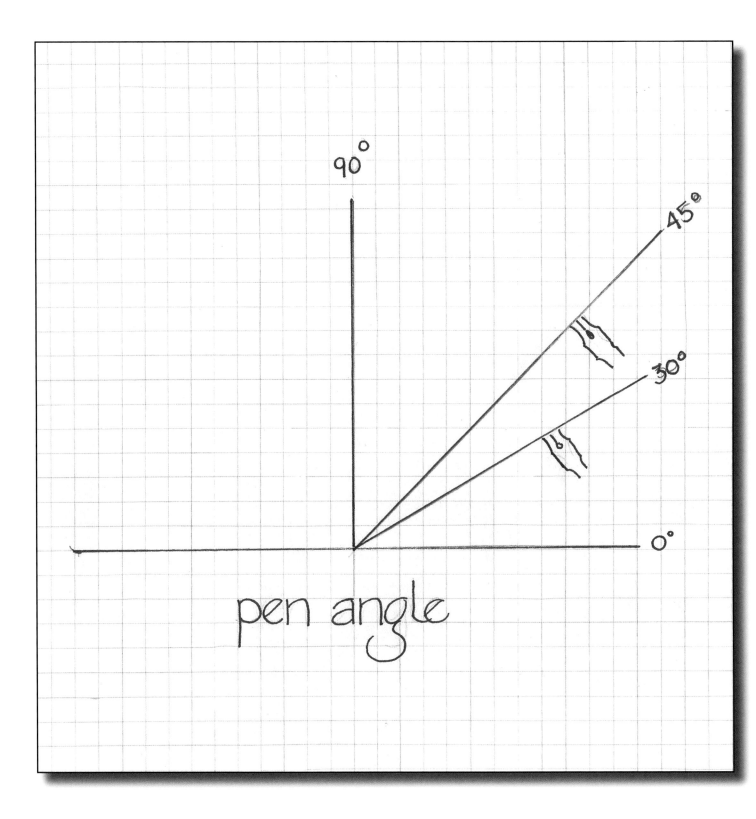

90°

45°

30°

0°

pen angle

2 .

Basic Tools & Materials

Lettering can be done just about anywhere, with a few inexpensive items such as a pen, paper, and ink. But having a dedicated space will help you feel better while you are lettering. Use a desk with suitable lighting. Natural light is best. Task lighting with a full-spectrum light can work well too, coming from the left if you are right-handed. The light should come from the right side if you are left-handed. This avoids shadows made from the lighting.

A slant board will help your back and shoulders from becoming stiff from leaning over the desk; it brings the work to you. Get a nice chair that gives you lumbar support while you work with your feet planted flat on the floor. Make this area your own as you will be sitting for long periods of time.

Use paper for padding while you write. Writing on a padded surface will help the entire nib make contact with the paper as well as give the nib room to spring gently back from a pressure stroke. I find that lettering on a pad of paper or a few sheets gives me a nice cushion to work on.

If you are using dip pens and are right-handed, you will need your ink on the right side so you don't have to cross over your paper with ink and risk it dripping on your work. You need a nib holder and a variety of nibs. I recommend Speedball C2, C1, and C0 nibs as they are very good and readily available. A set of Mitchell, Tape, or Brause nibs are excellent for smaller writing. See the sources section for where to order them.

You'll need practice ink. Higgins Eternal is a nice ink and readily available. You'll need a graph pad or marker layout paper. Make sure you have a pencil and pencil sharpener or a mechanical pencil to line your paper and make notes. Get a kneaded eraser and an 18-inch, red gridded, see-through ruler. A metal ruler with cork backing is also a must have. Paper towels and baby wipes make life's little cleanups easier and are good for wiping the pen's nib. X-Acto knife and #11 blades are the most versatile—you can use them to sharpen your pencil and they make the best eraser on good paper. Scissors, glue stick, and masking tape round out the list. These are the few things you need at first, but you can build your items as you need them.

Tools you need:
- Dip pens
- Nib holder
- Practice ink
- Graph paper/layout paper
- Pencil
- Eraser
- Ruler
- Paper towels/wipes
- X-Acto knife
- Scissors
- Glue stick
- Masking tape

Other tools that are nice to have:
- Adjustable hollow easel and board (slant board)
- Gouache and watercolors
- Mixing tray
- Paint brushes in various sizes in both flat and round
- Water container
- Colored pencils (the Prisma brand is good)
- Self-healing cutting mat
- Bottle of water with dropper top or pipettes
- Small mister or spray bottle for adding water to watercolors, gouache, or ink
- Restickable glue stick and Fun-Tak by 3M to hold ink bottles in place
- T square

The Mitchell round hand kit (left) contains a straight nib holder and various width size nibs. The Manuscript kit (above) contains a straight nib holder and various width nibs with a storage container.

DIP PENS

Nibs

There are a wide range of nibs available. They fall into two categories: edged nibs and pointed nibs. The style of lettering will determine the style of nib to use.

Edged nibs. Broad-edge nibs have a straight edge. Typically the edge varies in width from about 0.5 to 5mm. The wider the nib, the wider or bigger the letter or writing. Most are cut straight across, but others are cut left oblique so that the right-hand edge is higher than the left-hand edge. The edge slopes down toward the left so that left-handed calligraphers can hold the nib at the correct angle.

The easiest way to categorize nibs is by flexibility. A stiff nib does not splay easily when pressure is applied. If you have a heavy hand and a tight grip, a stiff nib is almost mandatory to avoid variations in the width of lines produced. Brause nibs tend to be stiff, and will take quite a bit of punishment, though they are hard to break in to form a smooth, consistent writing. Two other nibs similar to the Brause top reservoir nibs are the Hiro Tape and Heintze and Blanckertz nibs. These are made in Austria and Germany, respectively; both of these nibs tend to be more flexible than the Brause. A little lighter touch is necessary for the best results. The Brause, Tape, and H&B are made with a right-hand slant and are ground for left-handers.

Mitchell pens are probably the most common brand used by calligraphers. Mitchell nibs are made in many styles of edged pens, including straight, chisel edge, and varieties of special points. Round-hand nibs are the most flexible of the nibs mentioned so far; their flexibility makes them very good for "pressurized alphabets" where you want the width of the line to vary. These are available in right-hand and left-hand nibs. The nibs have slip-on reservoirs that come separately, and they can be used without the reservoirs.

Manuscript Round Chronicle are similar to the Mitchell round hand, but they are stiffer.

Pointed nibs. The most accessible nib in the United States is Speedball. They are American-made nibs. The Speedball has a reservoir on top, which is not removable like the nibs described above. This nib is the best for beginners and is a workhorse and will take the pressure of a heavy hand. Speedball nibs and sets are available in local art and craft stores.

Pointed nibs have a pointed tip rather than a straight edge. In calligraphy the pointed nibs are used for Copperplate, Spencerian, ornamental penmanship, and modern pointed pen. There are a wide range of pointed nibs available. The choice of pointed nib is based upon how flexible it is and how thick the point is. The more flexible the nib, the thicker the line that can be produced when pressure is applied. The thickness of the point will determine the

JAN FEB MAR APR MAY JUNE JULY AUG SEPT OCT NOV DEC

There are a variety of pen holders available. Find one that is comfortable in your hand.

width of the line without applying any pressure. These are personal preference. You can buy a sampler of pointed nibs to try to see which one works for you, but starting with one that is for beginners may be the easiest. I like my students to work with Nikko G Nibs, which are high quality, hand cut, medium flexibility, and chrome plated. They will give you nice hairlines and behave for new students. The others I recommend are Gillott 303 or 404, Hunt 22, or Hunt 101.

Pen Holders

There are many pen holders on the market; try them and see which one works best for you and fits your budget. If you purchase a kit, the nib holder normally comes with the nibs. Koh-I-Noor cork tip is a very good holder for the beginner. The cork cushions the fingers and also seems to dry up the ink so your fingers get less messy. Speedball has a nice hourglass-shaped holder that comes in black, garnet, and sapphire. Mitchell has #53 triangle pen holders that won't roll off your desk but also keep fingers in position so you can't roll your pen and lose your pen angle. Manuscript has an ergonomic holder as well as the solid color holders.

Oblique pen holders for copperplate. The choice of nib holders for copperplate style of writing depends on the nib you are using and whether you are left- or right-handed.

If you are right-handed, you may want to use an oblique pen holder. It helps a right-handed person hold the pen at the correct angle for copperplate writing. A left-handed person should use a straight nib holder because their hand and arm are already at or near the correct angle.

The Speedball oblique pen holder is suitable for most pointed nibs. Sometimes, though, you need a pair of pliers to flatten the back of the nib to fit the pen holder. For small nibs I use 3M tacky to help hold the nib in place. This is also good to place under your ink pot so it will not slip or move as easily.

CARE OF NIBS AND TOOLS

With new nibs, clean them with a baby wipe or paper towel and water. If stubborn ink residue is left, a little ammonia or window cleaner will help. If this doesn't work right away, you can soak nibs in a container with ½ cup hot water, ¼ cup ammonia, a little isopropyl alcohol, and a drop or two of dishwashing detergent. Use a toothbrush to remove any extra ink. This mixture and procedure can be used on fountain pens as well. Remember to rinse them thoroughly and dry them before putting them away.

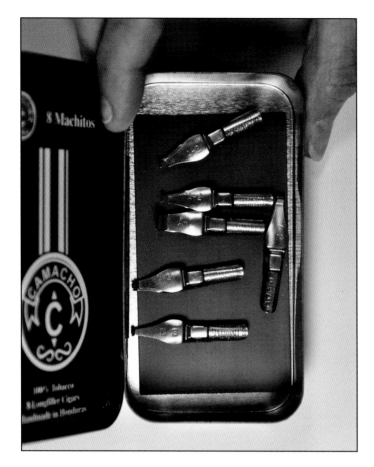

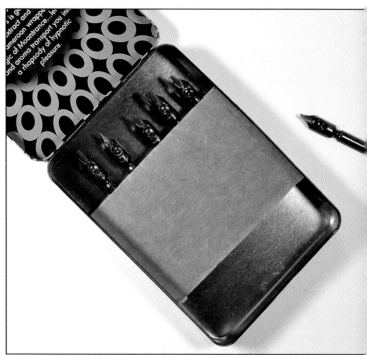

Use a mint or cigar tin for nib storage. A magnetic strip inside will hold nibs secure. Another way is to fit a piece of corrugated cardboard inside a tin—you can push nibs inside the ribs to hold your nibs secure.

Nib Storage

Store nibs in a container with a silica gel package found in packaging material to absorb any excess moisture.

Use a small box or tin to store your nibs. Use adhesive magnetic strips to hold nibs in place and keep them in order. Another way to organize them is to use corrugated cardboard and stick the ends of nibs in the cardboard to hold them in place. You can label the nib size on the cardboard.

Storage of Nib Holders

Use a jar to store your nibs upright with various nib sizes ready to go.

For travel, I use a long box, which holds a small bottle of ink and extra nib, pencil, and small ruler. A small, clear tackle box or art bin is light and can be carried almost anywhere you go.

Use a pencil holder or paintbrush roll holder to hold your pencils, nib holders, and other materials.

Create and use handmade holders for knitting needles or floss holders. You can also create your own using bamboo placemats. Weave ribbon through to hold your materials. I am sure you can come up with some creative ways to house your tools and materials.

ERASERS

Plastic erasers come in block shapes of various sizes. Most are made of soft white vinyl, but some are dual purpose, consisting of two-thirds white vinyl and one-third blue vinyl. These are used for ink, graphite, or type erasing. Magic Rub, Factus, or Staedtler latex- and PVC-free erasers come in black for dark papers. Use white erasers for white or light-colored papers and black for black or dark papers, as this will reduce the eraser dust and marks on the surface.

Eraser pencils have a round pencil-like shape and are encased in wood, paper, or plastic, these can be sharpened to give a small area to erase.

A **kneaded eraser** is a gray block, which is kneaded for cleaning after each use. You can also knead this eraser into a small point and press and release a few times to pick up graphite or dirt from the papers.

Electric erasers hold a core or plug of eraser, which can be changed according to the medium being erased. There are a number of different eraser materials on the market. I use Staedtler latex-free.

When using good papers and gouache, the cleanup of a mistake can be easier than you think. Using a sharp X-Acto knife, scrape lightly over the letter to remove gouache. This is a slow process, but you can be successful if you don't rush. Once the color is removed, use a bone

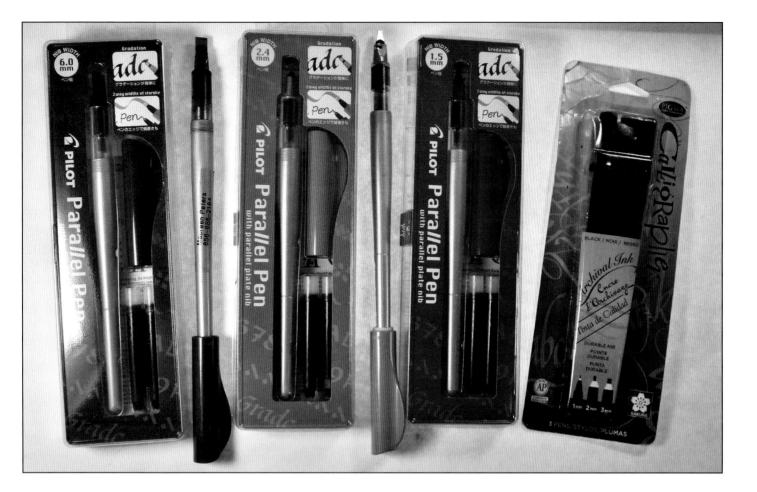

folder or back of a spoon to burnish the fibers back down and letter over the area. If the fibers were soiled deeply and you needed to go deep into the paper, you can use the kneaded eraser to pick up the final stages of dirt and then burnish. It may be necessary go over area with gum sandarac powder. Sprinkle it over the area and rub with a clean cloth or cotton ball.

Gum sandarac is used to repair papers that have been overworked or are slick and also to prepare vellum for writing. Sandarac acts as an ink resist, which holds the ink and prevents it from spreading, resulting in sharper letters. Purchase gum sandarac in powder form and apply it with a cloth or cotton ball.

FOUNTAIN PENS AND MARKERS

These are wonderful tools to take with you and practice with when it's not appropriate to use dip inks. I love working with markers and playing with changing colors. Most are not permanent, nor will they adhere on all surfaces, and they tend to bleed on porous papers, but they do have their place.

Markers

These come in fine, medium, and broad and in an array of colors. Some are better than others. New on the market are

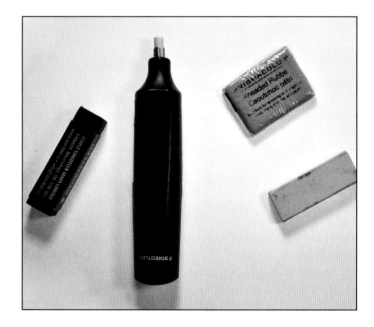

Pilot Parallel Pens in various sizes and the Calligrapher by Sakura hard-tip felt marker set (top).

Good erasers to have on hand include black for dark paper, electric and battery-powered erasers, kneaded, and white erasers.

Sakura Pigma Calligrapher available with 1mm, 2mm, and 3mm nylon tips. They will take a heavy hand. These give crisp, clean edges and sharp hairlines; they are waterproof and archival. They are available in various colors.

Elegant Writers and Zig Calligraphy markers are available in water soluble forms. Zig also has waterproof and chalk pastels. There are many other brands to choose from. Experiment and enjoy being creative. These markers are great for practice.

Fountain Pens

These are the easiest to use and come in a variety of price ranges and quality. Here are a few suggestions. Check out ones online or in fine stationaries and try them if possible to see if they are a fit for you before purchasing them. The disadvantages of fountain pens are that they are not flexible, have a limited range of color inks, and are harder to clean.

Manuscript and Speedball Panache fountain sets have various nib choices and use cartridges to deliver the ink or a converter to use bottled ink. They are readily available in local craft stores.

Pilot Plumix uses Pilot's Parallel cartridges, which come in twelve assorted colors.

Pilot's Parallel pens are extremely versatile pens. They can travel, use cartridges, and have a converter that allows you to use lightfast inks and other fluids without getting clogged. They have a larger range of nib sizes.

INKS AND COLOR FOR DIP PENS

Inks

The word ink comes from the Greek word *inkauston*, which means "to burn in." Burning may refer to the coloring process of early baked tiles or the way iron gall ink, with its the acid content, burned into the page. General types of inks are as follows:

Pigmented ink. The coloring matter is finely ground, insoluble partials suspended in a medium of glue or gum and water plus additives such as scent, shellac for shine, or preservative. These inks are usually lightfast and are rarely used in fountain pens because they clog them.

Dye ink. The coloring agent is soluble in water and is almost always fugitive (fades in light). These dye inks are used in fountain pens.

Waterproof ink. This ink contains shellac or polymer to dry impervious to water. India ink is such an example. Some inks claim to be waterproof but are only semi-waterproof.

Semi-waterproof ink. Semi-waterproof ink will resist moisture such as handling with dry fingers but not if left in a puddle of water or if a drop of water has been left on the paper.

Most of these inks have seen many advances in the last few years that help keep them waterproof and flowing easily. Some watercolor has the ability to become permanent if it uses ink in the formula to render the watercolor permanent after it dries. If you need a specific fluid that has all or some of the above characteristics, check with your local art store or online for the correct fluid for your project.

Black ink. Here lies a world of different inks for you to choose; the first one to start with is Higgins Eternal. It is permanent when it dries and does not fade. This is available at most craft stores. I recommend decanting the ink into smaller jars for use while working on projects or just practicing to keep your ink free from dust and from evaporating in the jar. If I am having difficulty with ink flow on cheap paper or specialty papers, I can experiment with a small amount of ink to help it flow or sit on the paper better without changing the whole bottle.

Tip for Fixing Bleeding

If the ink bleeds on paper, add a drop or two of gum arabic, or add a drop/wormlet of gouache to the ink to help coverage on the paper or support. Experiment to see what works for you given your unique pressure and lettering style and the conditions of dry or humid paper. These little tricks will help you get the most out of your lettering.

Sumi ink. The highest quality carbon for Chinese ink sticks is produced by slowly burning materials such as oil, bones, or hemp in a row of large chambers connected by narrow channels. The airborne carbon drifts from chamber to chamber, collecting on the walls. Only the finest particles travel as far as the last chamber and are used to make the finest quality ink. A paste of this carbon, glue, or gum is formed into sticks and dried. This cold ash process is done often and is changed every three to ten days. When buying ink sticks, choose those with finely stamped designs. Crude designs indicate crude and grainy ink. Some scribes prefer matte sticks to shiny as shininess indicates the presence of shellac, which can clog the pen. Song, OAS, and Li Long are good sticks to choose. There are a few available in craft stores.

If you would like to try this method, you will need a grinding stone to release the ink from the stick. Rub one end of the stick back and forth on the slant of an inkstone in a pool of five to ten drops of distilled water. More drops can be added if necessary. Grind enough for the day's use only. Grind until you have a creamy pool of ink. After the grinding is finished, wipe your stick dry to prevent it from drying out and cracking. You can work from your stone using a brush to load the ink on the nib or decant into a little jar. As you are using ink from the jar or stone, the ink may dry out a little. You can dip your brush into water to help the flow, or add a drop or two of distilled water to

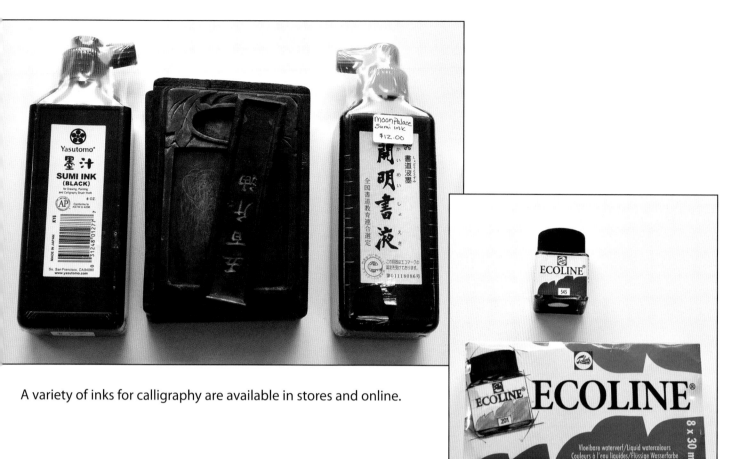

A variety of inks for calligraphy are available in stores and online.

your jar and stir. This is a nice morning ritual. The smell of the ink melting in the stone makes for a relaxing moment.

Bottled sumi. This is a convenient way to use the stick ink without the work of grinding. Moon Palace has nice flow and is pigmented. It sits up on the page with a little shine when used with pointed pen, has a nice smell, and is waterproof when dry. Best Ink from OAS is a Japanese sumi ink. Yasutomo is a dense black ink readily available in craft stores and does not corrode nibs.

Color

In the past ten years, a lot has been happening in the world of calligraphy with ink and colored ink. Experiment to find what you like and what works best for you and your project.

Watercolor paint can be loaded on the nib for color variety. Working with tube watercolor, squeeze about a half-inch wormlet of paint into a mixing dish or palette. Add water, mix to make the consistency of milk or cream, and work with it to see just how thick or thin you need it to be. It needs to flow off the nib but sit on the page. When using watercolor instead of ink, you can add more pigment, water, or gum arabic to solve any issues with your support or paper surface. You can add a drop or two of gum arabic

to the watercolor or gouache to help it adhere to the surface. But be careful—too much and it flakes off like powder, so add sparingly.

Gouache paint is similar to watercolor but modified to make it opaque. A binding agent, usually gum arabic, is present, just as in watercolor. Gouache differs from watercolor in that it has a chalk, which makes it heavier and more opaque with greater reflective qualities. Gouache is primarily used for lettering as it has a quick coverage and hiding ability, so you get less color variability in your lettering. But sometimes you want to transition color, and watercolor is the best medium for this.

Gum arabic is the binder (glue) that binds the pigment in watercolor and gouache.

If you are having trouble getting it to flow off the nib, it may be too thick. Add water, a drop or two at a time, to see if the flow improves. If it is too watery and runs or bleeds on the paper, then you need to add more pigment to the mixture. The trick is to find the right combination of pen fluid and paper.

Blacks. Lampblack is dirtiest and ivory black is the richest and flows well. Earthen colors contain clay and are gritty. These may have some issues with flow especially with cheaper brands.

A palette with small pop-top jars is great for decanting ink, thus keeping the container of ink from being contaminated or spilled. Use it for making ink with watercolor and gouache.

White. Dr. Ph. Martin's Bleedproof white is an opaque white for writing on black or dark paper.

Acrylic inks and paint. Acrylic inks and paints are permanent as they are pigment bound by acrylic polymer resin that is emulsified with water, which can go from thick to thin and everywhere in between. They stick to almost any surface, are flexible, and can be adjusted with various mediums to extend drying time and texture for various techniques. Flow can be an issue with these fluids, but many new improvements in the past few years with mixed media have helped to compensate for the problems. FW and Liquitex are among those readily available. Others are Golden liquid acrylic and Dr. Ph. Martin's Spectralite inks. I love the Dr. Martin's in metallic shades.

Using acrylic in the tube is an option, just as with watercolor and gouache. Mix to the consistency of cream, and add water, not too much to make it bleed, but just enough to make it flow off the pen. With acrylics you will need to keep a baby wipe or wet paper towel handy for cleaning your pen nib often to keep your flow consistent. This may seem difficult at first but the challenge is worth the time and effort. Don't be afraid to experiment. The knowledge you gain will make the learning fun.

These inks and paints are for dip pen nibs only. They will clog your fountain pens and could render them useless. There are a few inks on the market like Winsor and Newton calligraphy inks that are safe for use in fountain pens. Always check your inks to see if they are recommended for fountain pens before using. See Sources for Supplies for more information and options.

Gold color. Using gold for lettering creates a beautiful page. This does require a little bit of patience and some experience but can be mastered in time. You need to experiment to see what works for you and to learn patience to handle the job at hand. One of my favorites for beginners is Dr. Ph. Martin's Metallic as it is ready to dip into or use with an eye dropper to fill the nib.

Gouache has metallic silver and gold colors. It comes in tubes that can be mixed with distilled water to a milky consistency. You can dip or use a brush to load onto the nib. Due to the nature of metallic paints, they tend to thicken while using. You'll need to stir them constantly and add water.

Schmincke has gold and silver in watercolor pans, which are nice and fit into your watercolor palettes.

Winsor and Newton has calligraphy liquid ink in gold and silver. This is already liquid and is ready to use. It is convenient, but you can't control it if it is too thin for your paper to support.

Another gold I use is Chinese gold in a white ceramic dish. I have found it in art stores.

Finetec Pearlescent is one of the better looking as well as easiest to flow off the nib. These need to be brushed onto the nib.

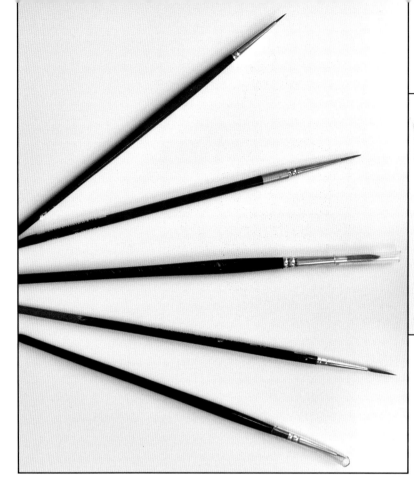

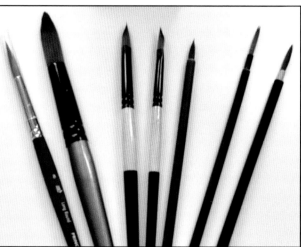

Brushes allow you to add color to calligraphy work. They range from inexpensive to very pricey.

BRUSHES

Did you ever wonder about the tool you were painting with? Did you ever go into an art store to buy paintbrushes and not know what kind would be best for your needs? There are many different kinds of brushes available to the artist. Let's look at some of the various types of brushes available to you.

Natural-Hair Brushes

Making natural-hair brushes is still the work of artisans. Master brush makers train up to five years learning the craft. Brush makers select hairs, comb and clean them, and place them in metal cups where they are aligned and shaped after they are tied with nylon thread. Next, the hairs are inserted in clamps onto the brush handle. The inside of the ferrule contains much more hair than that which extends outside the ferrule. The hairs are continually combed and cleaned and knifed as each individual brush is made. The hairs are then cemented in the ferrules and baked while the cement cures and hardens. The base of the ferrule is crimped to fasten the hairs securely to the handle. The work is very precise.

A major part of brush making is deciding what type of hair to use to make each brush. The finest brushes are made with sable hair, which comes from the tail of a small male rodent, the kolinsky, found in Siberia and Korea.

These brushes cost around ten dollars for the smallest to over three hundred dollars for a very large brush. A good red sable brush can be substituted for a kolinsky brush. Red sable brushes are made from the tails of weasels. These brushes give very good results and are considerably less expensive, running about $15.

Ox-hair brushes are made with hair from behind the ears and fetlocks of oxen found in central Europe and some parts of North and South America.

Sabeline brushes are also made of ox hair, white or light colored, silken in texture and dyed the color of red sable.

Squirrel-hair brushes are made of hair from the tails of certain species of squirrels: blue, gray, and Kazan from the Kazan region of Russia. Squirrel hair is sometimes mixed with pony hair to help keep down the price of the brush.

Pony-hair brushes are made with hair from the pony's mane and hide and mixed with goat hair, which is similar to pony hair but coarser.

Goat-hair brushes use hair from the goat's skin, and it is used in lesser quality brushes to keep the price down.

Camel hair is a general name for brushes. The hair is not from camel, but from squirrels, ponies, and goats, depending on the quality of the brush.

Bristle or hog hair is obtained only from the spinal section of wild boars and hogs found in China, Russia, Japan, and other colder regions. Black bristle brushes come from

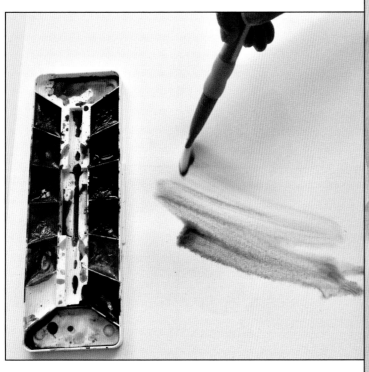

Experiment with watercolor washes to add backgrounds to calligraphy projects.

South America and are usually used in schools because they are the least expensive type of brush made with natural hair.

Nylon and Synthetic Brushes

Almost every brush manufacturer makes synthetic brushes under various trade names, such as Liquitex's Sablon or Grumbacher's Control Plus. These are designed to give the artist the look and feel of sable without the cost. There are many manufacturers of these brushes, and they are a great place to start your collection. You need only a few brushes to start. Start with what you can afford and will have fun working with.

I use the white bristle brushes with watercolor pencils so I can lift and scrub the color easier and I keep my Winsor and Newton Series 7 sable brushes for fine watercolor. If I just want to play, I love Winsor and Newton Sceptre brushes and have a set for lettering as well as for painting. The brushes I use often for loading my nibs is a Niji Waterbrush or Aquash waterbrushes from Pentel. These have the water in the barrel and clean easily. Squeeze it into a paper towel to clean the brush. One other brush worth mentioning is a Princeton Monogram brush, which is wonderful for miniature work. With it I can create fine lines in white work or details in an illuminated letter.

Just remember the choice of a brush is a personal decision. You may not like my favorites. The best thing I can tell you is to play around with them, feel them, because in the end you are the one who will need to use and love them.

PAPER

Paper dates back to the Chinese around 105 AD. To use paper, one needs to know a little about its composition to make choices in using different types.

Choosing a paper may be daunting at first. This is because calligraphers need a smooth paper with a tooth or edge so they can make sharp letters. In comparison, watercolor artists do not need a smooth surface. As a beginning calligrapher, you are going to go through a lot of paper, so you want to select the cheapest that is suitable to use. Some photocopier papers are suitable. I recommend Great White or Kodak 24-pound copier paper. Borden and Riley Boris Marker layout or Canson Marker layout paper come in pads, work very well, and are available locally. Some are semi-transparent, enabling you to see guide sheets through paper and can save you time in ruling up every practice sheet. I like to use translucent or vellum to trace letters, practice, and as small layouts for cardmaking. Always experiment as the paper quality varies and new papers are always coming on the market.

Paper, or the material used to letter or paint on, is also sometimes called "support." The medieval illuminator

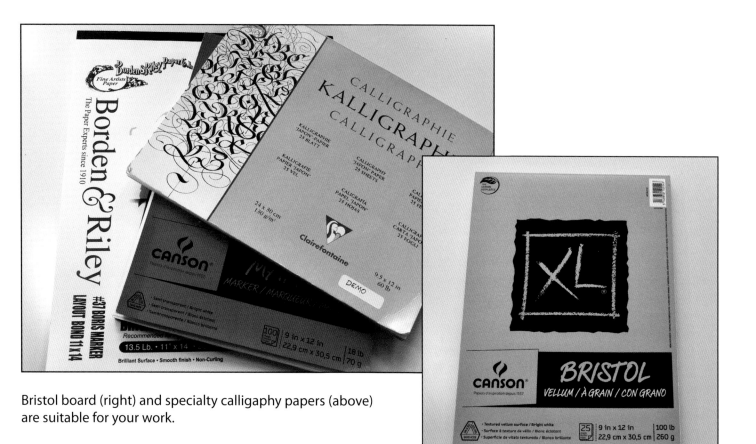

Bristol board (right) and specialty calligaphy papers (above) are suitable for your work.

used parchment (sheep, goat, or calf hide). Paper and papyrus are both supports.

Grid paper helps you letter without ruling up. There are a few good grid pads—Westwind grid pads are 11 by 17 inches. Paper and Ink and Copperplate have their own with the 54-degree slant lines. I recommend any of these grid pads. Check the Source section to find where they are available.

Here are a few things to know when buying paper for projects.

Weight. Paper comes in different weights: 90 pounds, 140 pounds, 300 pounds. The weight is the measurement of a stack of that paper (usually 500 sheets). Go with a heavy paper. Ninety pounds is normally not recommended as it is thin and warps when wet. Illustration board is measured in plies, the higher the ply the better the board. Three ply is better than two ply. Bristol board is fine and a two ply will not buckle when wet.

Surface is described by tooth it exhibits. Hot press has a very smooth tooth, which makes it hard for the ink to grab and allows the ink to sit on top of the surface, but with practice it is very good for detailed work. Cold press is perhaps the most popular paper and is recommended. It has a medium surface and lends itself to the widest range of painting styles. Rough is not recommended for beginners but lends itself to making beautiful marks with a modern edge.

Handmade is the most expensive of the papers as it is made one sheet at a time. Handmade papers have the most irregular and spontaneous patterns. Ink flows differently in each area, which can make for a very interesting piece.

Mold-made paper is machine made and like handmade is made one sheet at a time. The pattern of the paper is more regular and the paper is less expensive than handmade.

Machine-made is the least expensive paper. It is made in a continuous roll and pressed while damp with an embossing roller, which gives it a mechanical, regular pattern. Letters made on machine-made paper are the same in depth and brilliance.

Rag content is important. Cotton fibers are stronger than wood, and rag content helps determine the absorbency and permanence of the paper. Normal percentages of rag content in paper are 25, 50, and 100 percent.

Always test paper for its writing qualities. If you find problems with its holding ink, you can make adjustments to make the ink adhere to the surface. Workable fixative is the easiest, but there are other methods. Slick surfaces make it hard to control the inks' beading effect, so I would not recommend trying to change a slick surface to hold ink but to change the ink to work with the surface.

LINING PAPERS

Creating lined paper helps you master the principles for each hand and the lettering construction and weights. Once your lines are complete, save the grid or make a photocopy. Ruling your paper can be a challenge. When you need to make lines on good paper, you should follow some guidelines that will help you make the lines and your slant lines easier.

Every hand has a recipe for the optimum proportions of letter construction depending on nib height.

For every nib size, you will need to rule paper, using the following method.

Measure with a red grid ruler, find the closest measurement, and use this measurement to rule your lines. Remember you will have separate measurements for your ascenders and desenders.

Dividers can help measure lines. A divider is a tool used to measure distances that resembles a compass but has two points on it. This will make the most precise measurements.

Open the divider to the exact x-height or body height given in the nib height steps. Now figure out the ascender space and then the descender space. Mark these on your paper and lineup.

Another way is to tick mark your nib width starting with your x height, ascender, and descender under your x-height on a scrap piece of paper. Once dry, you can use this as a template and tick mark down the side of your paper. Use the grid ruler or a T square to complete the lines.

Use a very sharp pencil. Rule guidelines on the paper to fit the hand you have chosen. Some people write within the guidelines and some people overwrite the guidelines a bit. It's a matter of personal preference.

If you need slant lines on the paper for a slanted hand such as Italic, measure down the paper 11 inches from the top of the left side. Every 5 degrees of slant will equal 1 inch over from the left side of the page. Make a mark at the top of the page at the 1-inch mark and create a slant line to the bottom of the paper or to the 11-inch mark if the paper is larger than 11 inches. Follow this slant line across the page using a red grid ruler. You can make the lines at ½ or ¼ inch apart.

If you need a 10-degree slant line, measure over 2 inches. If you need 15 degrees, make a mark at 3 inches at the top of the paper and measure down 11 inches and create a slant line from the mark to the 11-inch mark.

You can purchase grid paper as well as guidelines for various nib widths—check the Sources section or look online. There is a calligraphy rule program to help you make guidelines. Check out calligraphypaper.appspot.com. It's one of many guide generators available online.

C-2 is a nice versatile pen width.

C-0 is very large but perfect for beginners—you can see the construction of the letter forms.

C-4 is a very small nib creating tiny letter forms.

The italic project uses French curves to create writing lines. Another way of lining papers is to use colored pencils to enhance the project. You leave the line in, as in the watercolor flower project.

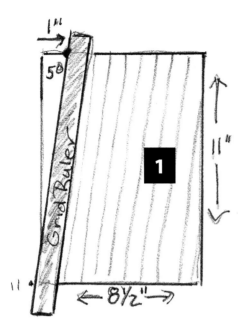

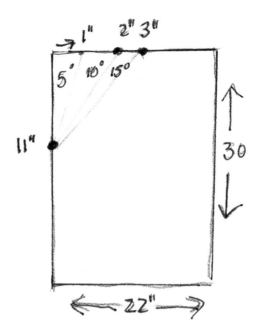

Figure 1 (top left) is a 5-degree slant, measuring down the page to 11 inches and across the top 1 inch.

Figure 2 (middle left) is a 10-degree slant, measuring down the page to 11 and across the top 2 inches.

Figure 3 (bottom left) is a 15-degree slant, measuring down the page to 11 and across the top 3 inches.

The figure at top right shows how to create slant lines for larger sheets of paper. Measure down the left side and across the top 1 inch for every 5 degrees needed.

This grid has 8 blocks per inch in this picture so we measure down the page 11 inches and mark this measurement. Then move across the top 3 inches and mark this measurement. Then draw a diagonal line from the 11 inches to the mark at 3 inches at the top of the page. Repeat across the page. This guide helps you keep a consistent slant.

For a consistent slant with the Italic hand your grid will look like this.

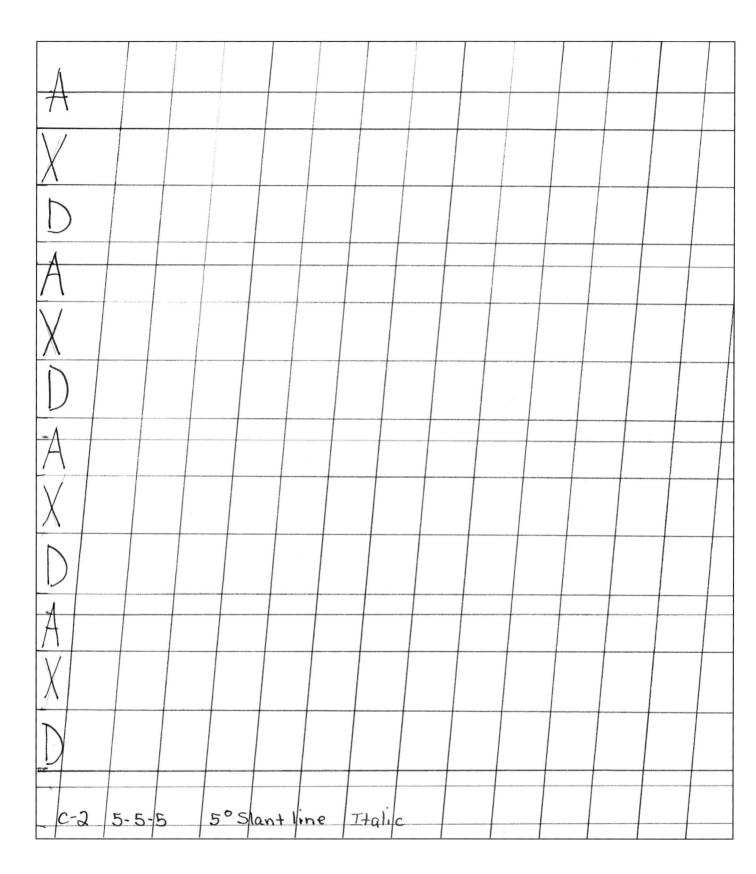

C-2 5-5-5 5° Slant line Italic

Now we will break down the vertical lines into writing lines: X indicates the area where all the letters sit, lowercase **o**, **c**, **e**. The ascending space (A) is where the tall letters fall, lowercase **b**, **h**, **l**. The descending space (D) is the space for the letters that fall below the base line, lowercase **g**, **j**, **y**.

The Hands

Uncial

90°
20-30°
0°

‡ A B C D E F G h
I J K L M N O P
q R S T U V W
X Y Z
n M T U W
0 I 2 3 4 5 6 7 8 9

Uncial hand is a sturdy, round majuscule book hand used from the third to the ninth centuries. Irish monks developed the alphabet over four centuries. There is no one official set of letters. Some texts recommend the letters be five pen angles in height, others three or four. The early-fifth-century uncial was written at a steep pen angle of even 45 degrees, and later writing was done at a flatter angle of 15 degrees. Uncial is a total capital hand and can be difficult to read in long passages—keep this in mind when deciding to use this alphabet.

Because the letters are short and round, uncial has a strong presence. The letters should not be too crowed or slanted; they are straight up and down. Practice them on a box grid.

The wedge serifs are a hallmark of this script; seventeen of these letters have them. The alphabet is shown here at 30 degrees and written at four pen widths in height.

These letters are drawn. They are not cursive and should be constructed in parts so they don't lose any of the beautiful thick and thin strokes.

Uncial

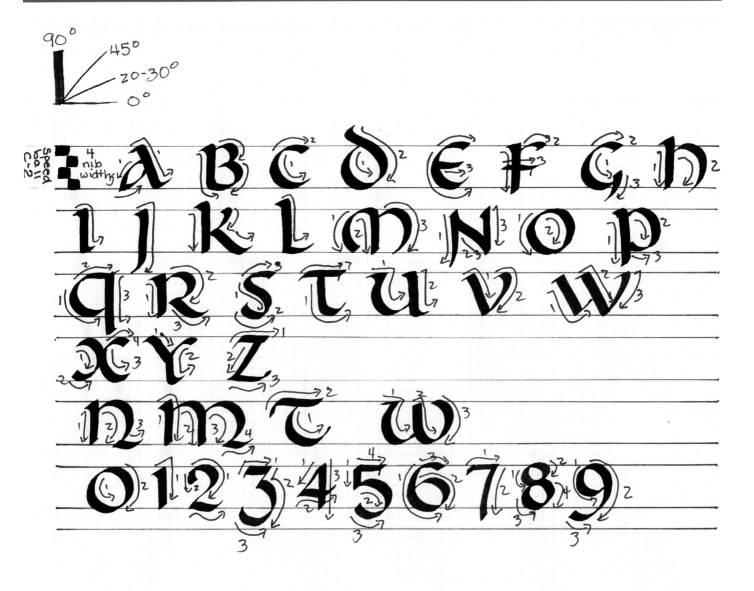

ILTJ

I, L, T, and J use straight strokes with a slab serif, except for the **T** and the **J**, which did not exist when this hand was created.

OCEGD

Each of these letters are ovals made in two parts.

HQPRFK

The stem stroke for the **H** goes above the waistline—if using the alternate **N** stroke, the stem stroke will stay below the waistline. Stem strokes for **R, F,** and **K** can go below the baseline—only the **F** shown here goes below the baseline.

M and B

M starts out with a curve stroke along with the same stroke from the **H** and the **B**. Keep the stem stroke straight with the wedge serif. Pull out the semicircles for the **B** in two separate strokes.

N

N can either have the stem stroke go below the baseline and curve in or have a foot. Just be consistent with

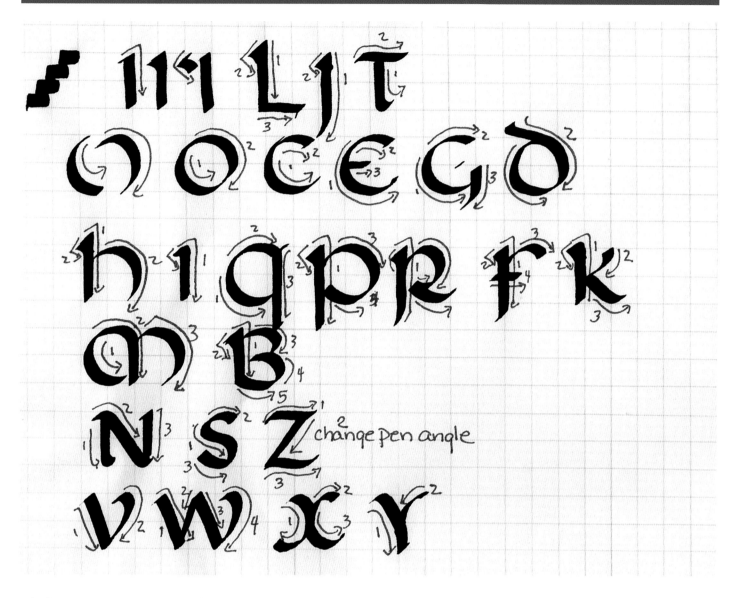

whichever one you use. Be careful of the diagonal center stroke, and bring down the last stroke to meet it.

S and Z

S has a lot of ink in one small space; make sure your **S** is upright and not leaning right or left. Keep the center curved stroke centered and create a cap and bottom stroke to keep it balanced.

V W X Y

V and **W** are modern letters and end with the same strokes. Use a slight diagonal for the first part. Remember to construct them with a downstroke and don't push up for the **V** and **W**. The alternative **W** is based on the **U**.

X is based on the oval **C** with the backstroke of the **O** first. The **Y** is a longer diagonal stroke with a branching stroke.

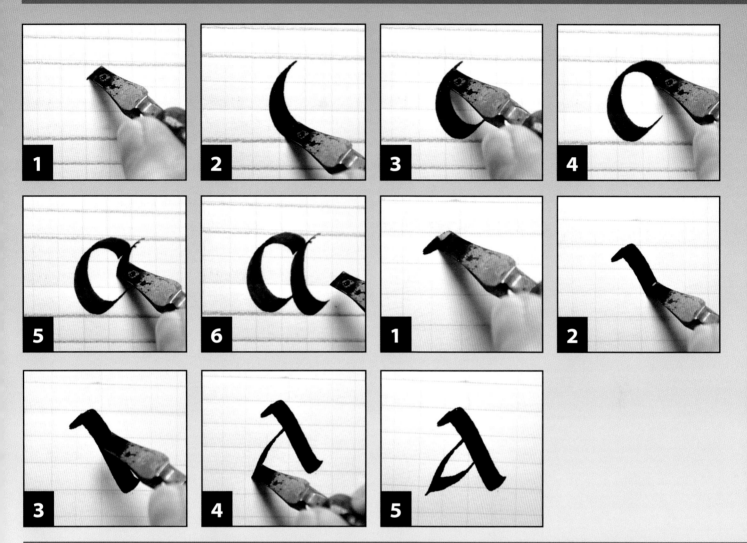

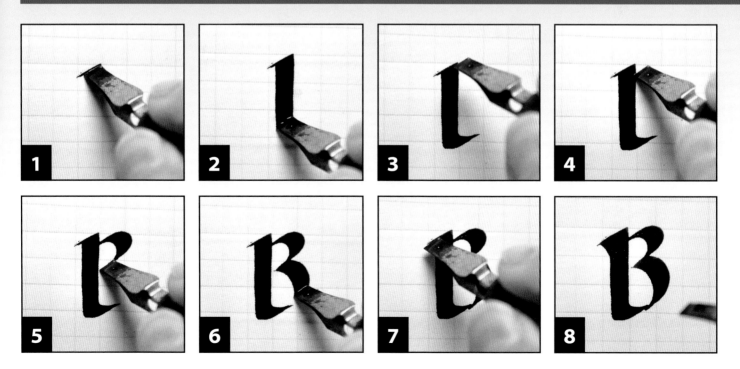

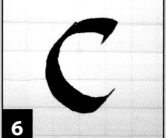

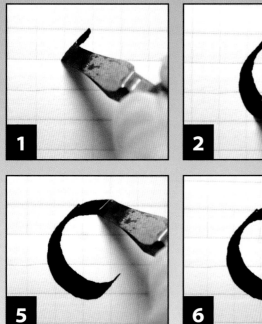

The Uncial C is simply an oval made in two parts: a downstroke and a cross-stroke.

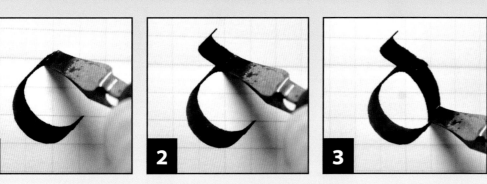

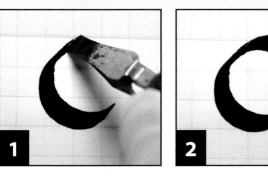

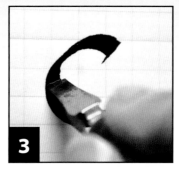

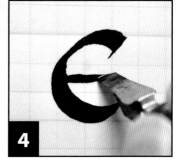

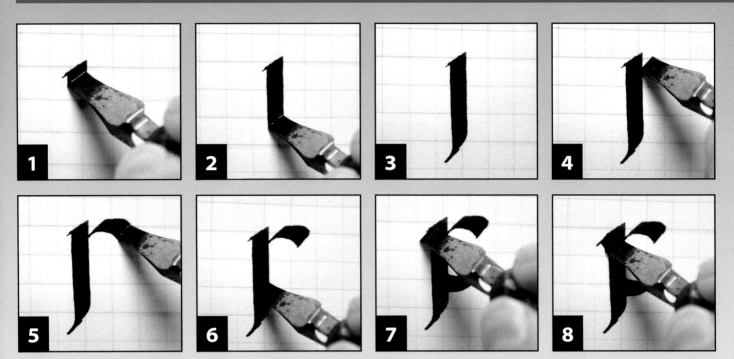

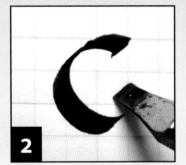
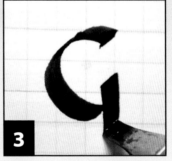
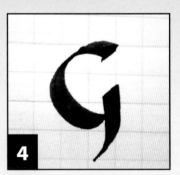
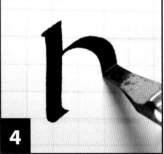

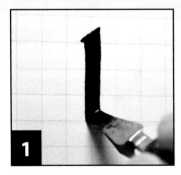
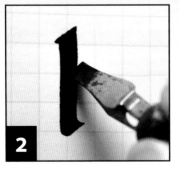
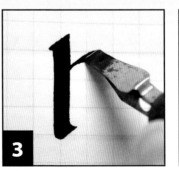

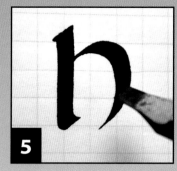
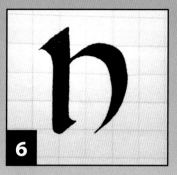
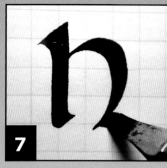

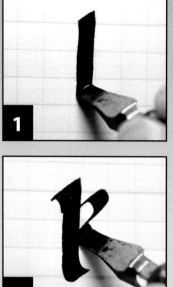

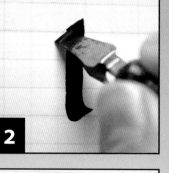

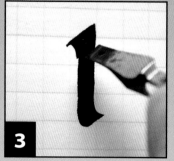

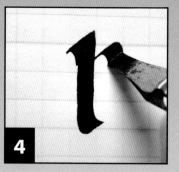

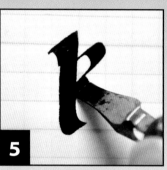

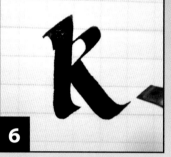

Stem strokes for the K can go below the baseline.

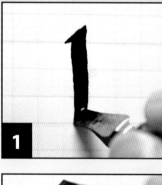

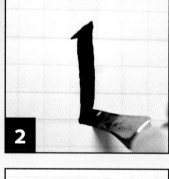

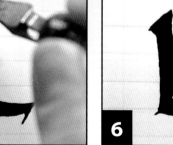

The L uses a straight stroke with a slab serif.

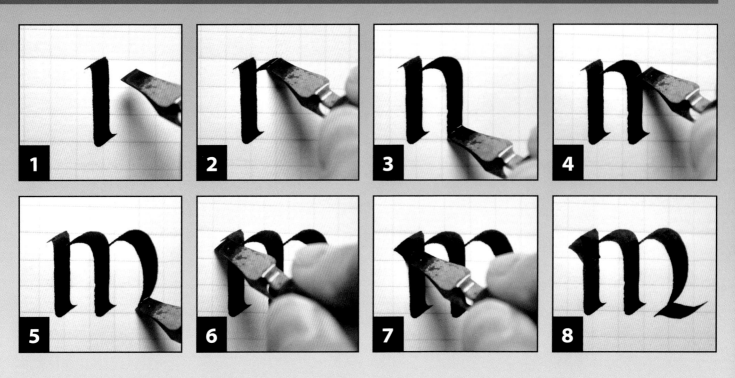

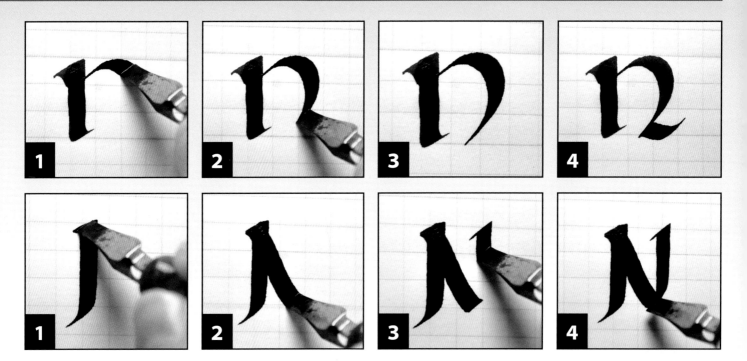

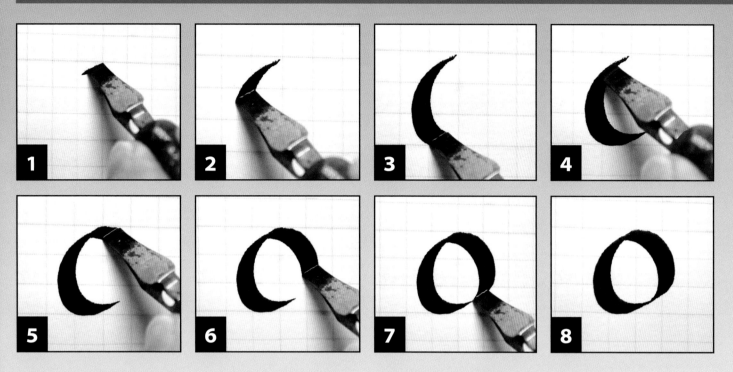

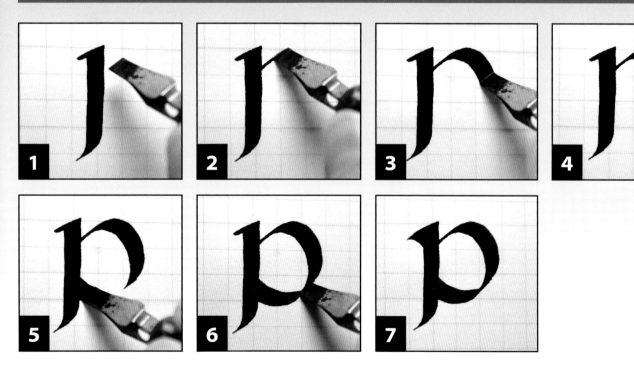

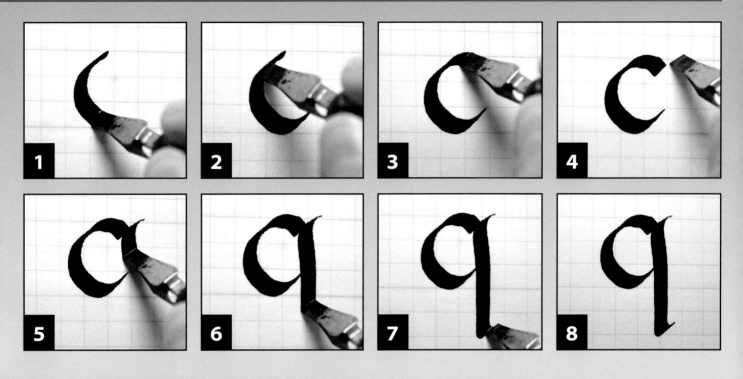

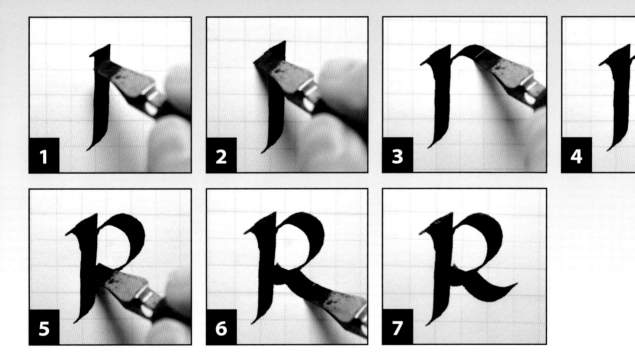

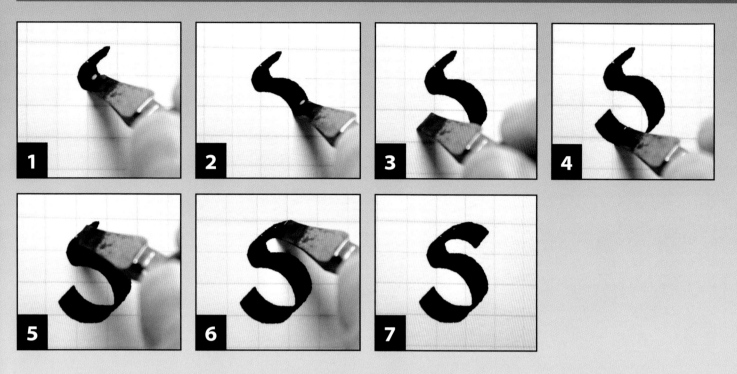

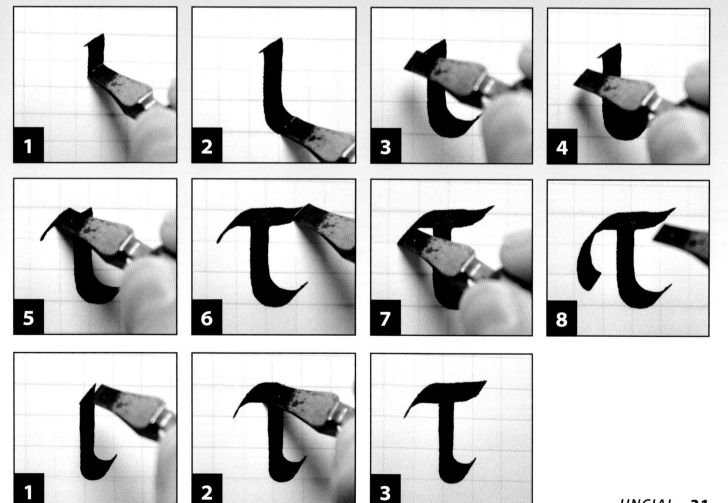

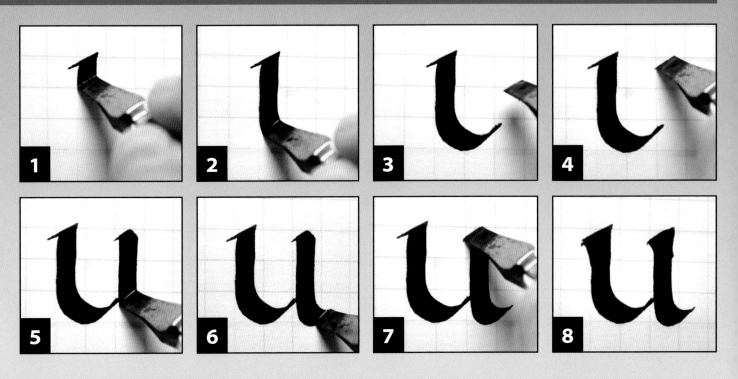

 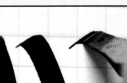

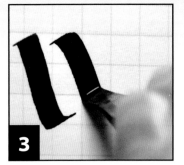

 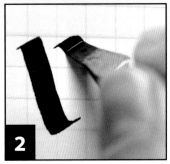 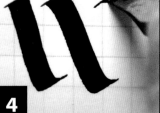

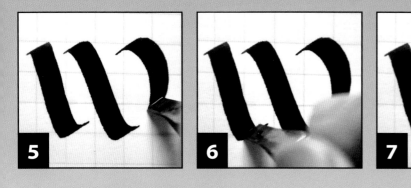

5 6 7

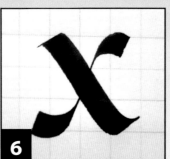

1 2 3 4

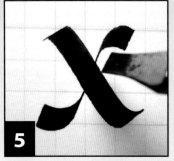

5 6

The X is based on the oval C with the backstroke of the O made first.

1 2 3 4

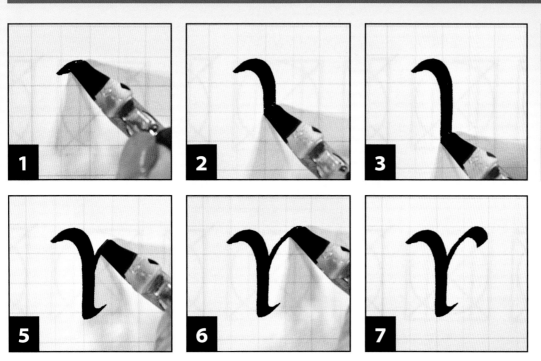

5 6 7

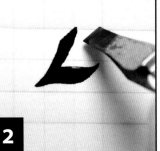
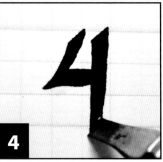

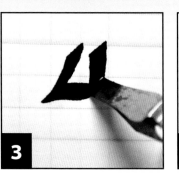

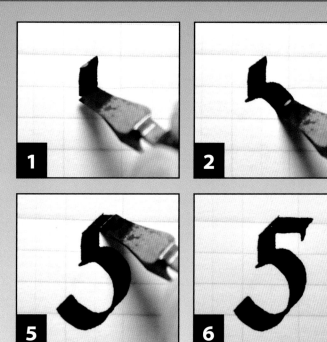

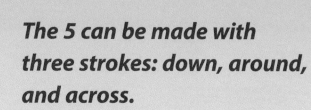

The 5 can be made with three strokes: down, around, and across.

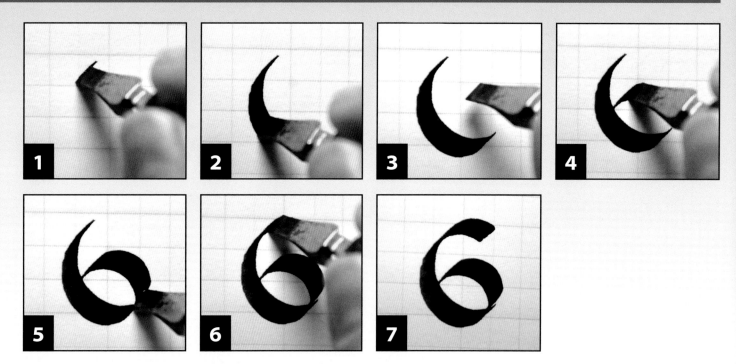

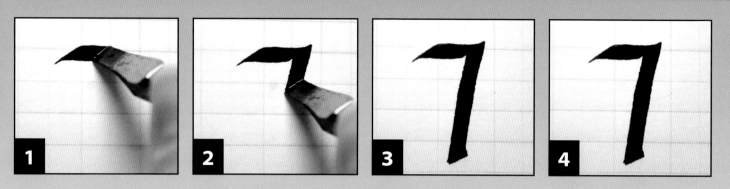

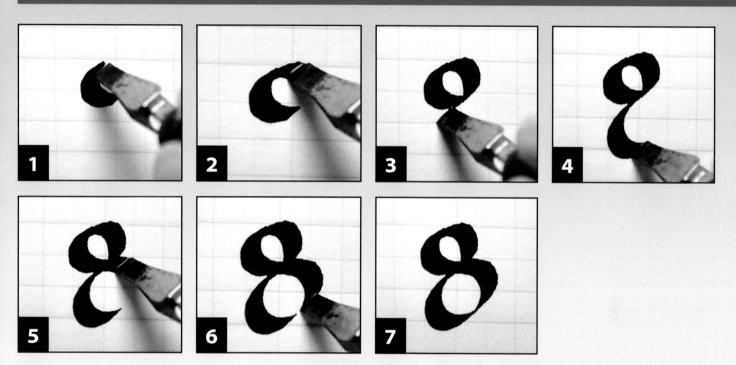

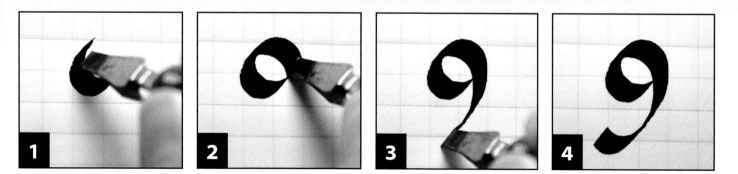

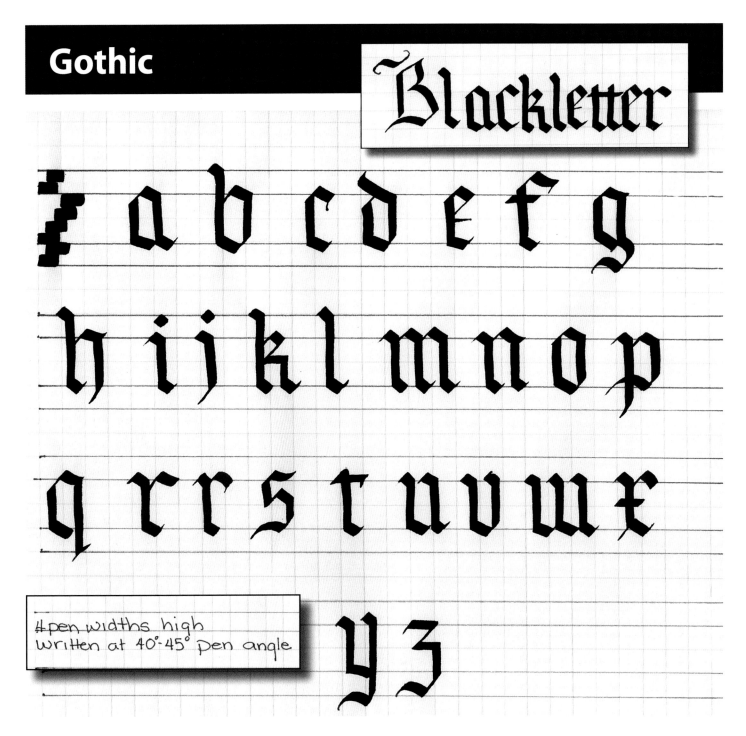

Blackletter

4 pen widths high
written at 40°-45° pen angle

lackletter or Textura (interlacing), as the name suggests, is a dense, compressed Gothic that leaves relatively little white space between the letters. On the page, it looks like a picket fence with closely spaced, thick, black vertical lines. It also features upright and lozenge-shaped terminations. The Gothic hand has very decorative letters but can be difficult to read.

There are many variations in the Gothic hand depending on where and when they were constructed. Gothic in Germany is spacious and rounded; in England it is tight with very little white space. Gothic was used from the 1100s through 1500 and was named after the late medieval style in architecture, which used angular, pointed arches.

Early Gothic grew out of Carolingian as a narrower, slightly angular version.

O C E

O, C, and E are constructed using the same strokes.

It helps to master these strokes before moving on to the **A** family.

A family

The **A** family consists of **A, G, D,** and **Q**.

A is the same footprint as the **O** with a tail. **G** has a half circle and a swash. **D** has an elongated stroke, and **Q** has a straight, elongated backstroke.

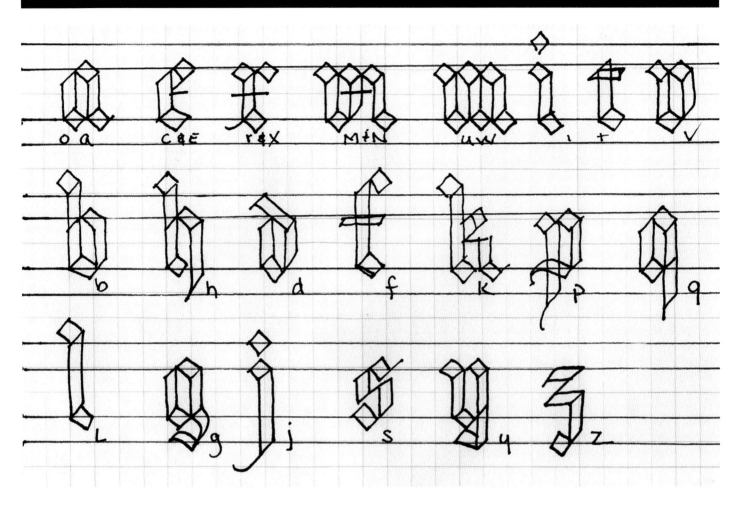

I R X

I starts out with a diamond or foot stroke, a long stroke, and then another foot stroke; it finishes with a diamond stroke to dot the letter.

R is the **I** stroke with an elongated diamond stroke at the top.

The **X** is the **R** with a thin line at the foot and a hairline across the center.

V U W

V starts with a diamond. Add a downstroke and an elongated diamond, move to the waistline, add a diamond, and then move down to meet the diamond stroke.

U is the letter **V** with a diamond added at the baseline.

W is the diamond, the downstroke, and the diamond three times.

M and N

Make a diamond, add a downstroke and another diamond. At the waistline add an elongated diamond with a downstroke and diamond to the foot. Continue this stroke a third time for the **M**. The elongated diamond pushes the top stroke out a little to keep the foot or base of this letter open. Pay attention to the legibility in this hand as it can degrade quickly.

Practice, practice.

T

T starts with a downstroke just above the waistline. It is not a tall letter—the crossbar is at or just below the waistline.

L

L starts with a diamond and downstroke and a diamond stroke for the foot.

J

J starts with a diamond and an elongated downstroke with a slight pull to the left.

3.8 pilot par

→ ◆ ◆ ◆ place left side of
Nib on line

pull down till Right
Side of nib is on
the line ◆ ◆ ◆ ←

⫼ ← pull down til the left side
touches the line

90°
40-45°
0°

F
F starts with a downstroke at the ascender line, keeping the right side of the nib at the line and the left side below the line. Pull the stroke to the baseline and add a foot or diamond. Go back to the ascender line and pull an elongated stroke to finish the top of the **F** and add a crossbar at or just below the waistline.

B
For **B**, first create the **L** stroke. At the waistline put the pen down so that the right side is on the waistline and create a diamond stroke. Add a downstroke to connect to the foot stroke.

H
H starts with the **L** stroke. As with the **B**, add a diamond at the waistline and pull a downward stroke, ending just below the baseline.

K
K starts with the **L** stroke. At the waistline, slide up a hair and make a diamond and pull back into the stem. Pull straight out with a flat stroke, and then add a downstroke and a foot.

Gothic

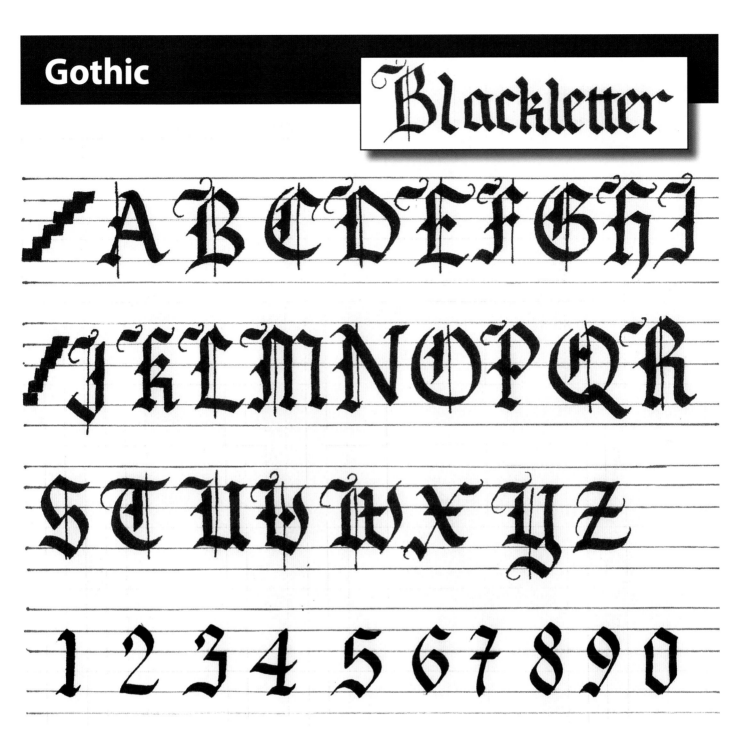

P

P starts with a diamond and a downstroke, pulled below the baseline and then pulled slightly to the left. At the waistline pull from the stem to the waistline. Add a diamond and downstroke. Add a stroke beginning on the outside left of the stem curving to meet the downstroke of the **P**.

Y

Y starts with the **I** stroke. Go to the waistline and create a diamond and a downstroke that goes below the baseline. Add an elongated diamond.

Z

For **Z**, slide up to the waistline and pull toward the right. Pull a diagonal stroke to the center and a flat stroke out. Add a downstroke and finish with an elongated diamond stroke.

S

For **S**, start with the right side of the nib at the waistline, pulling down and sliding up a pen width and then pulling another downstroke. Pick up the pen and pull an elongated diamond. Return to the waistline and pull an elongated diamond for the cap of the **S**.

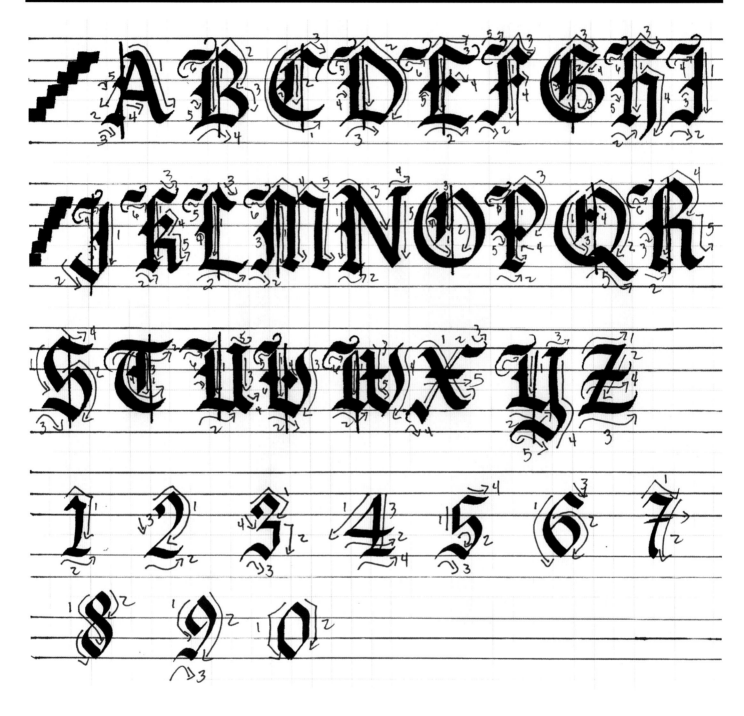

GOTHIC CAPITAL FAMILIES

These are blackletter and as the name suggests they are dense black letters against the white of the page. These are written 6 pen widths high. Practicing on a grid is helpful.

B D E U V W Y
These have a straight spine and a traveling or long stroke.

P R F J I H K L M
Variations of the straight spine or backbone.

Gothic

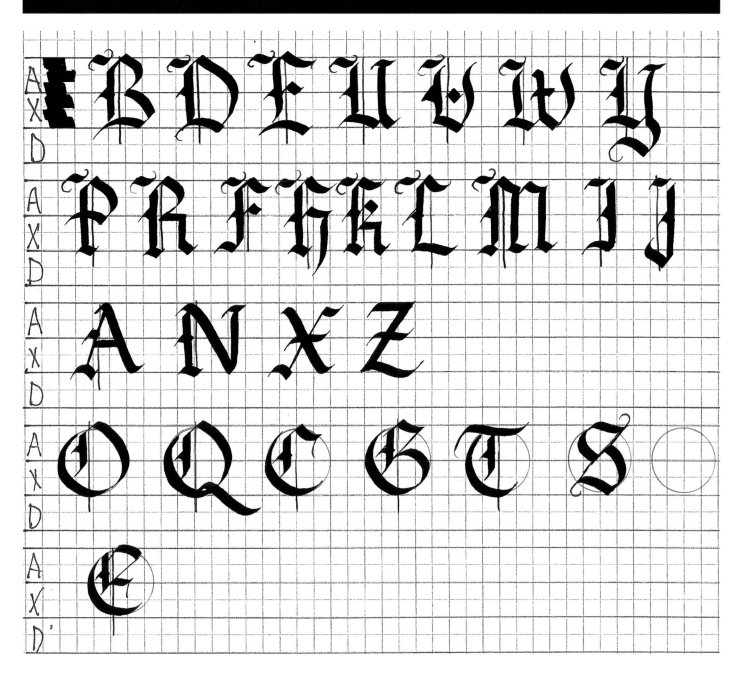

A N X Z
Are diagonal letters.

O Q C E G T and S
Are on the circle letters.

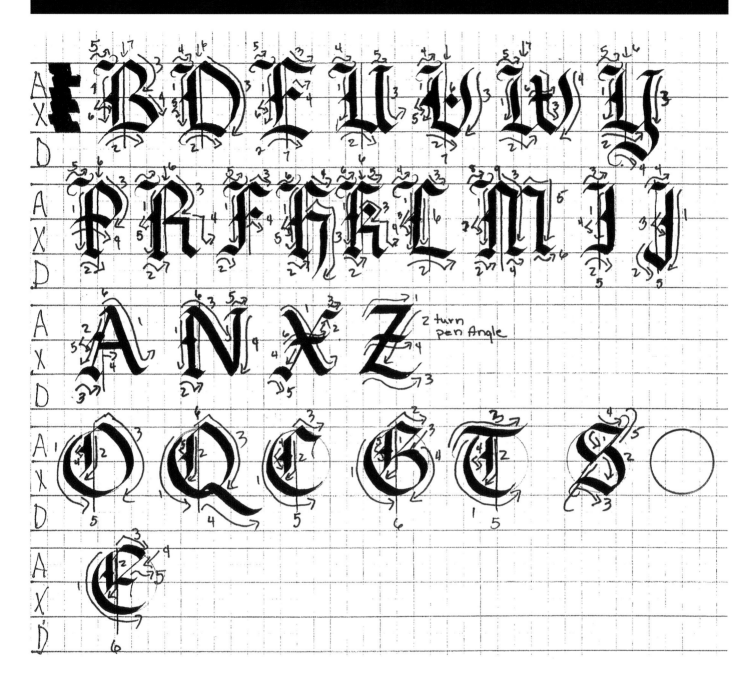

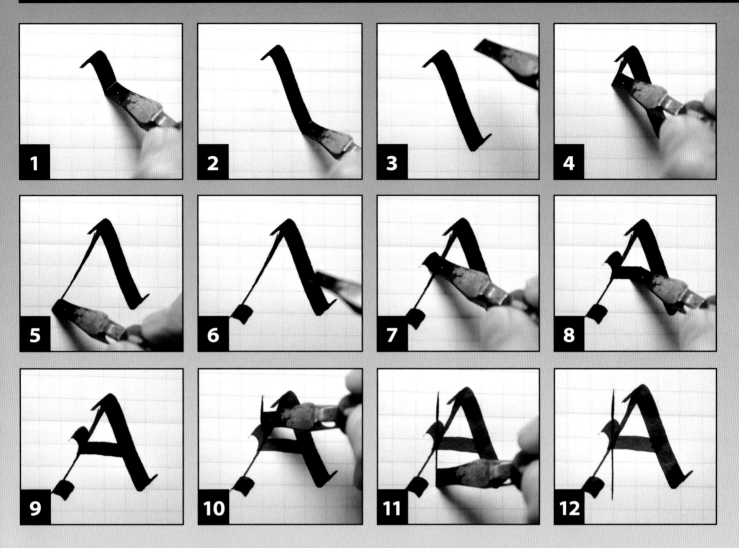

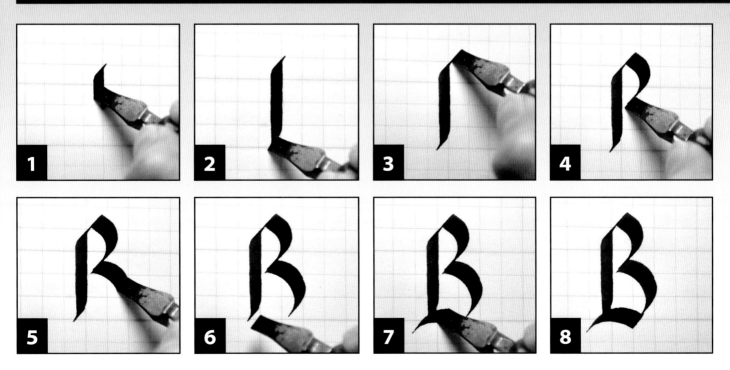

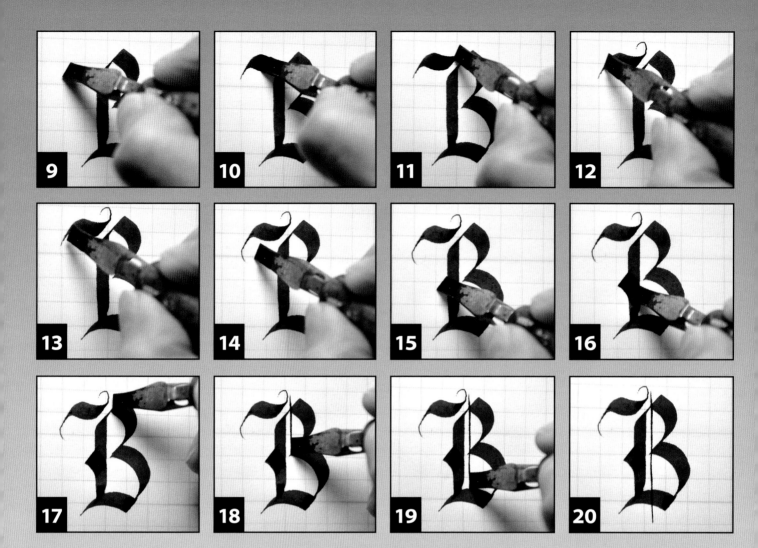

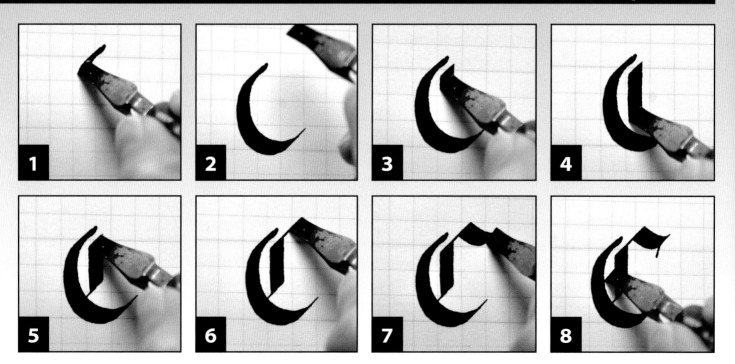

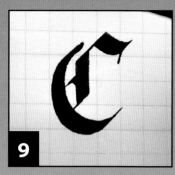

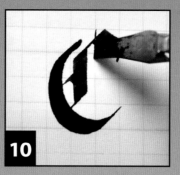

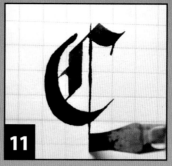

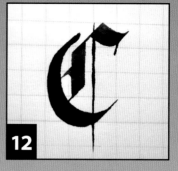

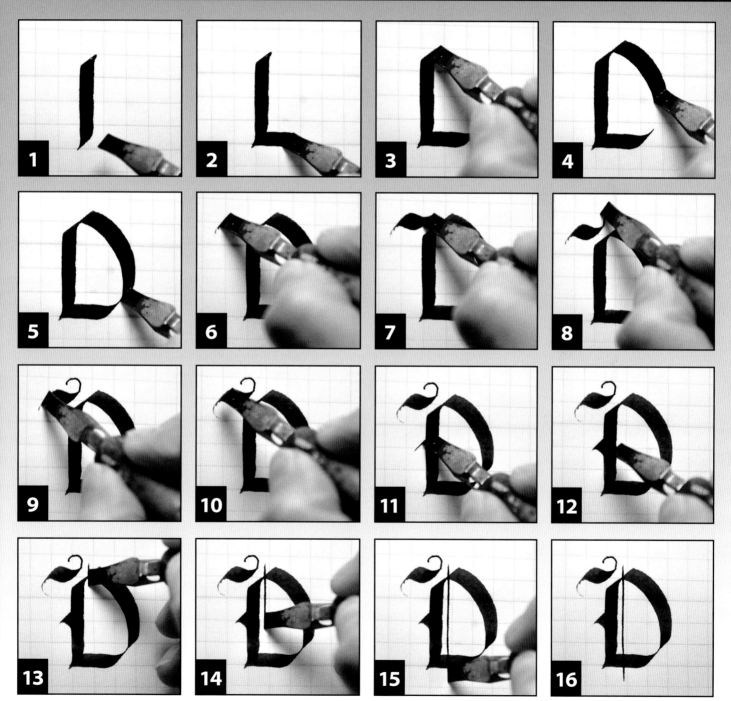

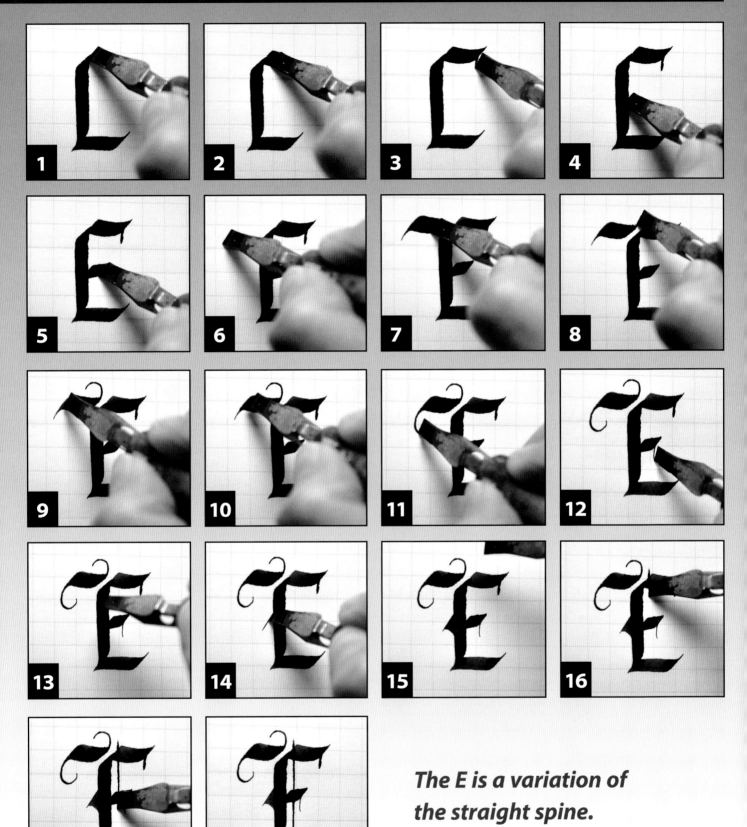

The E is a variation of the straight spine.

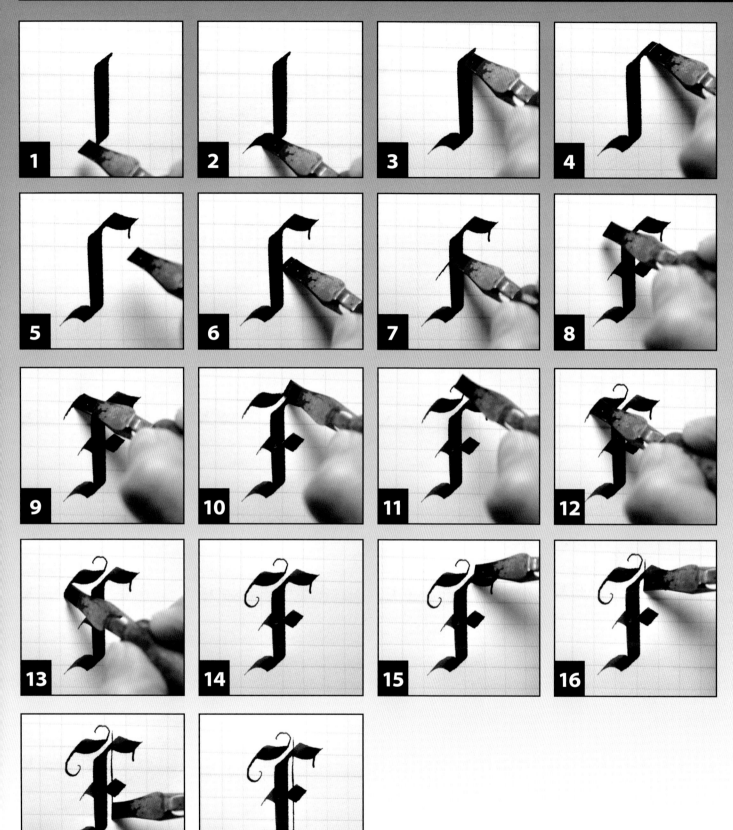

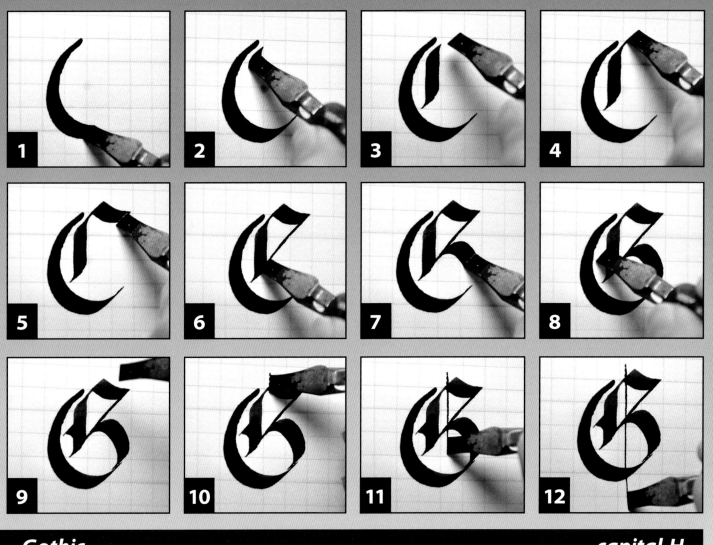

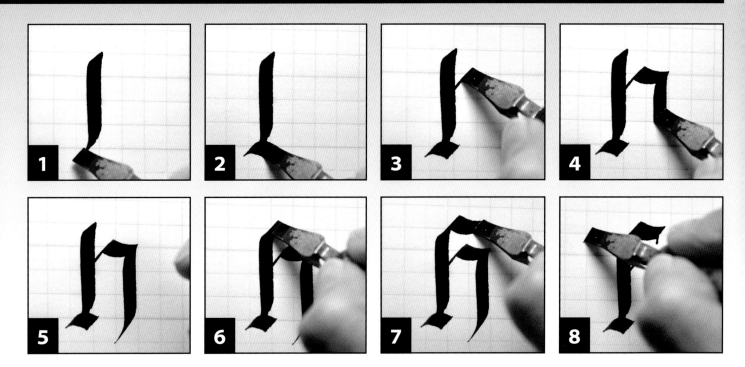

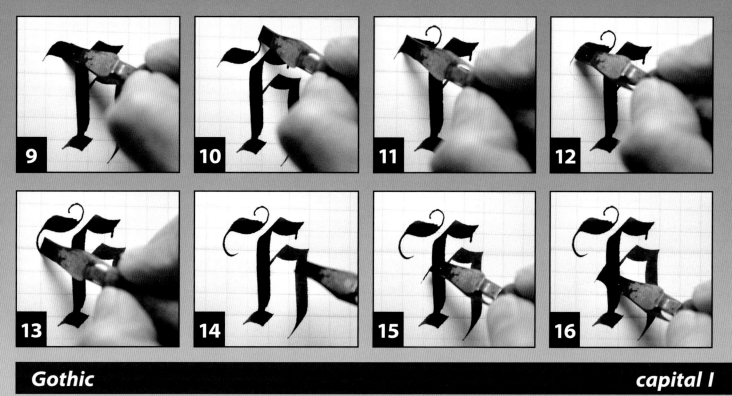

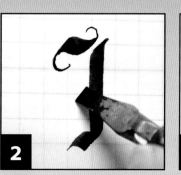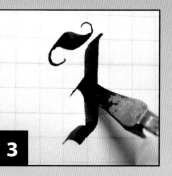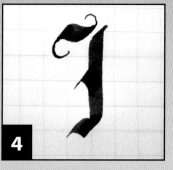

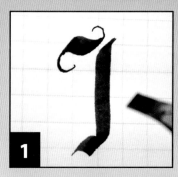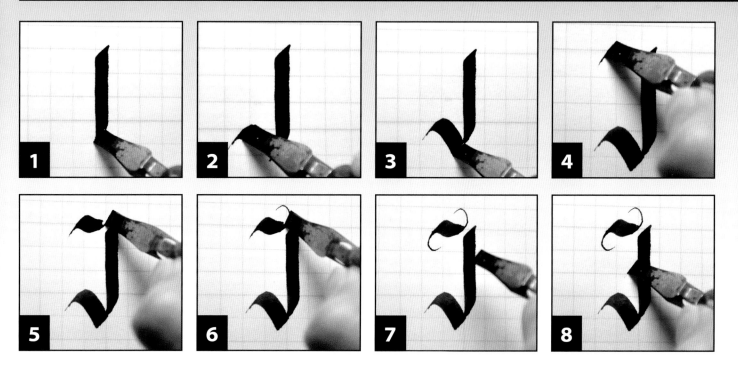

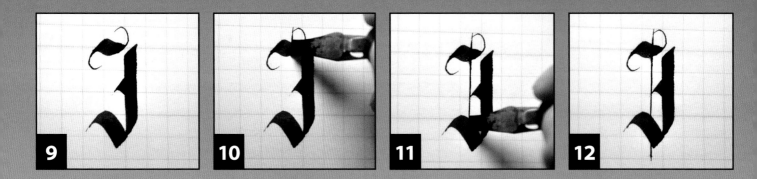

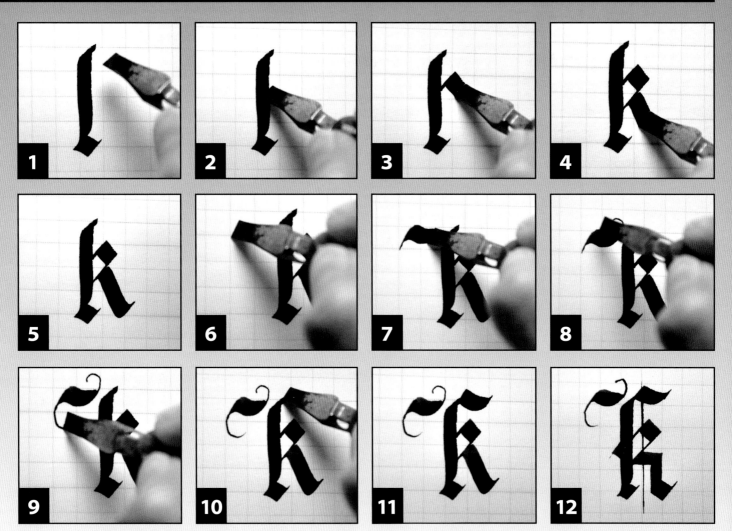

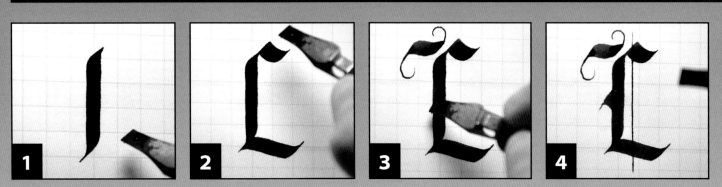

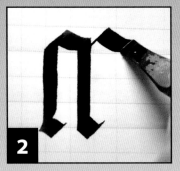
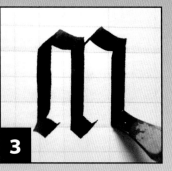
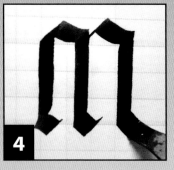

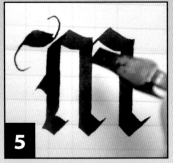
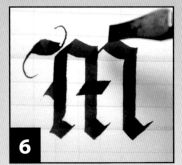
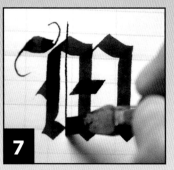
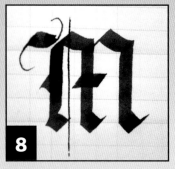

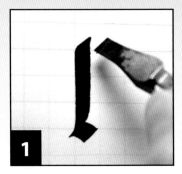
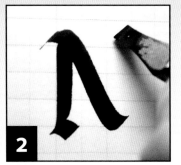
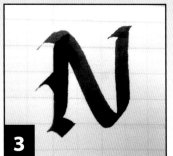
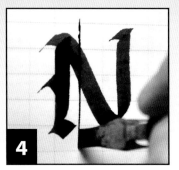

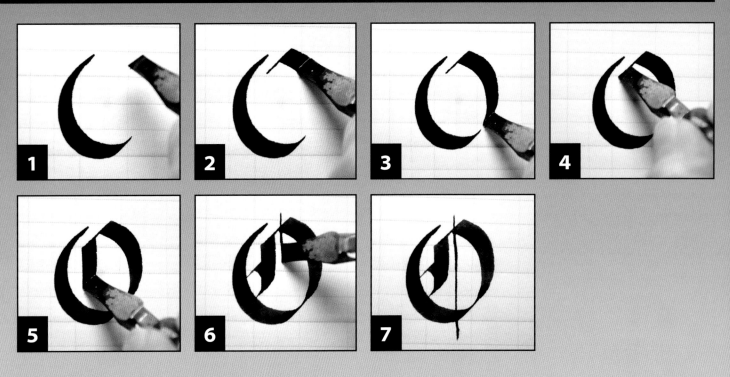

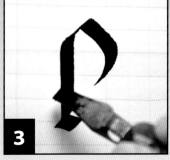
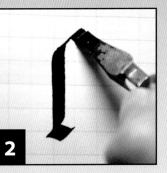
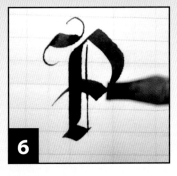

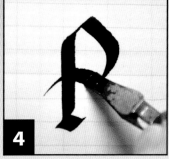

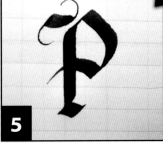

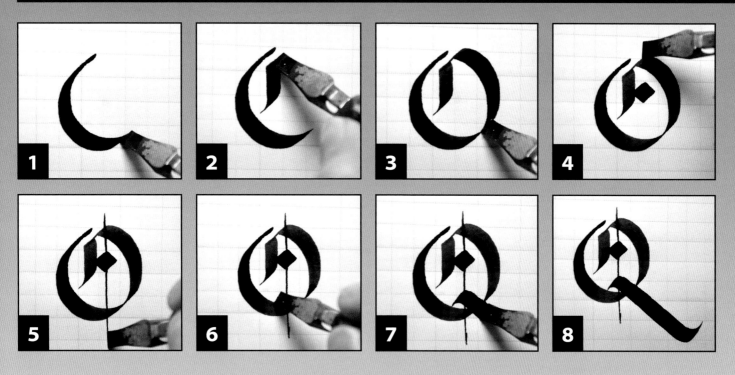

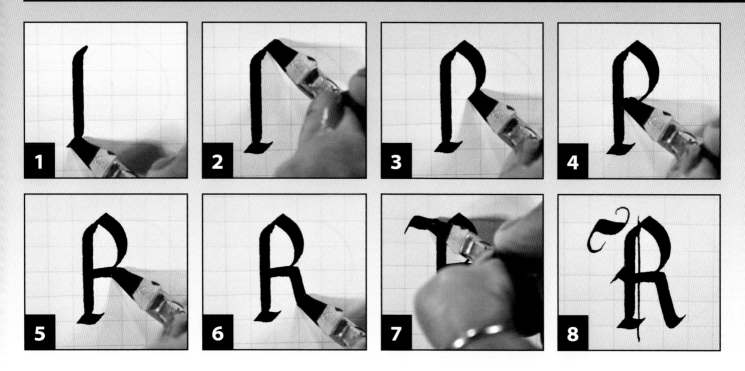

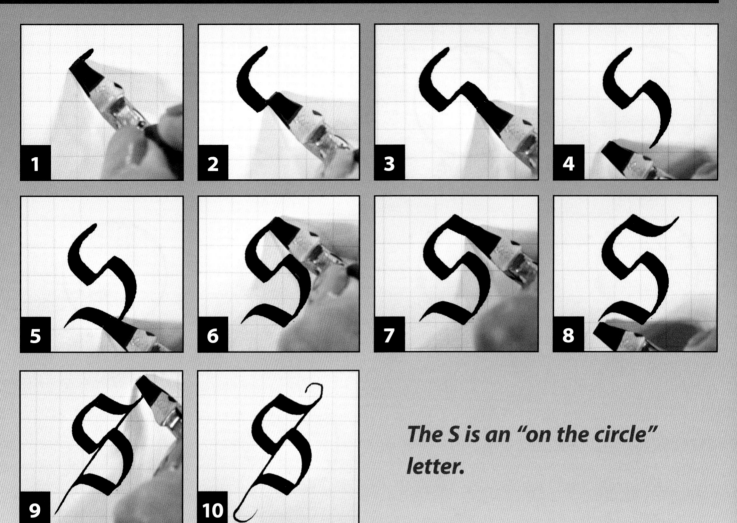

The S is an "on the circle" letter.

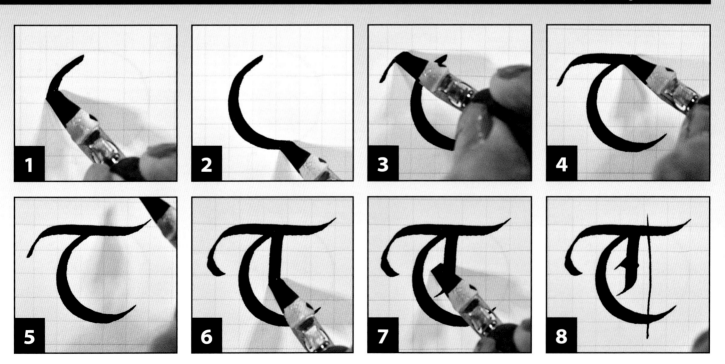

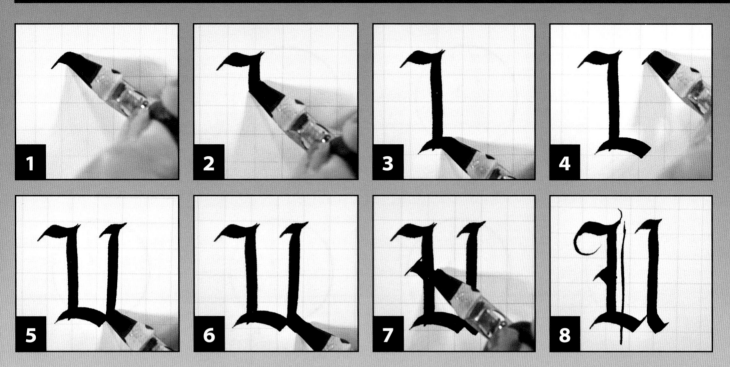

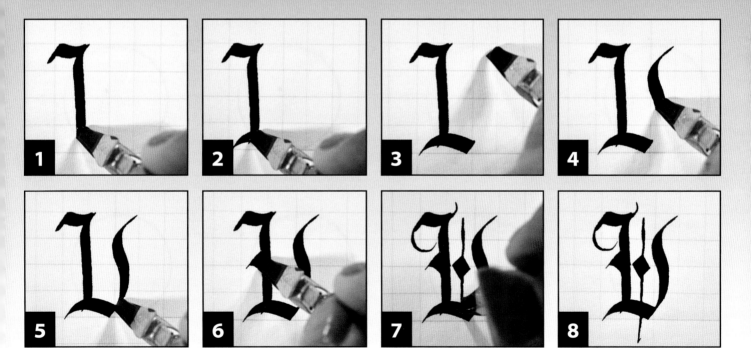

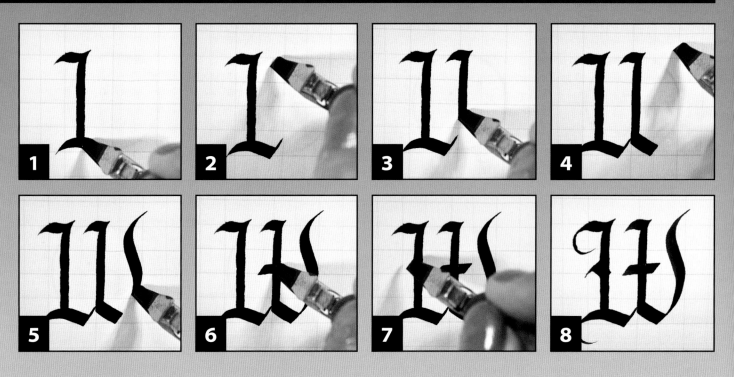

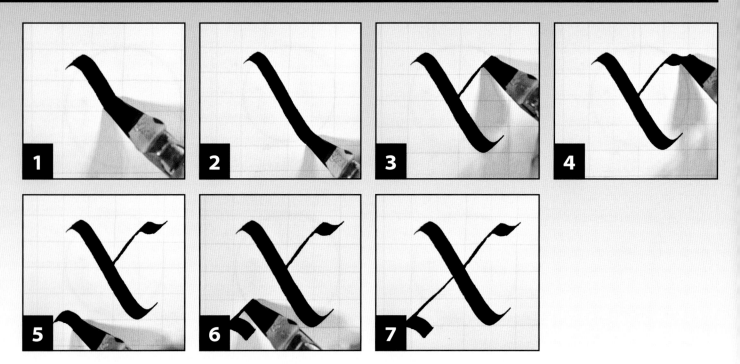

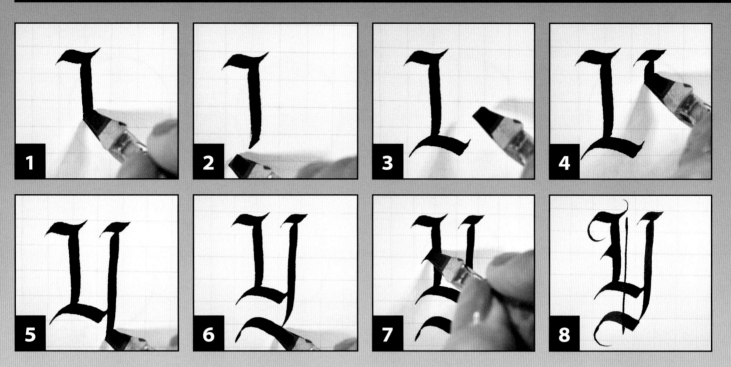

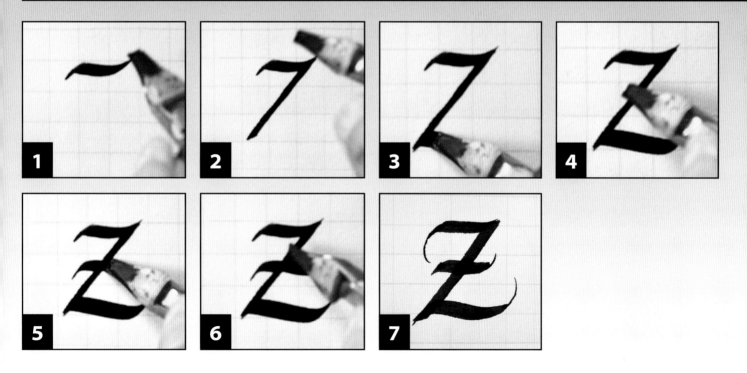

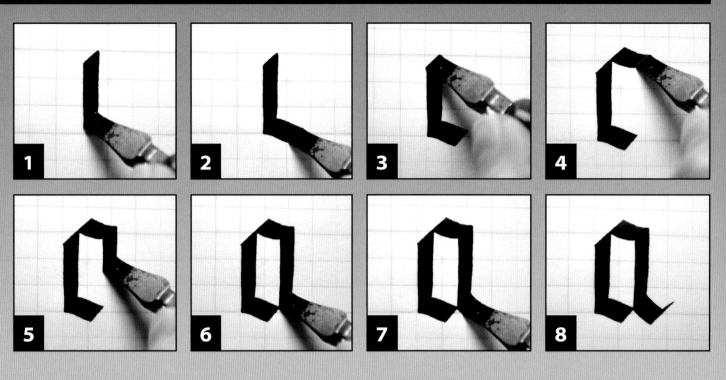

1	**2**
3	**4**
5	**6**
7	**8**

1	**2**
3	**4**

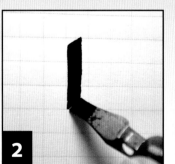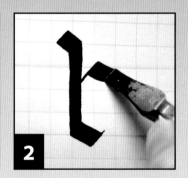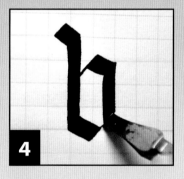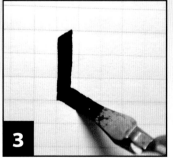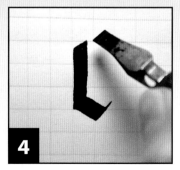

1	**2**
3	**4**

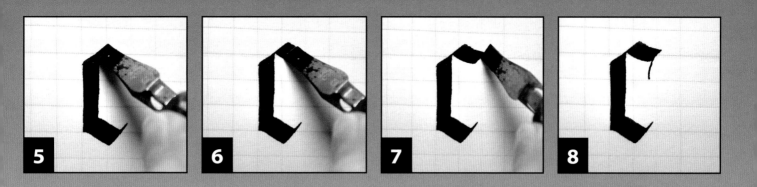

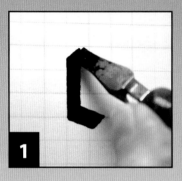 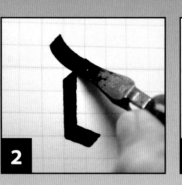 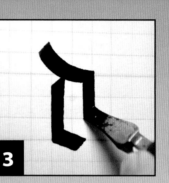 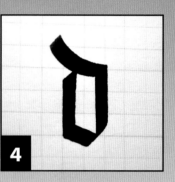

Gothic lowercase E

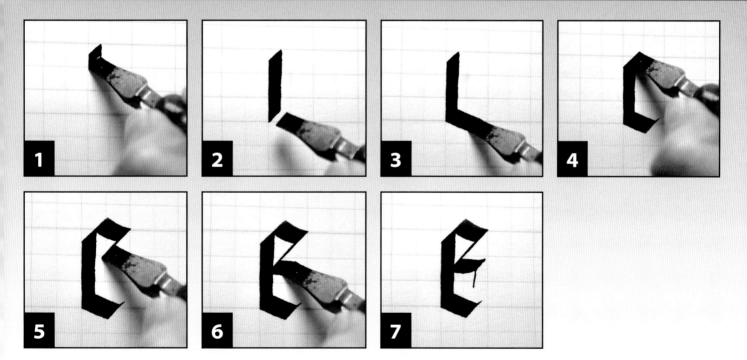

1

2

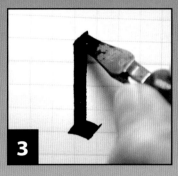

3

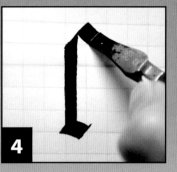

4

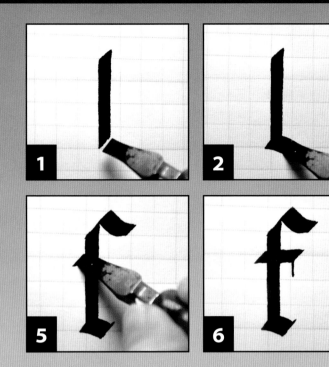

5

6

To finish the f, add a crossbar at or just below the waistline.

1

2

3

1

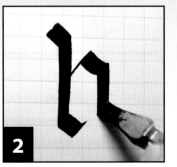

2

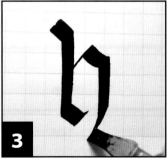

3

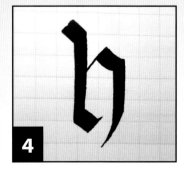

4

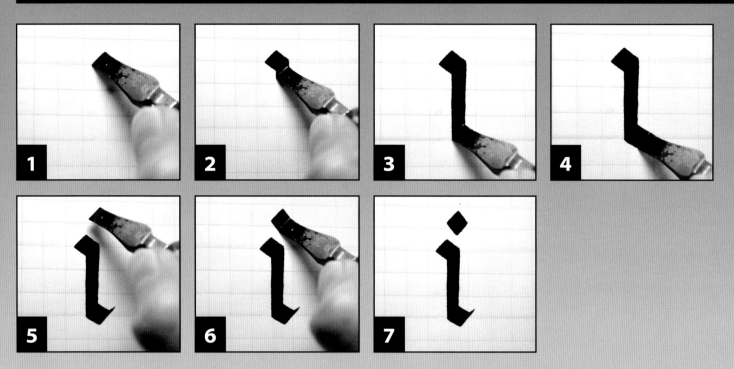

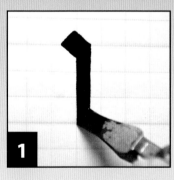
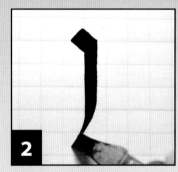
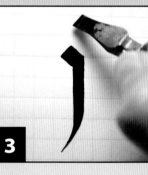

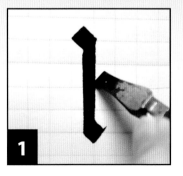
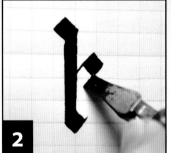
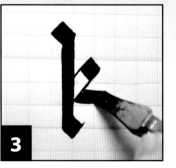
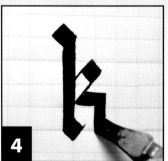

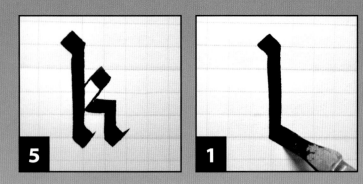

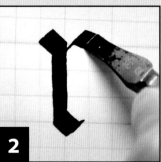

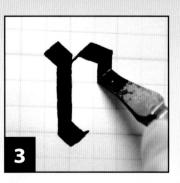

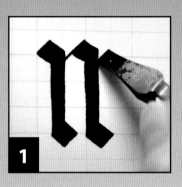

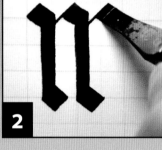

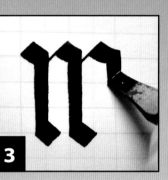

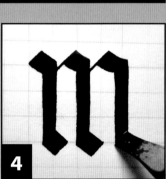

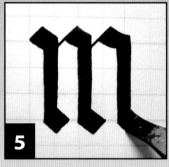

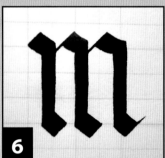

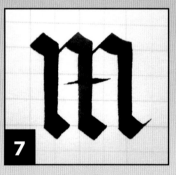

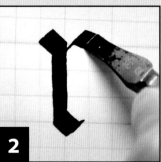

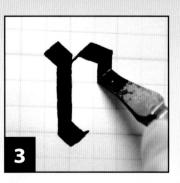

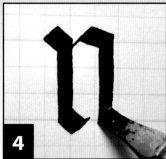

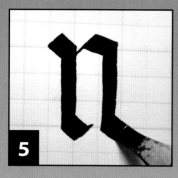

5

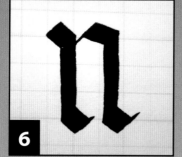

6

The elongated diamond pushes the top stroke out a little.

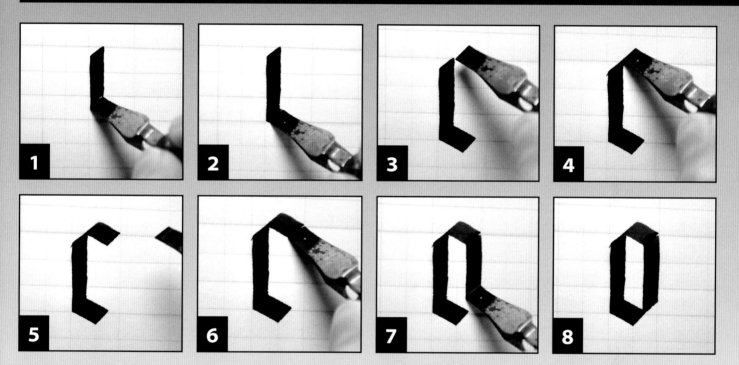

1

2

3

4

5

6

7

8

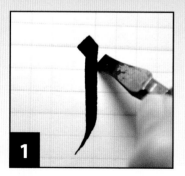

1

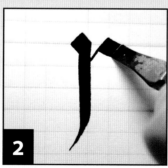

2

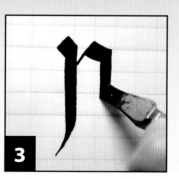

3

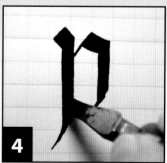

4

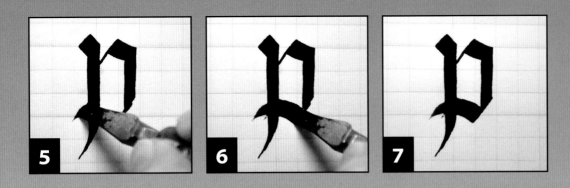

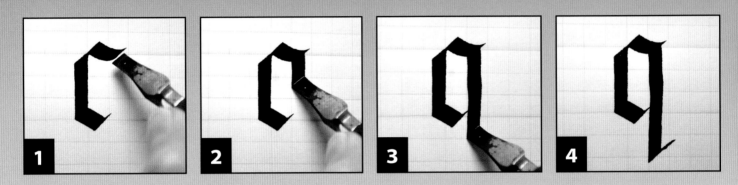

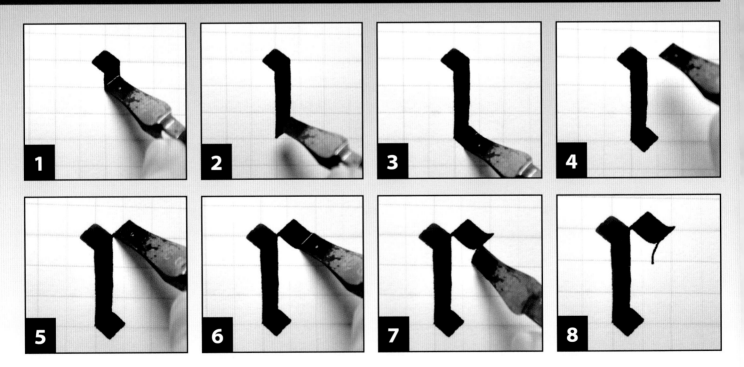

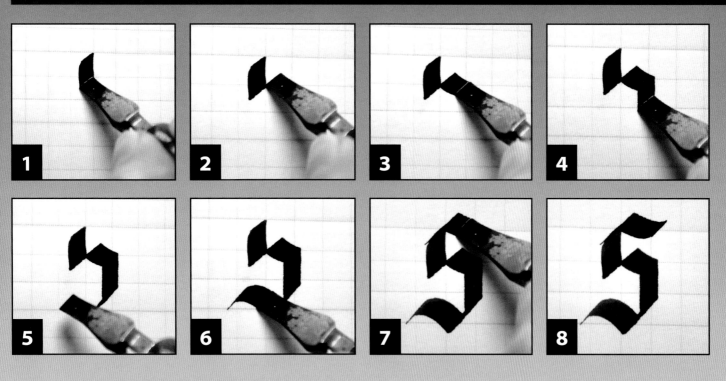

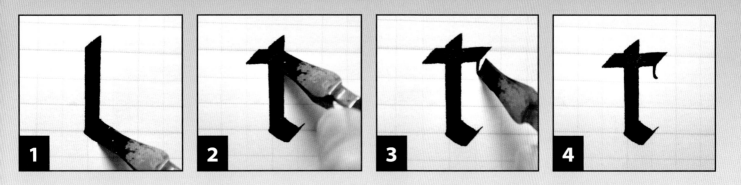

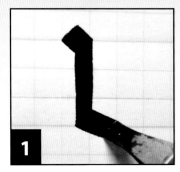
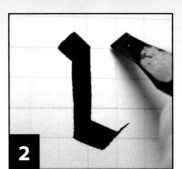
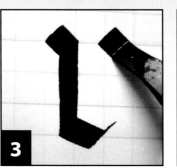
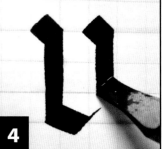

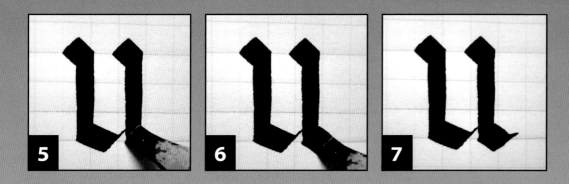

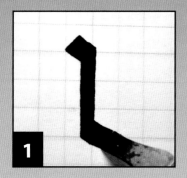
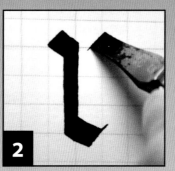
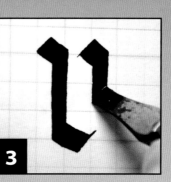
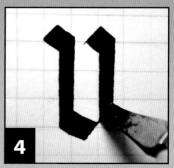

Gothic *lowercase W*

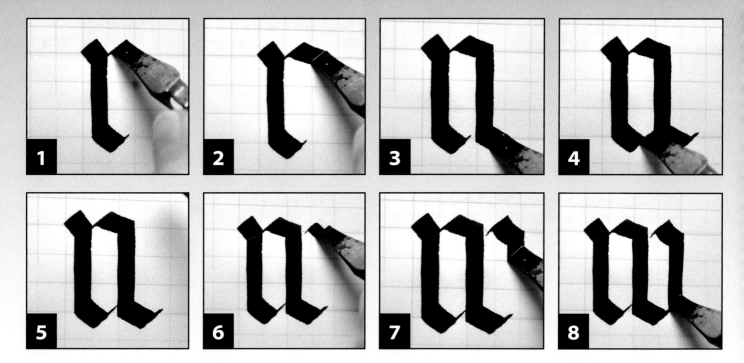

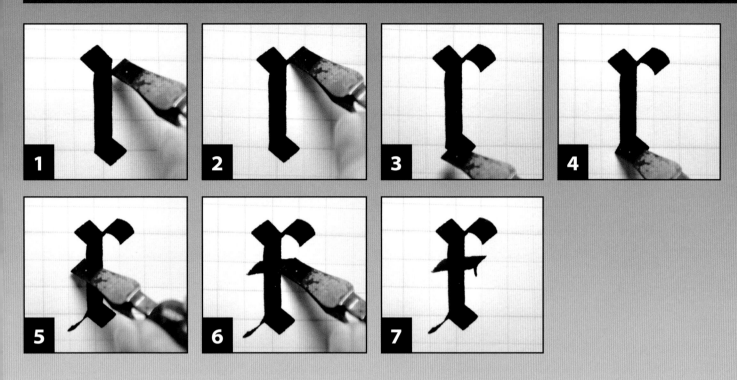

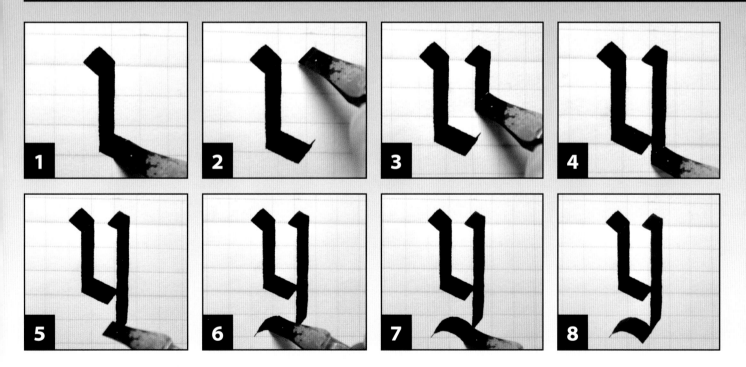

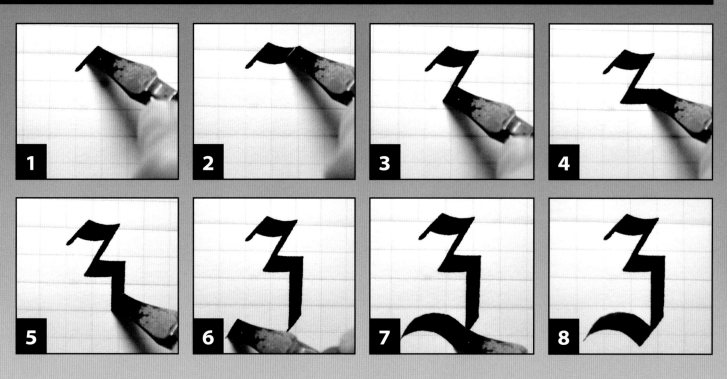

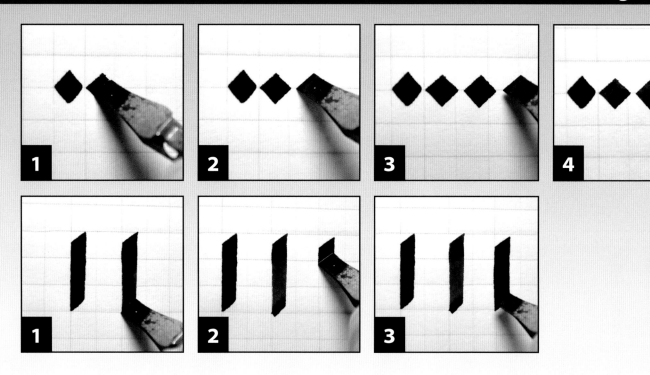

Lombardic Caps

The capitals of these hands are known for their rotund construction.

Carolingian

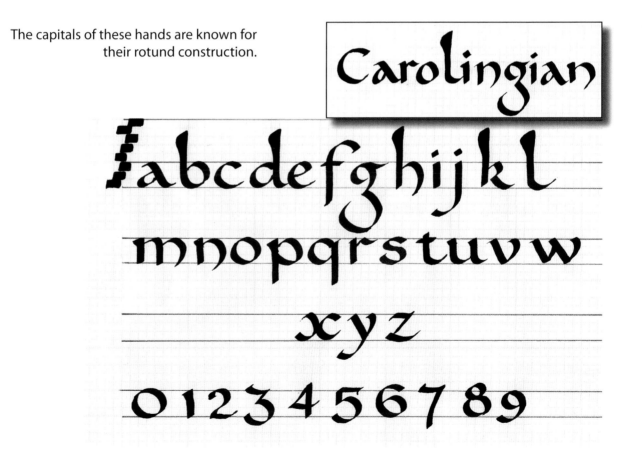

Roman

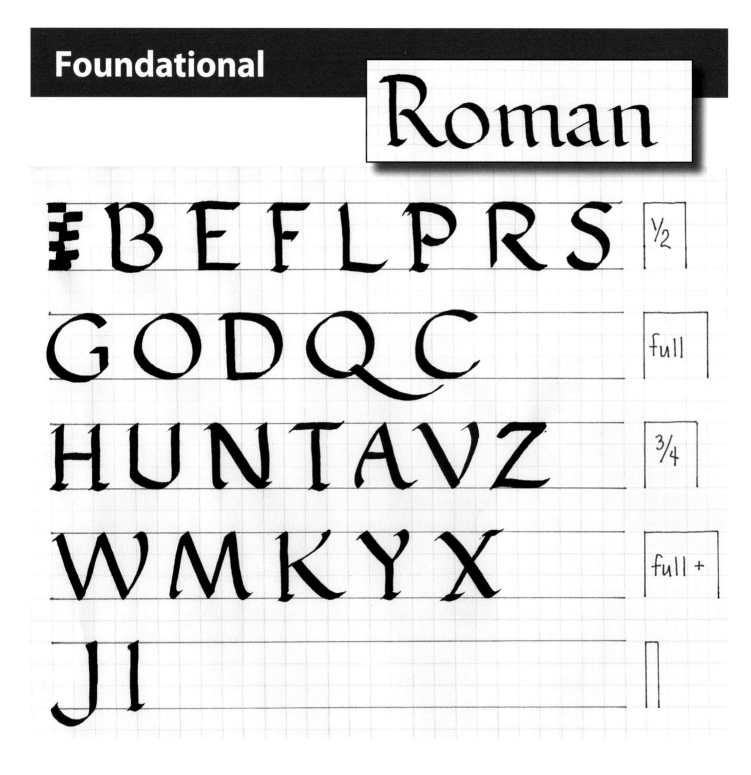

The Roman Foundational hand is based on lettering that appears on Trajan's Column, a triumphal structure erected in Rome in 114 A.D. (the **J**, **U**, and **W** are modern additions). The column's inscription is one of the most influential capital scripts in the Latin alphabet and has served as an excellent model for calligraphers throughout history.

The ancient letters, chiseled into stone, are formal and upright, with a distinctive geometric structure. This hand is versatile and beautiful.

BEFLPRS

These letters are constructed to be half as wide as they are tall.

GODQC

The round letters, which are full-size, are as wide as they are tall.

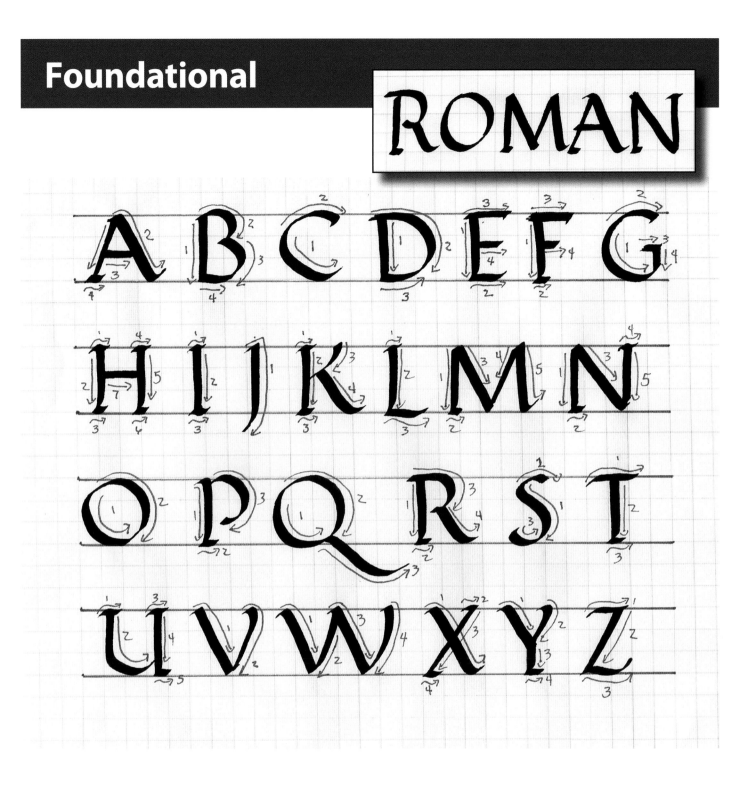

HUNTAVZ

These letters are three-quarters as wide as they are tall.

WMKYX

These letters are plus-size and are a little wider than they are tall.

Foundational

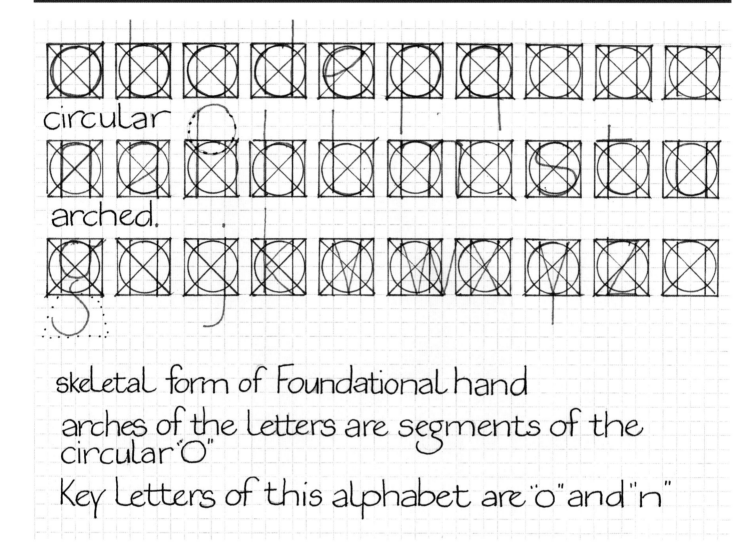

circular

arched.

skeletal form of Foundational hand

arches of the letters are segments of the circular "O"

Key letters of this alphabet are "o" and "n"

Come said the wind to
the leaves one day,
Come o're the meadows
and we will play.
Put on your dresses
scarlet and gold.

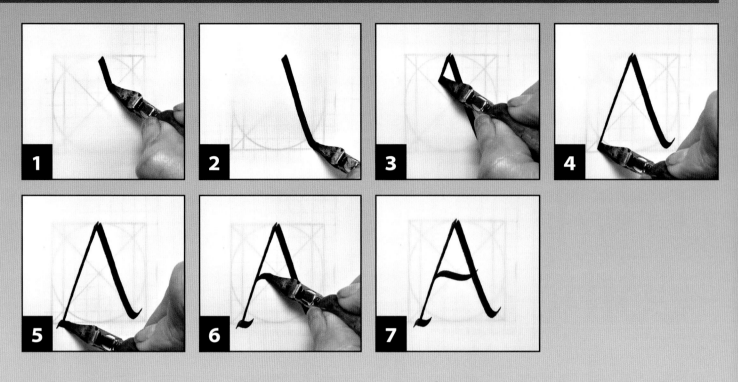

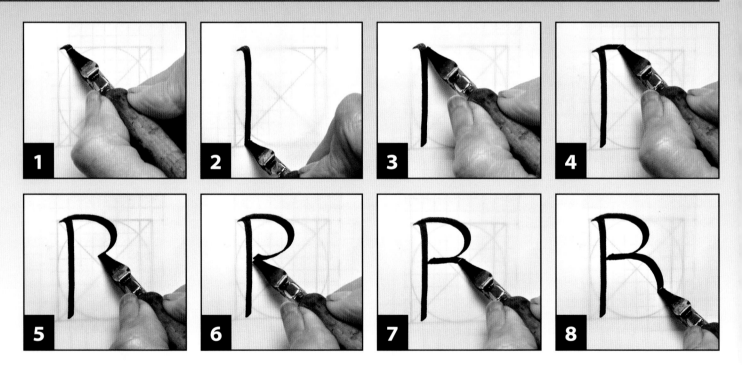

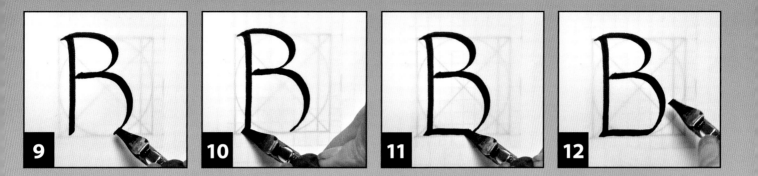

9 10 11 12

 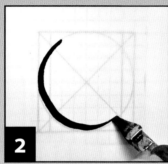 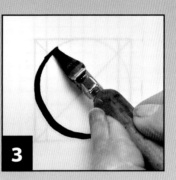 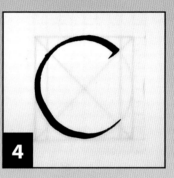

1 2 3 4

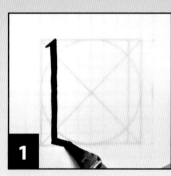 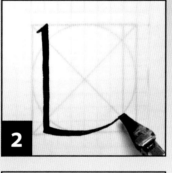 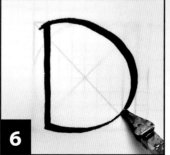 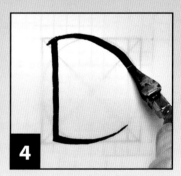

1 2 3 4

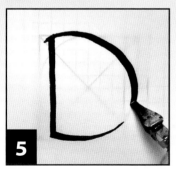

5 6

The D is as wide as it is tall.

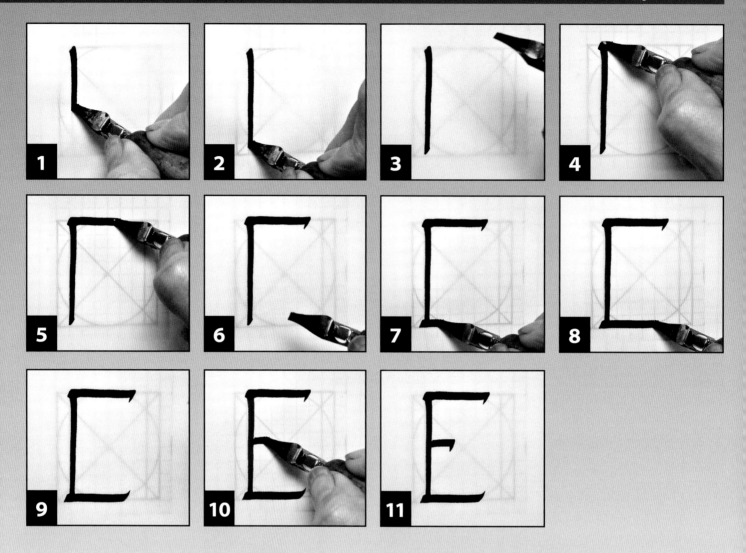

 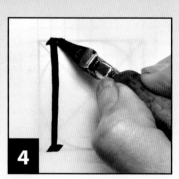

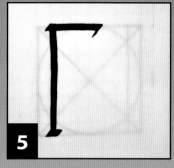

5

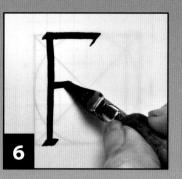

6

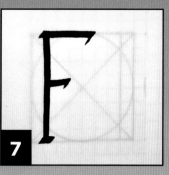

7

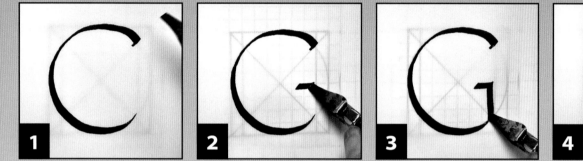

1

2

3

4

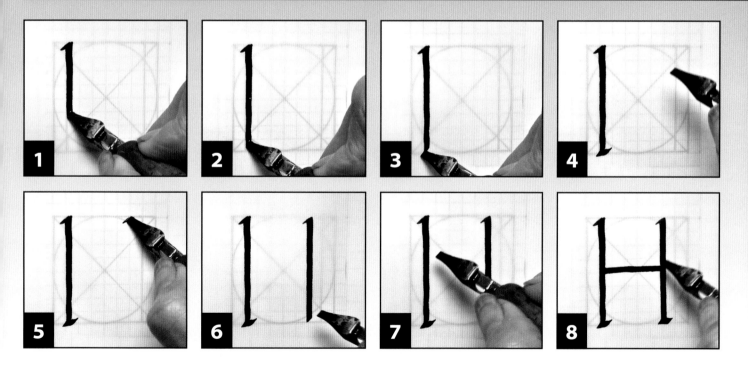

1

2

3

4

5

6

7

8

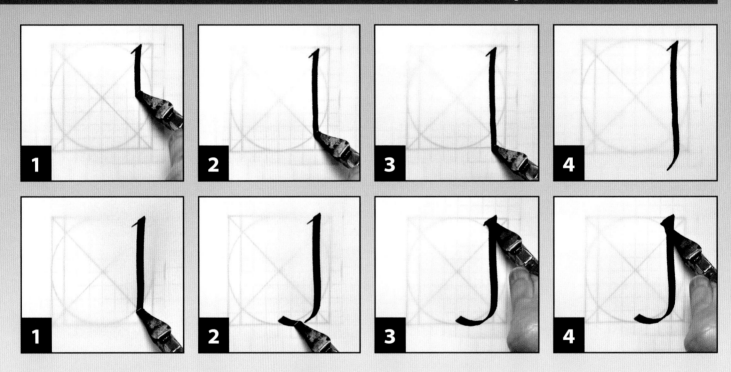

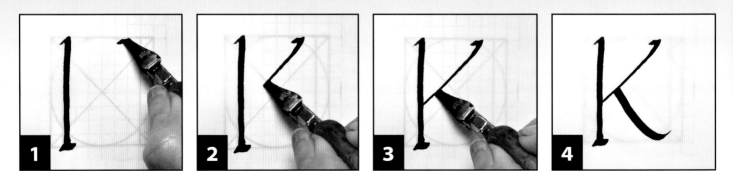

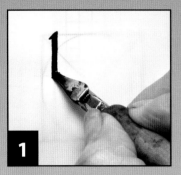
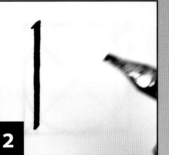
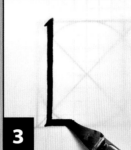
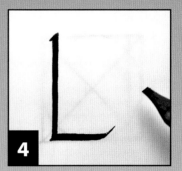

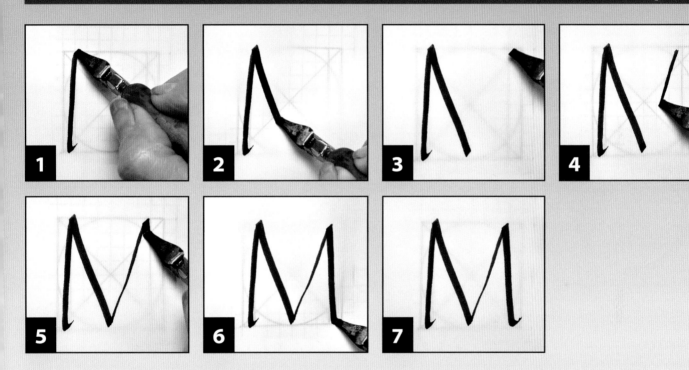

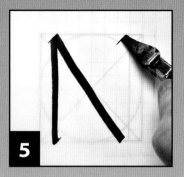

5

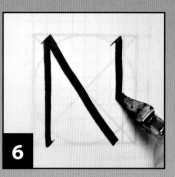

6

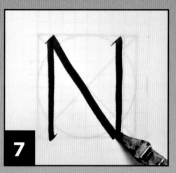

7

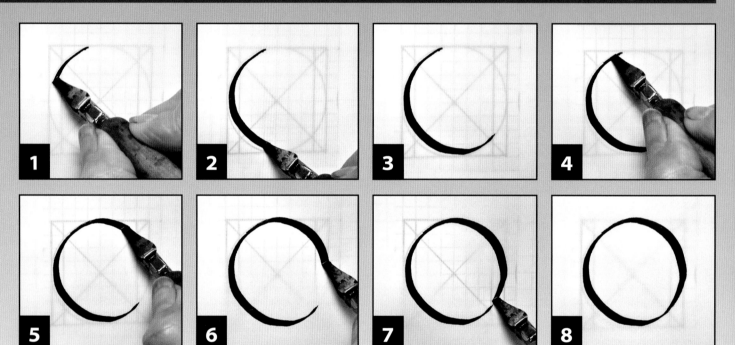

1

2

3

4

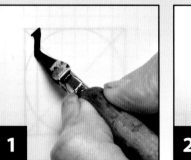

5

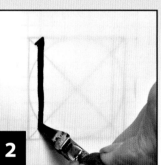

6

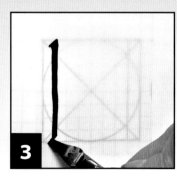

7

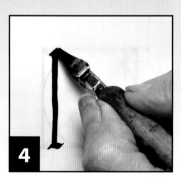

8

1

2

3

4

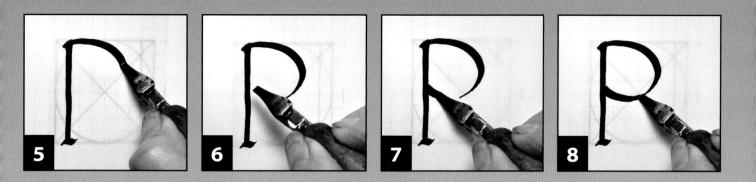

5

6

7

8

1

2

3

4

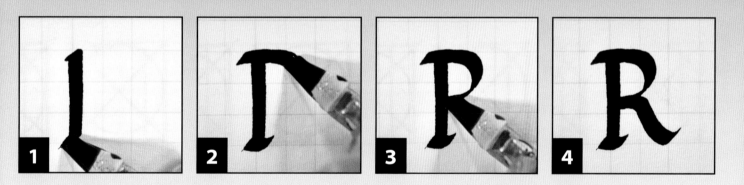

1

2

3

4

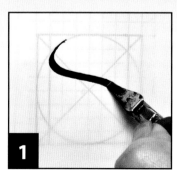
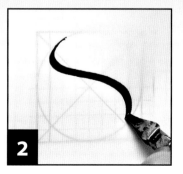
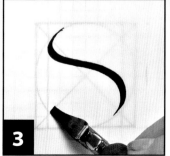
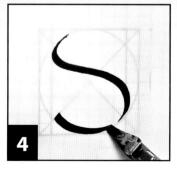

1

2

3

4

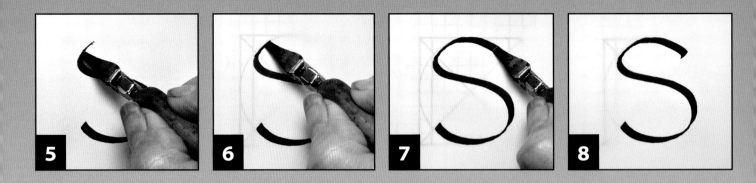

Foundational

capital T

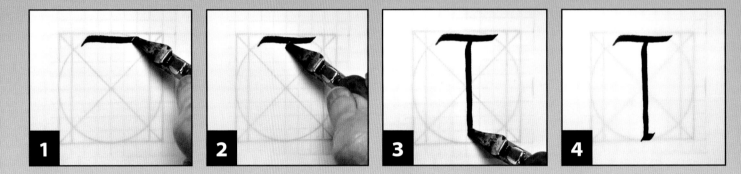

Foundational

capital U

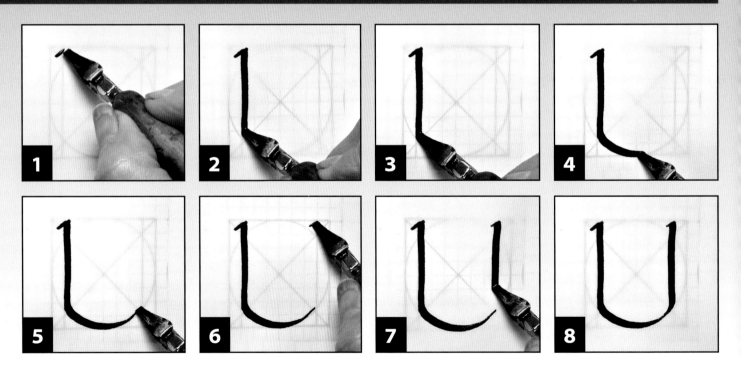

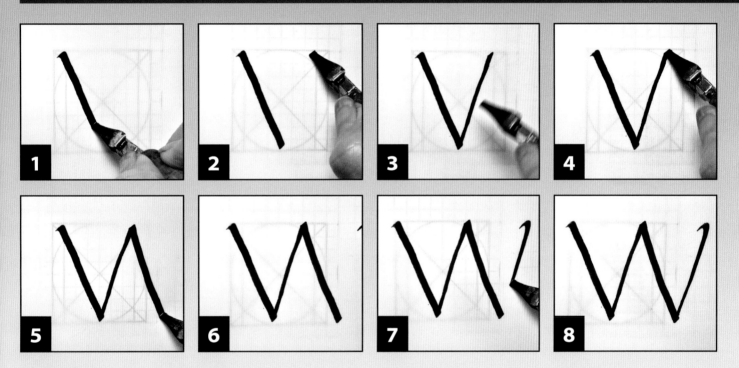

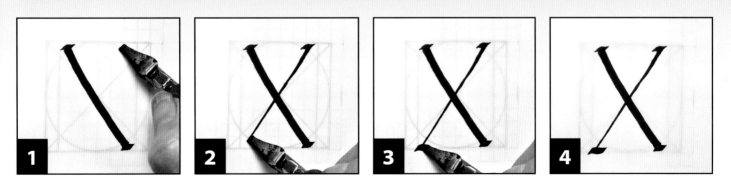

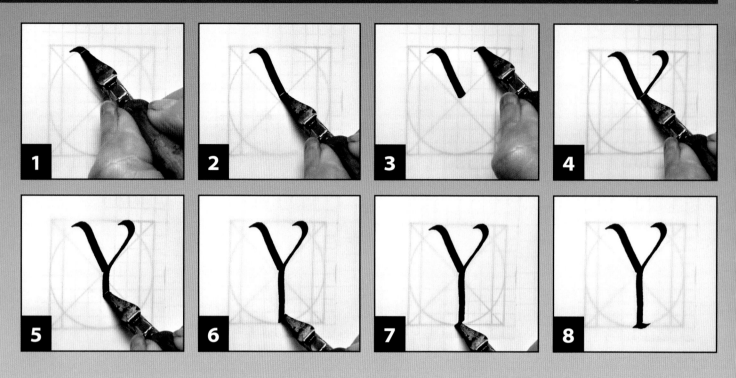

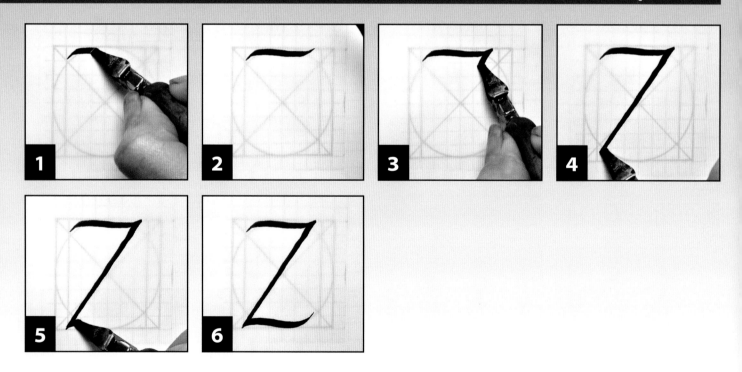

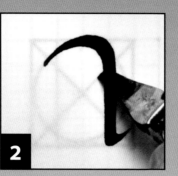
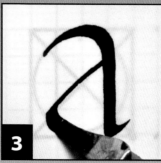
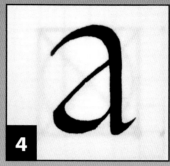

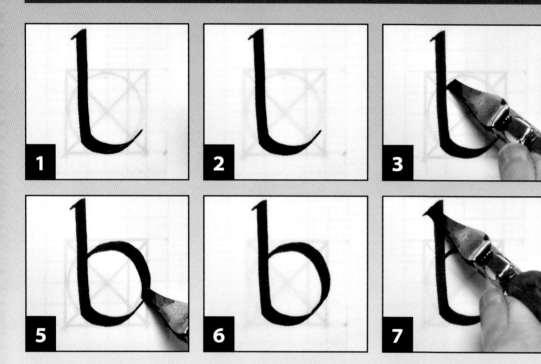
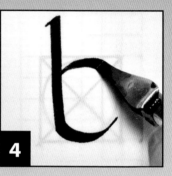

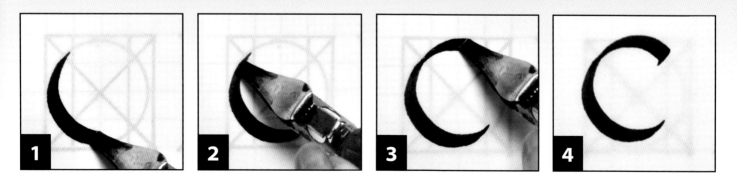

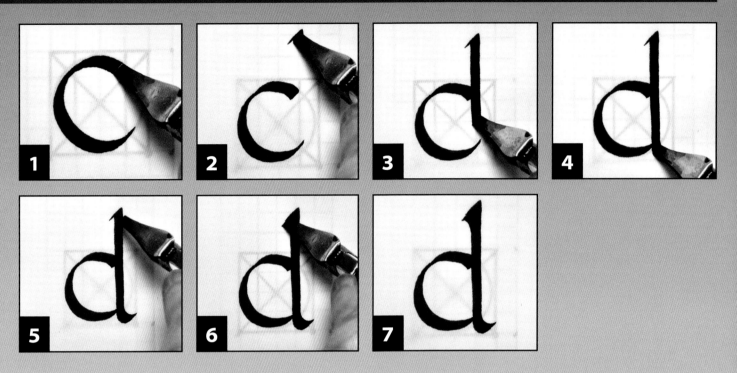

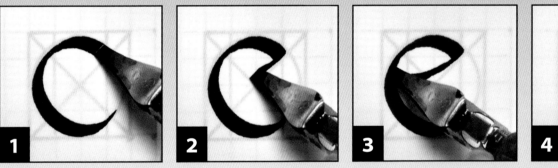

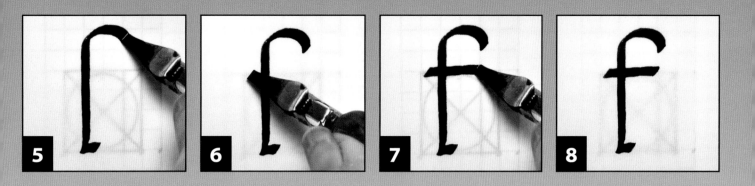

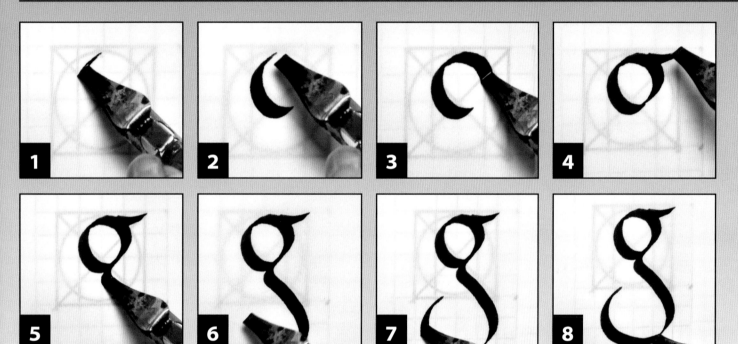

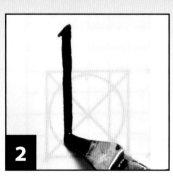
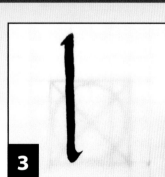
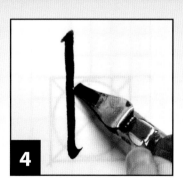

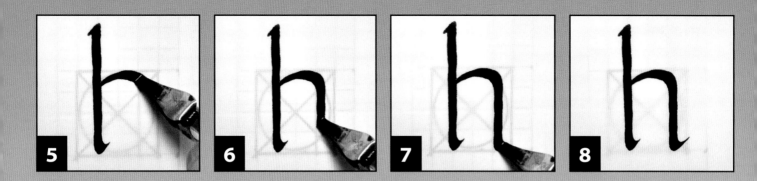

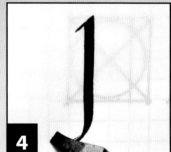

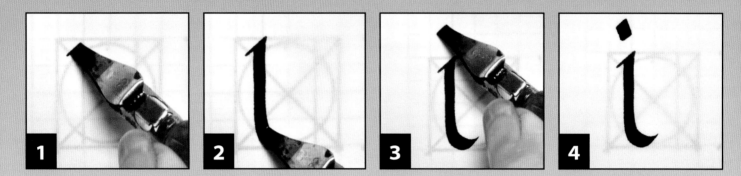

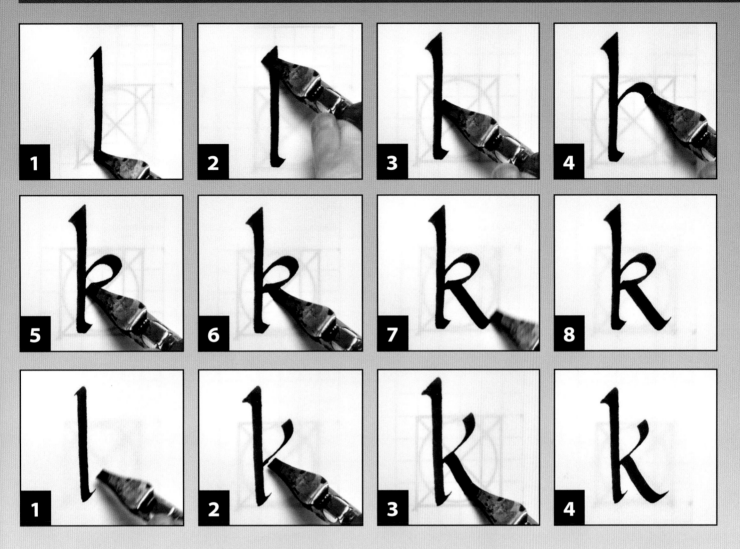

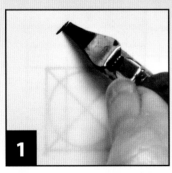
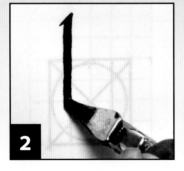

Foundational *lowercase M*

Foundational *lowercase N*

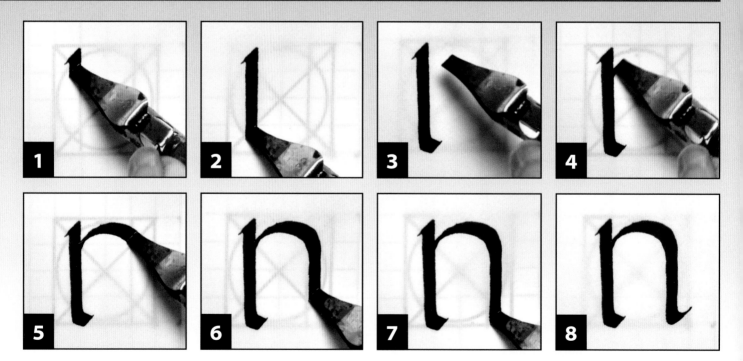

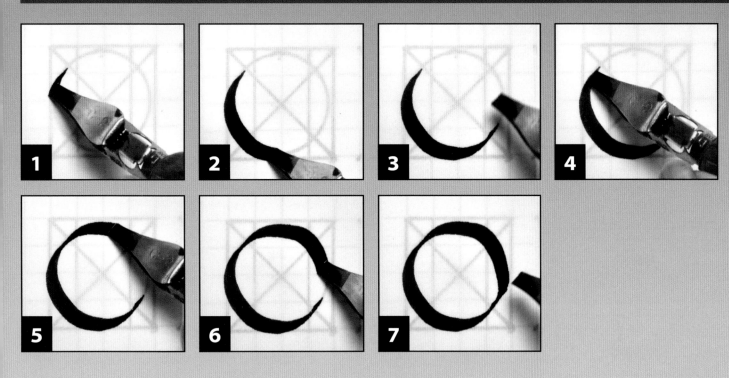

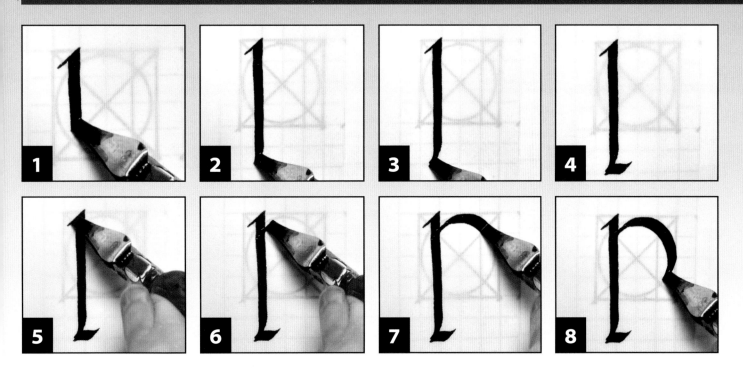

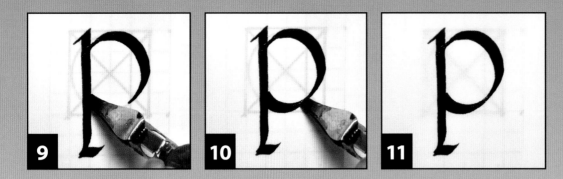

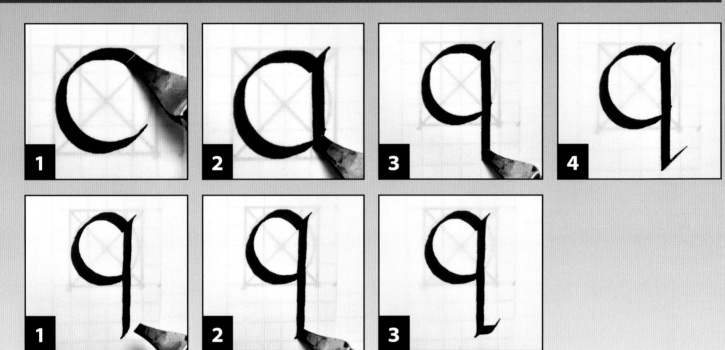

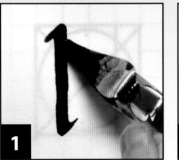
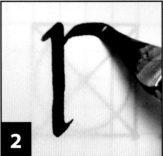
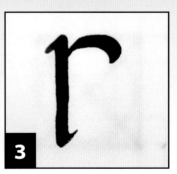

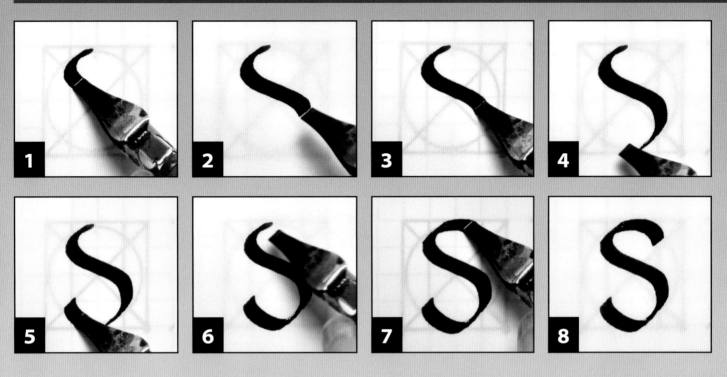

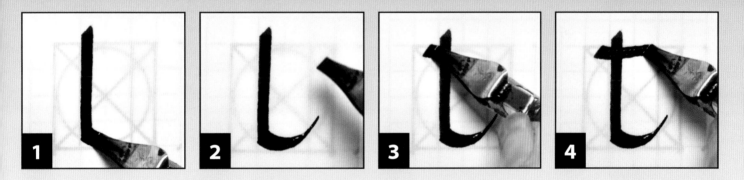

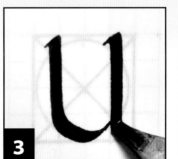
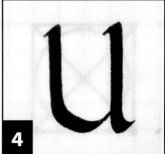

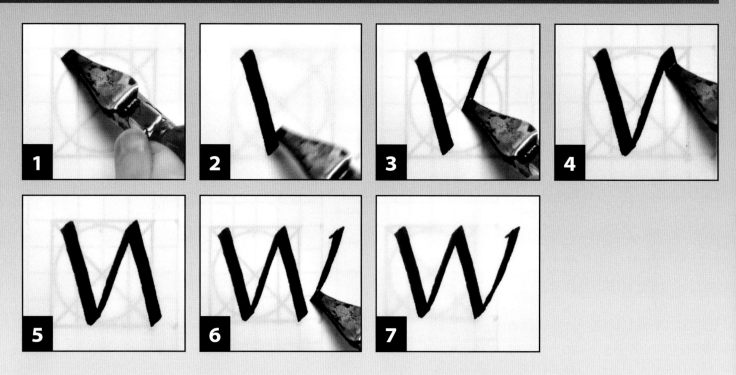

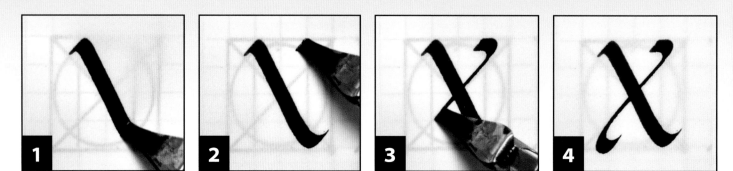

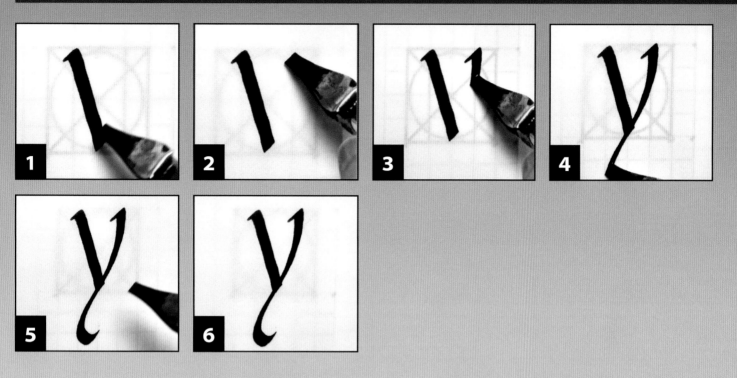

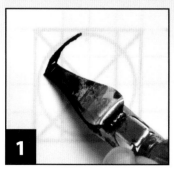 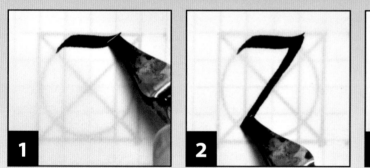

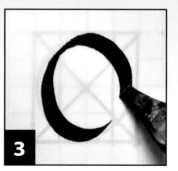

 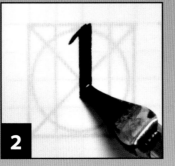 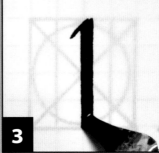

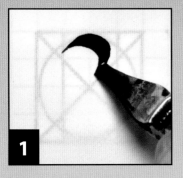 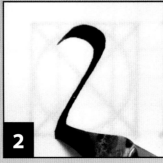 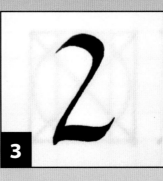

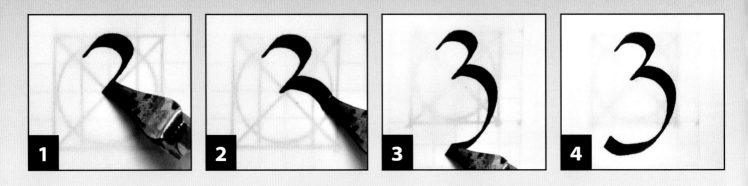

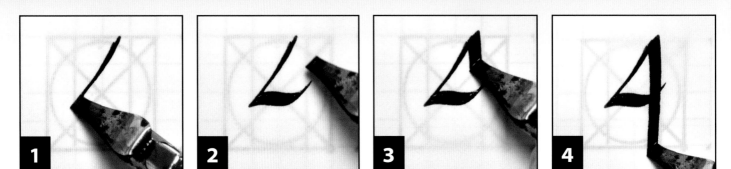

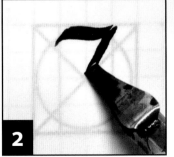

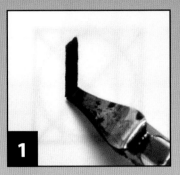

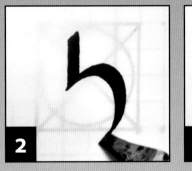

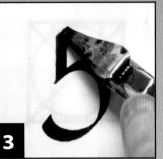

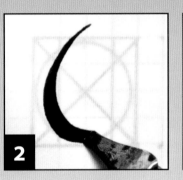

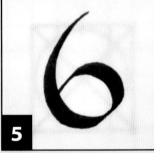

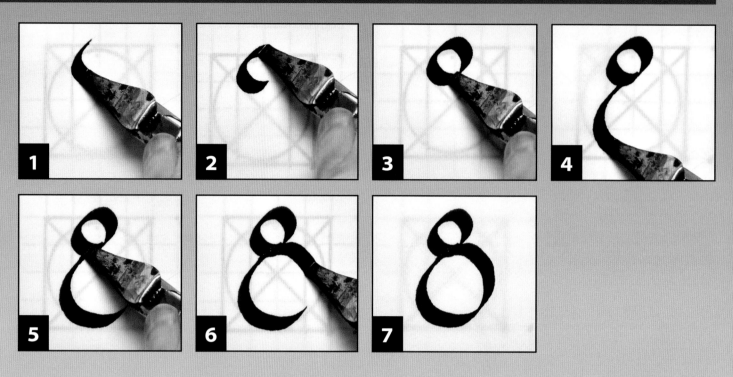

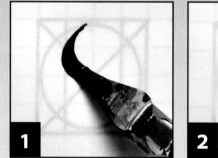

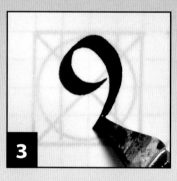 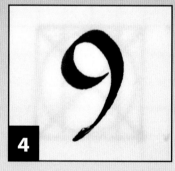

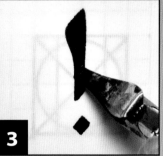
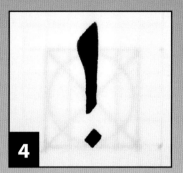

Foundational *parentheses*

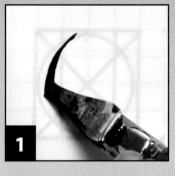
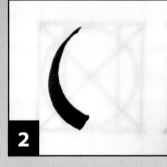
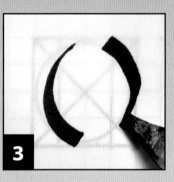
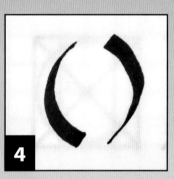

Foundational *question mark*

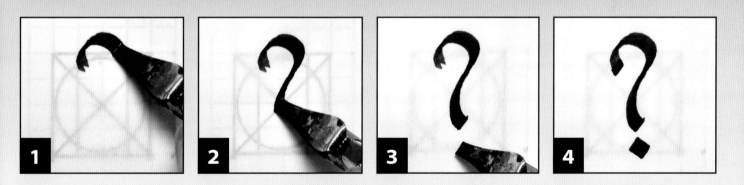

Foundational *quotation marks • semicolon*

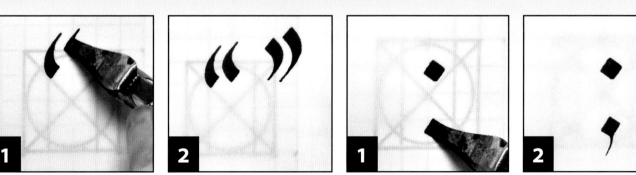

Italic

This script was developed by Humanist scholars in Renaissance Italy, hence the name. They needed a lettering style that could be written quickly and legibly. The Italic hand is a flowing and rhythmical script written at a 45-degree pen angle and a 5- to 10-degree angle or slant.

LOWERCASE

Lowercase letters, or minuscules, are three-quarters the height of the capital letters.

O C E

Ovals are created in two strokes. Do not push the broad-edge pen up, making an oval, or you may spray ink everywhere.

Start at about eleven o'clock, pulling down and out to the baseline and around to about 5 or 4 o'clock. Come back up to the original stroke, pulling from this stroke, moving around clockwise to about 1 o'clock and aiming to meet up with your last stroke.

C is half of your **o** stroke.

Start out at 11 o'clock, pulling down and out to the baseline, moving forward to 4 o'clock, and stopping. Come from the start of the first stroke over and stop at 1 o'clock.

E is the **c**.

Start out at 11 o'clock, pulling down and out to the baseline, moving forward to 4 o'clock, and stopping. Come from the start of the first stroke over and stop at 1 o'clock, pulling back to the upper center in the bowl of the **e**.

I L T J

Keep your pen nib at a 45-degree angle. Make an entry stroke to the waistline and pull down to the baseline and kick up.

L is an elongated **I** stroke. In the ascending space, make an entry stroke. To start, pull down to the baseline and kick up to finish the stroke.

T starts just above the waistline. Pull straight down to baseline and kick up. Cross the **t**.

J starts out the same as the **I**. Make an entry stroke to the waistline and pull down through the baseline and into the descender space, pulling to the left and stop. Pick up your pen and pull back to meet your tail of **j**.

A family

Start your stroke just below the waistline, pulling out and down to the baseline. Pull up toward the waistline. Put a ball cap on the top of the **a** starting from the beginning stroke over, and then pull down to the baseline and kick off to end the stroke. Remember that the shape between the bowl of the **a** and the stem should be a triangle.

D starts out with the same stroke as the **a**.

Start your stroke just below the waistline, pulling out and down to the baseline and up toward the waistline. Put a ball cap on the top of the **a** starting from the beginning stroke over. Place your pen in the ascending space and pull down, meeting the bowl, moving to the baseline, and kicking off to end the stroke.

Start your stroke for **g** just below the waistline, pulling out and down to the baseline and up toward the waistline. Put a ball cap on the top of the **a** starting from the beginning stroke. Place your pen on the back of the bowl and move down past the baseline and pull slightly left. Pick up your pen and pull a stroke to meet the downstroke.

For **q**, start your stroke just below the waistline, pulling out and down to the baseline, and pull up toward the waistline. Put a ball cap on the top of the **a,** starting from the beginning stroke. Place your pen at the back of the bowl and pull down as in the **g**, but keeping it straight and kicking up at the bottom of the descender line.

U and Y

U and **y** have the same triangle space between the bowl and stems.

Make an entry stroke to the waistline and pull down to the baseline, and then pull up toward the waistline. Place your pen nib on the waistline, pull down to the baseline, and kick up to end the stroke.

Y is the same stroke with the stem going into the descender space.

Make an entry stroke to start toward the waistline, pulling down to the baseline and up toward the waistline. Put the pen nib on the waistline and pull down to the descending space and pull to the left. Pick up your nib and make a stroke to meet the last stroke as in the **g**.

B family

Start in the ascending space with an entry stroke and pull down to the baseline. Pull up in a branching manner toward the waist, curving around and down toward the baseline. From the stem of the **b**, pull the stroke across the bottom and up to meet the last stroke.

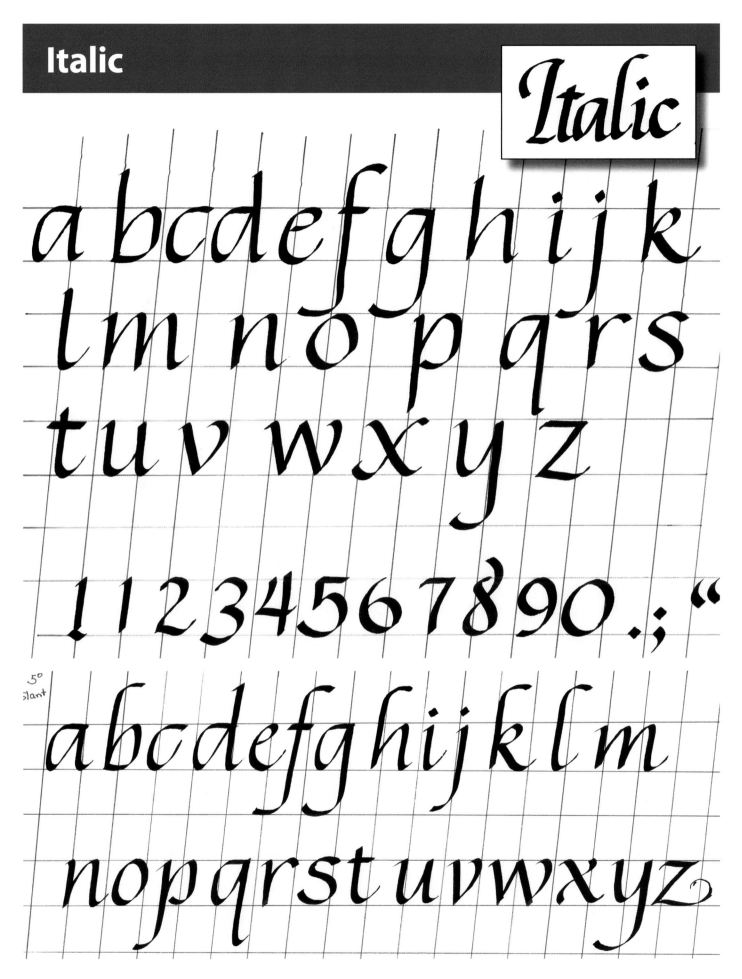

5°
slant

Italic

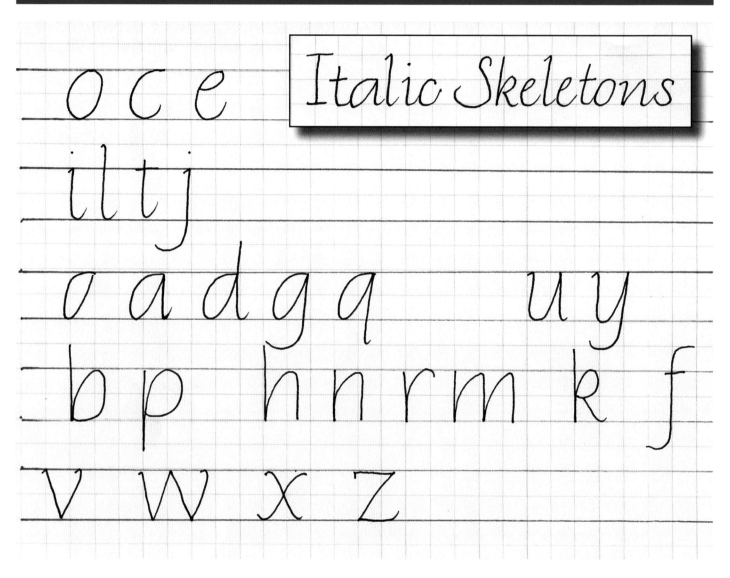

P

Start at the waistline with an entry stroke and pulling down to the ascender space. Come back to the baseline and branch to the waistline and down to the baseline. From the stem of the **p**, pull the stroke across the baseline to the bottom of the last stroke.

H

H begins in the ascending space with an entry stroke pulling down to the baseline. Branch from the stem to the waistline around and down to the baseline and kick up to end the stroke.

N

N begins at the waistline with an entry stroke pulling down to the baseline, branching up to the waistline and

pulling down to the baseline and kicking up to end the stroke.

R

R starts at the waistline with an entry stroke, pulling down to the baseline, branching to the waistline and around, and stopping to complete the **r**.

M

M begins at the waistline with an entry stroke, pulling down to the baseline, branching up to the waistline, and pulling down to the baseline, branching back up to the waistline, around, and down to the baseline, and kicking up to end the stroke.

Italic

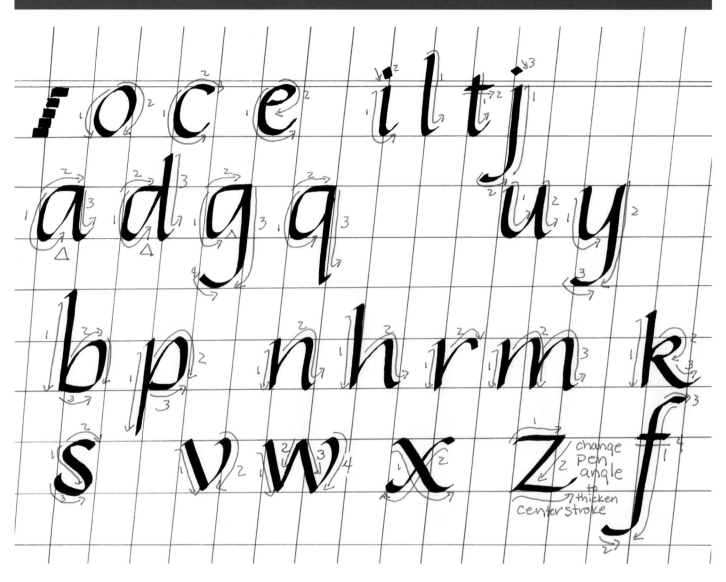

K

K starts in the ascending space, pulling down to the baseline. Lift your nib and place it on the stem just below the waistline. Branch up to the waistline and back to where you began the stroke. Kick out for a leg stroke for the **k**.

S

S starts with a curve center stroke. Lift the pen to begin the stroke and put a ball cap on top of the **s**. Come down to the baseline and pull the stroke to meet with the bottom of the **s**.

V

V is a diagonal stroke with an entry stroke pulling on the diagonal to the baseline. Pick up the pen and place it at the waistline, pulling around and down to the baseline.

W

W starts with a diagonal stroke to the baseline. Place the pen nib to the right at the waistline, pulling down to meet the first stroke. At the waistline from the last stroke, pull in a diagonal to the baseline. In addition, as with the **v**, pull the stroke around and down to meet the last stroke.

X

On a steep diagonal, start with an entry stroke at the waistline. Pull on the diagonal to the baseline and kick up for the ending stroke. On the right side of the diagonal stroke, pull through at the center of the first stroke to the baseline and kick up to finish the stroke.

Z

Start with an entry stroke to the waistline and pull across. Change the pen angle to 30 degrees, making the pen angle

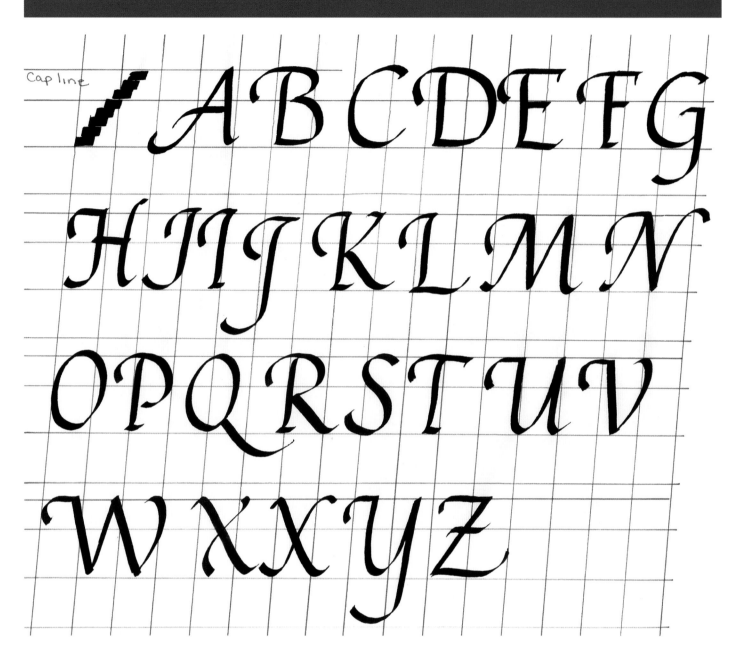

Cap line

a little flatter to beef up this center stroke. Pull toward the baseline and keep the end of this line parallel with the top stroke. Pull from this stroke to parallel to the end of the top stroke or just beyond, lifting up the tail.

F
The letter **f** takes up all the real estate of the ascender space, x-height, and descender space. It's a very needy letter.

Start in the ascending space, pull to the left and down on a slight diagonal through the x-height into the descender space with a slight pull to the left. Place the nib to the left of the bottom stem and pull to meet the bottom

stem of the **f**. In the ascender space, meet at the beginning stroke of the **f** stem and pull right, giving it a ball cap. Follow through with the center stroke of the **f** to complete the **f**.

CAPITALS

Capitals are all full height.

B D E F P R
These letters have similar construction, starting with the downstroke or stem. Pull the stem stroke to the baseline and to the left.

Italic

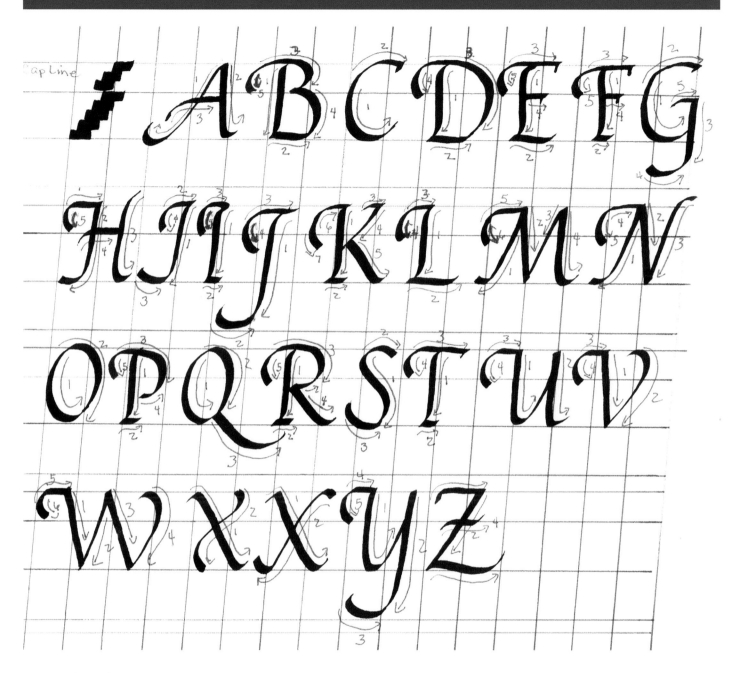

For the **B**, from the stem stroke, pull to the right to give yourself a place to aim when making the bowl of the **B**. In the ascending space, pull the bowl stroke of the **B**, bringing it to the stem in the upper part of the waistline, not below, keeping the bowl smaller than the bottom bowl. Pull out and create another bowl, meeting the bottom stroke.

From the stem stroke, pull to the right to give yourself a place to aim when making the bowl of the **D**. In the ascending space, pull straight across and then down giving the **D** a curve and meeting the bottom stroke. Keep the bowl lifted at the baseline—this will give it a happier look.

From the stem stroke, pull to the right for the foot of the **E**. In the ascending space, pull the stroke across to parallel the bottom stroke. The center crossbar is slightly shorter.

From the stem stroke, for the **F**, pull to the right and give the stem a small foot to sit on. In the ascending space, put the top on and a center stroke matching that of the **E**.

From the stem stroke, for the **P**, pull to the right to give the stem a small foot to sit on. In the ascending area pull the bowl stroke for the **P**, keeping the top of the **P** straight, and pull the bowl end. At the stem follow out to meet the bowl.

Italic

From the stem stroke, for the **R**, pull to the right to give the stem a small foot to sit on. In the ascending area, pull the bowl stroke for the **R**, keeping the top of the **R** straight, and pull the bowl end. At the stem, follow out to meet the bowl. Pull the leg of the **R** out to the baseline.

T I L

These are made up of elements of the first group. Pull down the stem stroke to the baseline and to the left.

From the stem stroke, for the **T**, pull to the right and give the stem a small foot to sit on. In the ascending space, pull the top stroke of the **T**.

From the stem stroke, for the **I**, pull to the right and give the stem a small foot to sit on. In the ascending space, pull the stroke for the **I** from the stem out to the left.

From the stem stroke, pull to the right to make the bottom of the **L**. Pull the flourish stroke from the stem out to the left.

H J K U Y N

These letters have a similar construction, starting with the horizontal top flourish, which goes directly into the downstroke.

Pull the flourish stroke to the stem of the **H**, pulling to the baseline and to the left. In the ascending space, pull down to the baseline and kick off the end the stroke. Put the crossbar in.

Pull the flourish stroke to the stem of the **J,** pulling to the baseline and to the left. In the ascending space, pull down to the baseline, pulling through to the descending area, pulling to the left. Put the nib down to the left, pulling back to meet the stroke, completing the **J**.

Pull the flourish stroke to the stem of the **K**, pulling to the baseline and putting a foot on the stem much like that of the **F** and **P**. In the ascending space, pull a diagonal stroke to the stem and pull out to make the leg to complete the **K**.

Pull the flourish stroke to the stem of the **U**, pulling to the baseline and lifting to the right toward the waistline. In the ascending space, make an entry stroke and pull down to the baseline and kick off to end the stroke.

Pull the flourish stroke to the stem of the **Y**, pulling to the baseline and lifting to the right toward the waistline. In the ascending space, make an entry stroke and pull down to the baseline and into the descending space and pull to the left. From the left side, pull the stroke to the stem to complete the **Y**.

Pull the flourish stroke to the stem of the **N**, pulling to the baseline and placing a foot at the baseline for the stem to sit on. In the ascending area, pull a diagonal stroke to the baseline. Above the capital space, pull the downstroke of the last leg of the **N** to meet the diagonal.

Letters without verticals: A M V W

The axes of these letters need to be slanted to make them fit in with the minuscule.

Start the **A** in the ascending space, pulling to the left to the baseline. Pull a stroke to meet the stroke. Put your nib back down on the first stroke, pulling down to the baseline and kicking off the end the stroke. Place the crossbar on the center of the **A** to complete the **A**.

Start the **M** in the ascending space, pulling to the left to the baseline and pulling to the left slightly for the ending stroke. Put your nib on the last stroke at the ascending space, pulling down to the baseline and pulling very slightly to the right to the baseline. Move over to the right and pull on the diagonal to meet the bottom of the last stroke. Put the nib on the last stroke in the ascending space and pull down slightly to the right to the baseline and kick up to end the stroke. Keeping in mind the space between these strokes should all be the same, the center **V** portion should match the two mountains.

Start the **V** at the ascending space, pulling on the diagonal to the baseline. Move over to give the center space and pull down to the baseline, meeting up with the last stroke. If you want a flourish, add this now to the left side of the **V**.

W starts out just like the **V.** Start at the ascending space, pulling on the diagonal to the baseline. Move over to give the center space and pull down to the baseline, meeting up with the last stroke. Pull down to the baseline in a diagonal stroke. Move over, giving the same amount of space with the first strokes, pulling to the baseline. Be mindful of the spacing between the strokes, just as in the **M**. If you want a flourish, add it now to the left side.

X S Z

X starts with the diagonal stroke in the ascending space to the baseline. In the ascending space, pull a diagonal stroke through the center of the stroke. This can be done in two separate strokes on either side of the first diagonal.

S is built on the **O**. Make the curve stroke, starting in the ascending space and pulling down to the baseline. Put a ball cap on at the ascending space and on the bottom in the x-height.

In the ascending space, make an entry stroke to the cap line and pull across for the **Z**. Change your pen angle to a flatter angle of 30 degrees. Pull the diagonal stroke to

playful pen

the baseline. Pull the baseline stroke across, keeping it parallel with the top stroke.

O C G Q

Ovals can be an oval or a little rounded. Be consistent, use either oval or rounded.

Just like the lowercase **O**, make this stroke into half-moons. Start at 11 o'clock, pull around and down to the baseline to 5 or 4 o'clock. You have something to aim for. From the ascending space, go back in to the original stroke of your **O**, pulling around from 11 o'clock to 4 or 5 o'clock.

Start your half-moon at 11 o'clock for the **C**, coming down to the baseline and moving to 4 or 5 o'clock. In the ascending space, go back into the original stroke, bringing it out to put a ball cap on top.

Start your half-moon at 11 o'clock for the **G**, coming down to the baseline and moving to 4 or 5 o'clock. In the ascending space, go back into the original stroke, bringing it out to put a ball cap on top. Pull a downstroke from the center of the **G** down to the descending space. Put a crossbar on top of this stroke. Pull a stroke to meet the bottom stroke much like a small **J** to complete the **G**.

Just like the lowercase **O**, make the **Q** stroke into half-moons. Start at 11 o'clock, pull round and down to the baseline to 5 or 4 o'clock. You have something to aim for. From the ascending space, go back into the original stroke of your **O**, pulling around from 11 o'clock to 4 or 5 o'clock. Put a tail on the **Q**, pulling to the right and down.

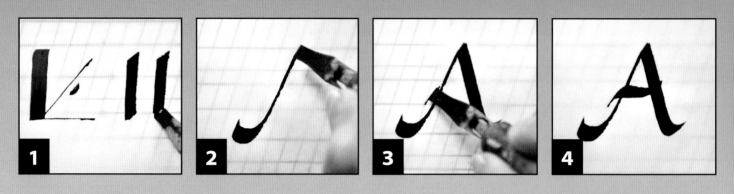

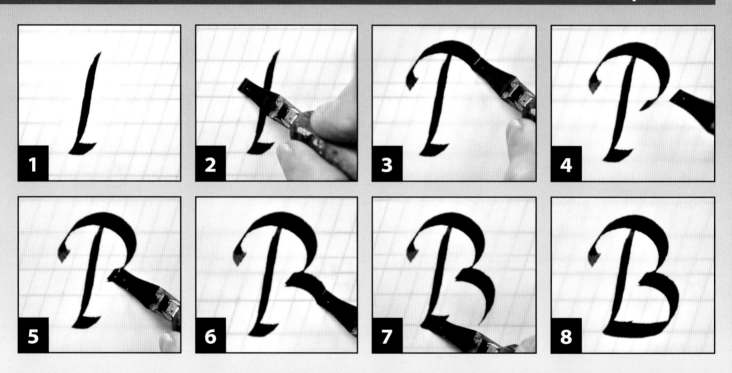

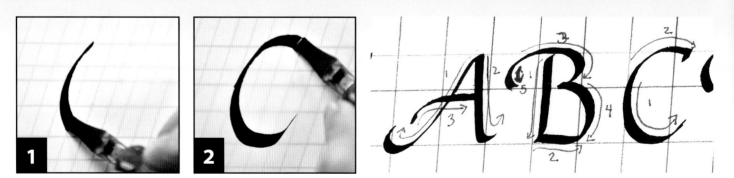

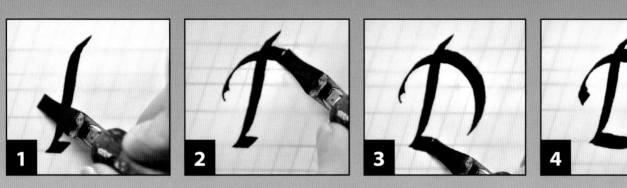

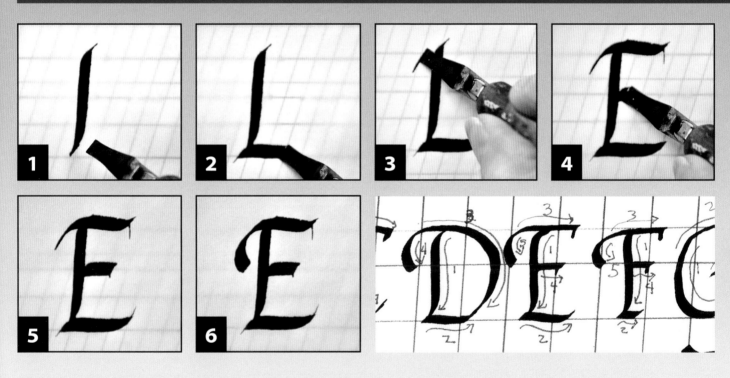

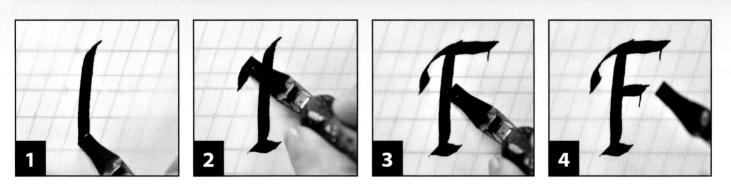

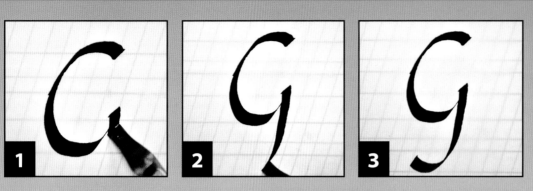

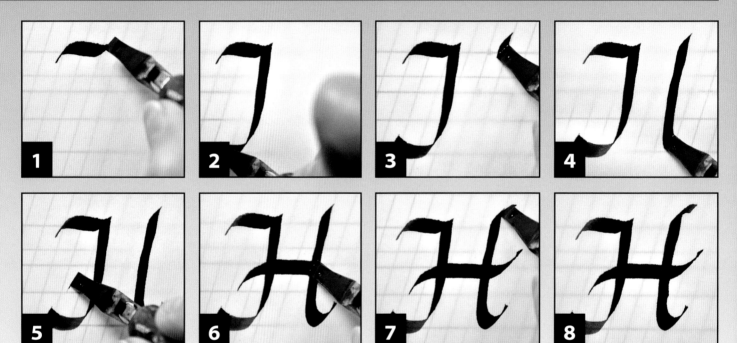

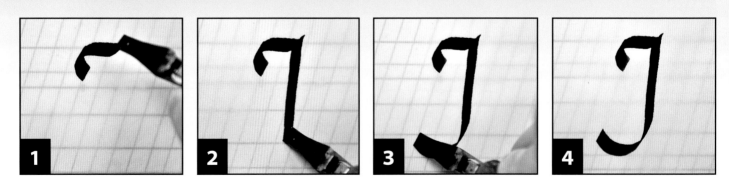

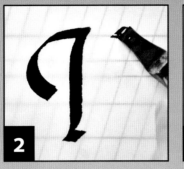

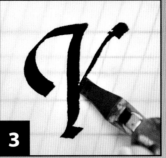

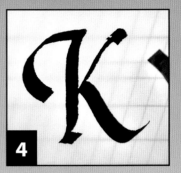

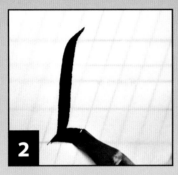

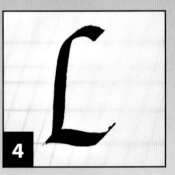

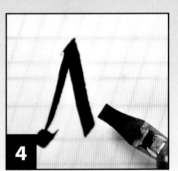

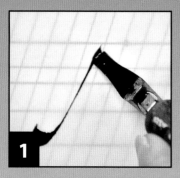

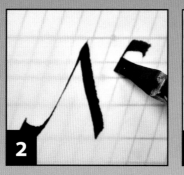

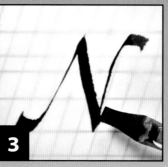

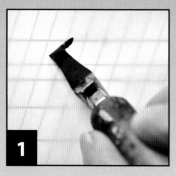

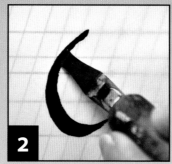

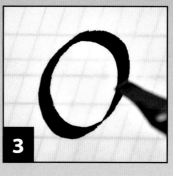

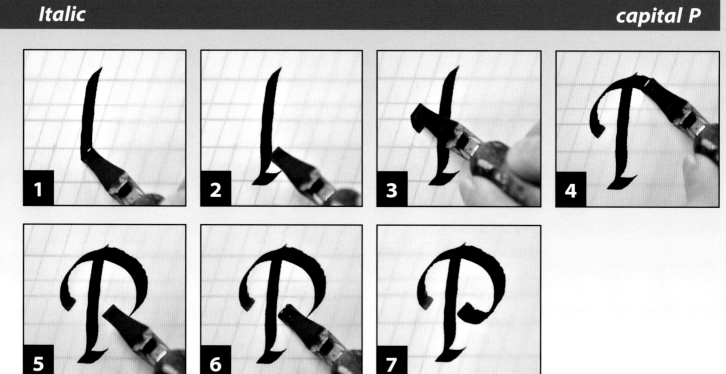

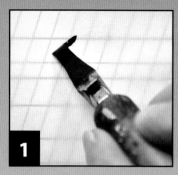

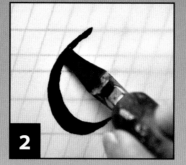

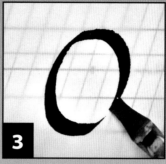

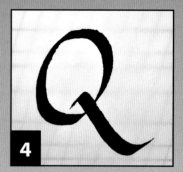

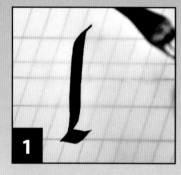

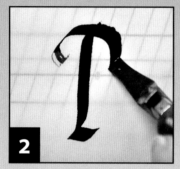

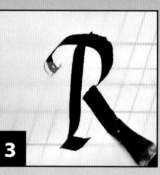

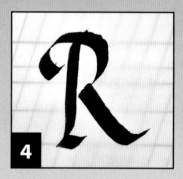

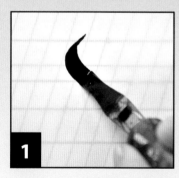

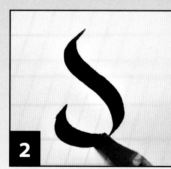

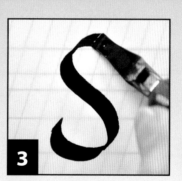

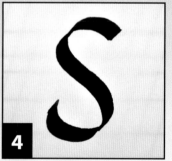

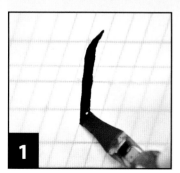

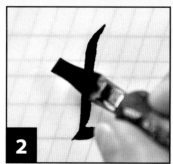

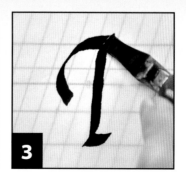

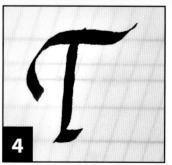

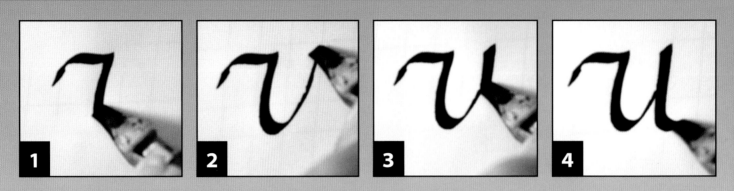

1

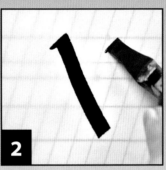
2

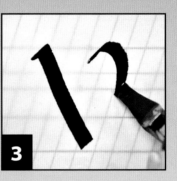
3

4

Italic *capital V*

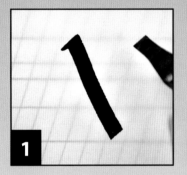
1

2

3

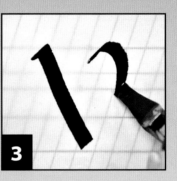
4

Italic *capital W*

1

2

3

4

Italic *capital X*

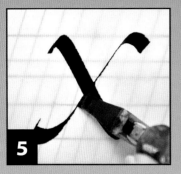

5

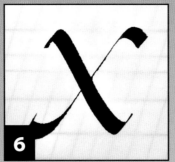

6

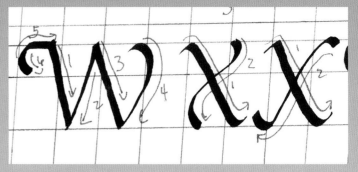

1

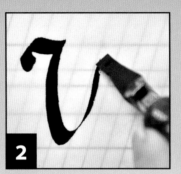

2

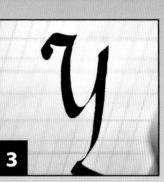

3

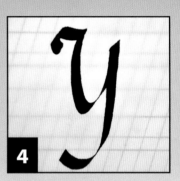

4

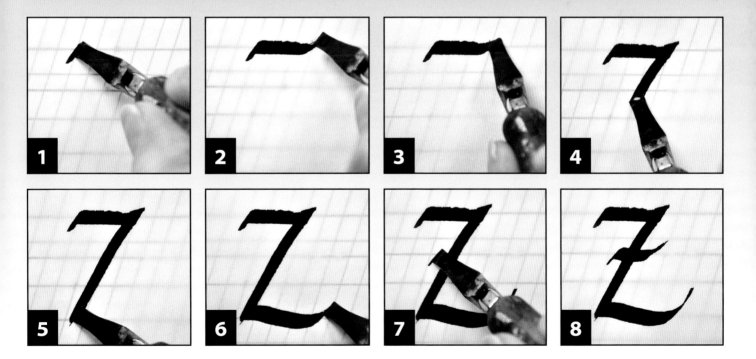

1

2

3

4

5

6

7

8

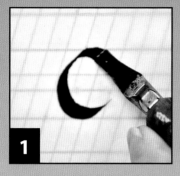
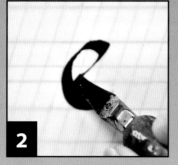
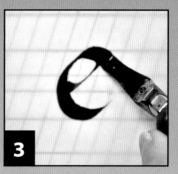
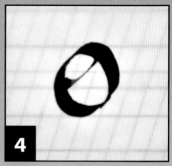

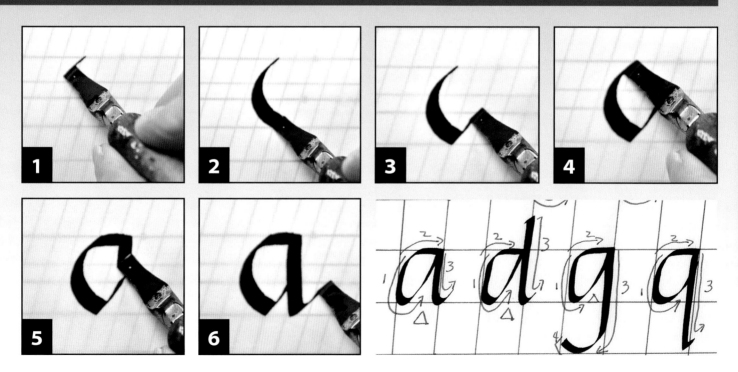

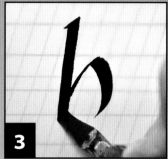
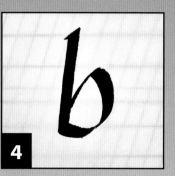

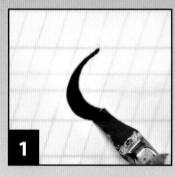
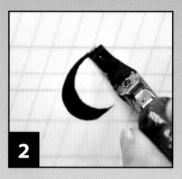
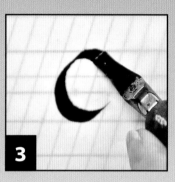

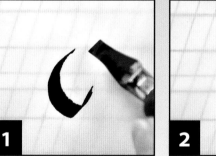
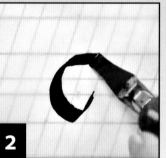
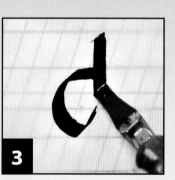
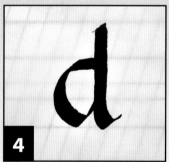

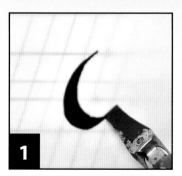
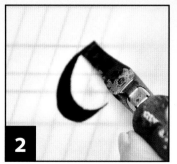
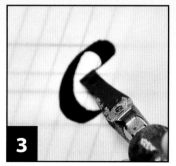
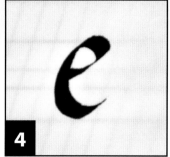

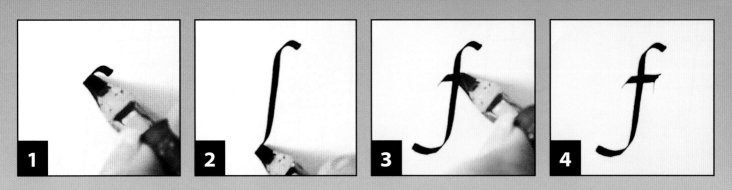

 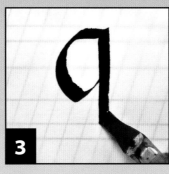 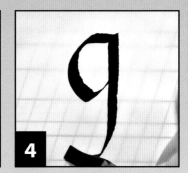

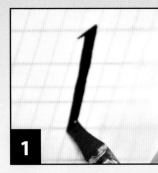 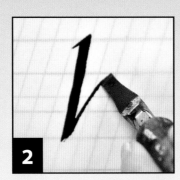 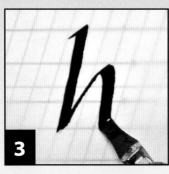

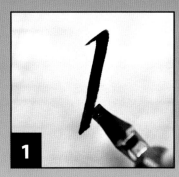

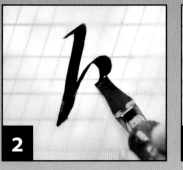

1

2

3

4

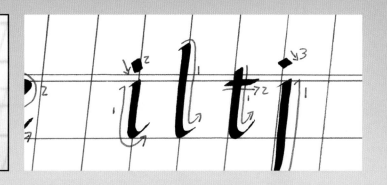

1

2

1

2

3

4

1

2

3

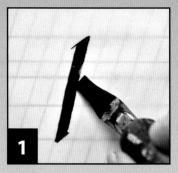

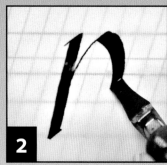

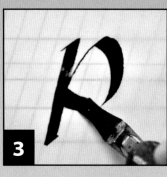

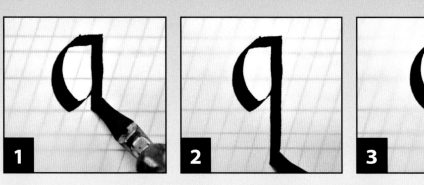

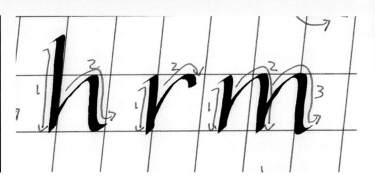

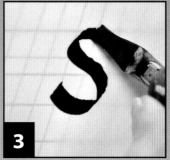

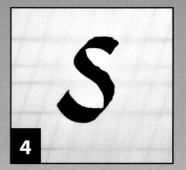

Italic *lowercase T*

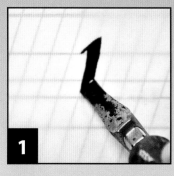

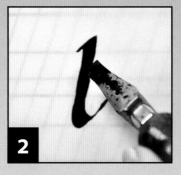

Italic *lowercase U*

Italic *lowercase V*

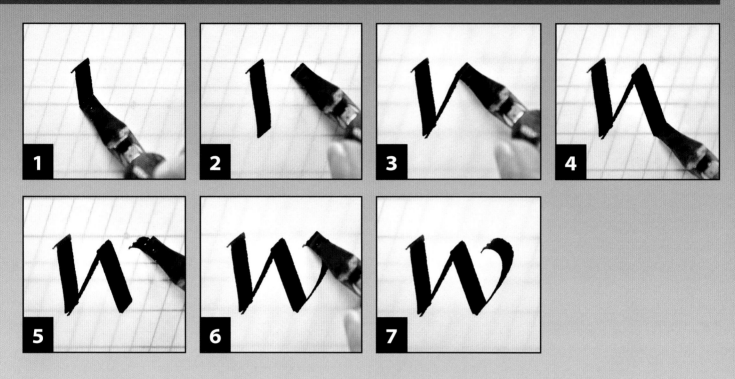

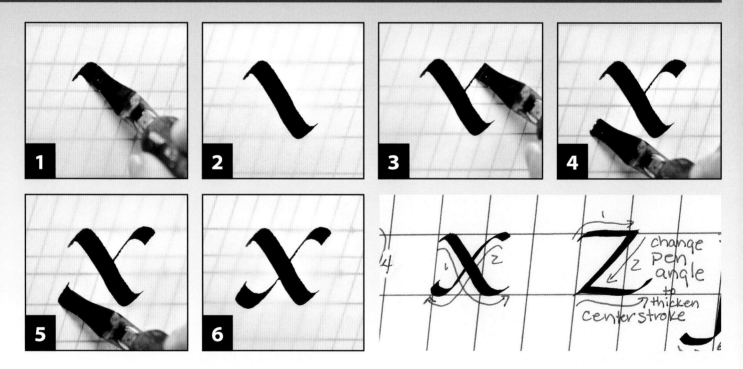

Casual Pointed Pen

This is a modern adaptation based on the Italic hand. It's made using a pointed pen nib and straight pen holder and is written on a square grid, using the pointed nib.

SOME BASIC INSTRUCTION

Use slight pressure to start the ink flow. Lighten up pressure toward the middle and then use slight pressure moving toward the bottom of the stroke.

Use pressure on the downstrokes and bear lightly on the upstrokes so you do not pick up paper fibers on the way up.

Try to keep a consistent flow from top to bottom.

For the oval stroke, use four boxes of the grid to begin construction until you have mastered the process.

Start in the center of the second top box. Aim to the midpoint or beginning of the second row.

Add pressure, moving toward the bottom corner of the box.

This puts a puddle of ink at the bottom of the box, which will give you ink to help you in your upstroke, which is a light stroke.

Practice the bone stroke and the oval strokes. While doing these strokes, think of drawing a lemon.

l family

These begin with a bone stroke.

Short bone is the **i** and a longer bone is the **l** (going into the ascender space). The midsize bone (falling in the middle of the ascender space) is the **t**. This crossbar can be straight or elongated.

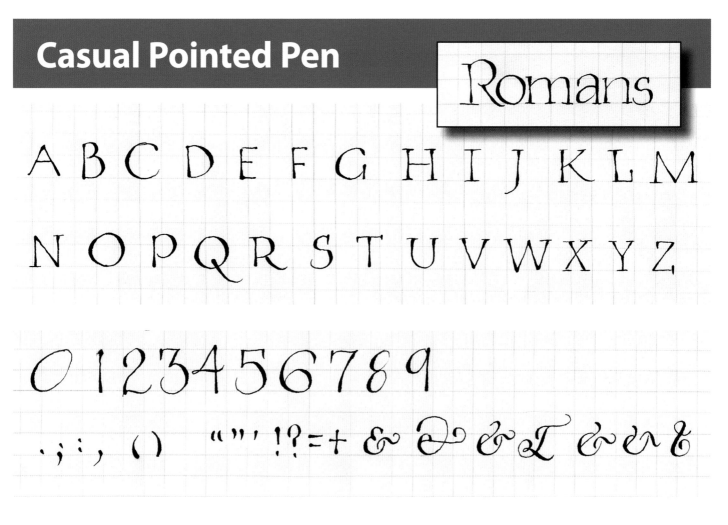

The **J** starts with the bone stroke and goes below the base line and slides to the left.

O C E

O, C, and **E** are lemons.

If you can create an **O** or lemon, you can make the **c**, which starts out just like the **O**, but you do not complete or close the circle. A tick mark can be used to start or create a finishing stroke to complete.

The **E** is the **C** with the same stroke for the cross bar of the **T** through the center of the **C**.

A family

These letters start with the **O** or lemon stroke and a small bone at the back.

The **D** begins with the lemon with an **L** or long bone stroke.

G is the lemon with a **J** stroke against the back of the lemon.

Q is the lemon stroke with a bone going into the descender space.

U and Y

These start out as a bone stroke. Glide up, add another bone stroke.

Y is the **u** stroke. Bone, glide up, and add the **J** stroke, ending in the descending space.

The B family

B starts with the **l** bone stroke, starting in the ascender space and ending at the baseline. The lemon is created at the bottom of the bone stroke at the baseline moving toward the waistline and coming back around to the baseline, meeting up to the bone stroke or back of the **B**.

P begins with the bone stroke, starting at the waistline and moving into the descender space. From the baseline, create another lemon. Up stroke is light pressure to the waistline, adding pressure, making the oval, and moving around toward the baseline and meeting back at the back of the **P**'s bone stroke.

H N R M K

If you can make these strokes, you can create an **H** bone stroke. Make the branching oval stroke to the waistline. Pause, add slight pressure to start downward stroke, light pressure in the waist of the downstroke, and pressure to end the downward stroke.

N is the same stroke, only starting at the waist with the bone stroke. Branch up to waistline, pause and pull straight down, adding slight pressure to stop.

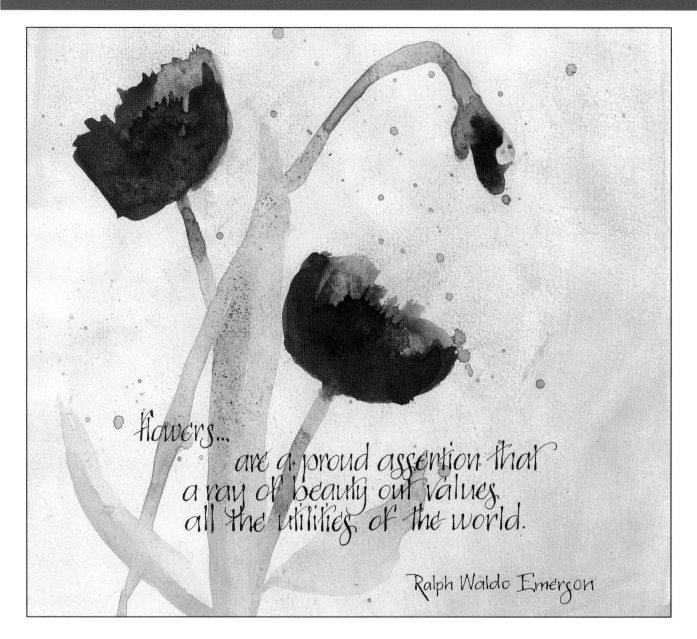

flowers...
are a proud assertion that
a ray of beauty out values
all the utilities of the world.

Ralph Waldo Emerson

R is the **n** strokes. Create a bone branch up, pause, and then start the downstroke and finish early.

M is the **n** stroke. Bone branch to waist, pause, bone stroke, branch, and pause and bone stroke.

K is the **b** stroke. Make the bone, add a baby lemon or bowl of the **b**, and kick out.

V and W

To make the **V**, add pressure to start the ink flowing, create a diagonal stroke, ending in the center with slight pressure. Move the pen to the waistline and bring the stroke to meet the bottom of the first stroke.

W is the **v** stroke twice. Alternatively, you can create this stroke with two **u** strokes, depending which you prefer.

S

The **s** is a lot of ink in one small space. Think of the oval or lemon when creating this stroke.

The **s** can be dropped into the ascender space to add character. Just take care in creating a readable character.

F

This is the bone stroke, with the branching stroke added. Think of this stroke as an elongated **r**.

Casual form bone

Casual form box

Casual form lemon

Casual capital A

 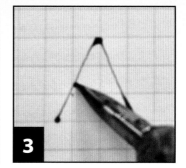 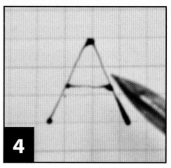

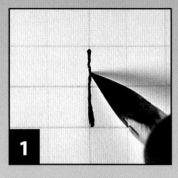
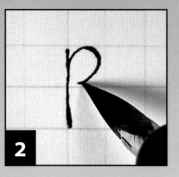
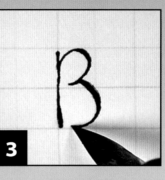

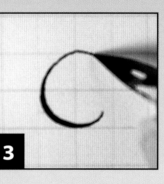
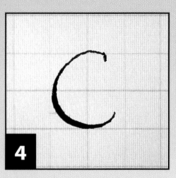

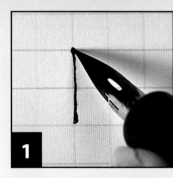
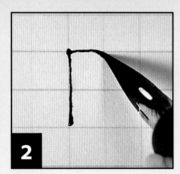
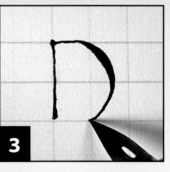

5

6

7

8

1

2

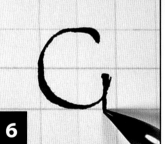

1

2

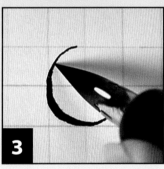

3

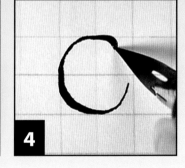

4

5

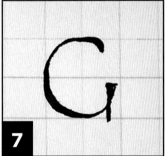

6

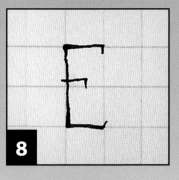

7

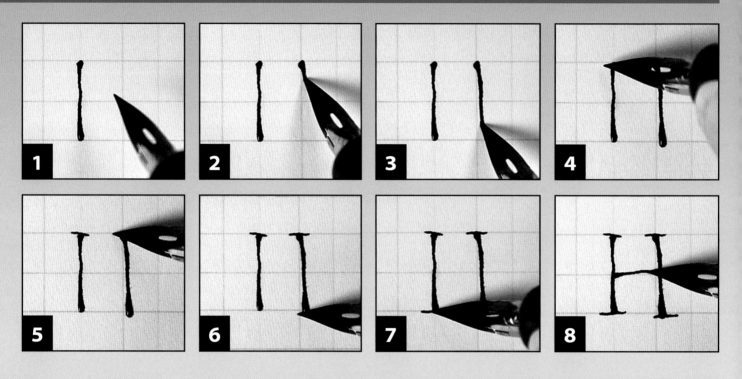

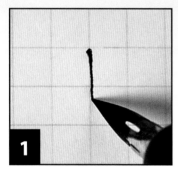
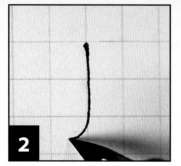

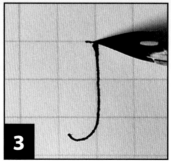

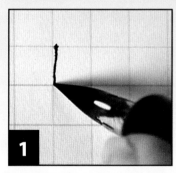

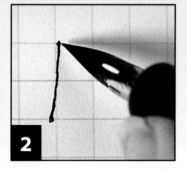

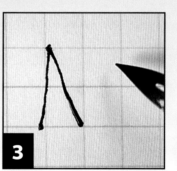

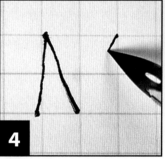

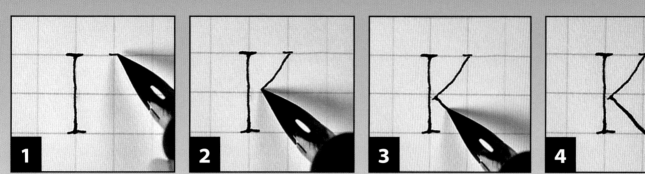

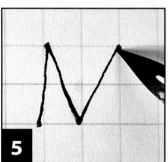

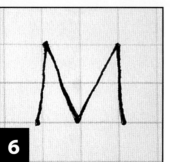

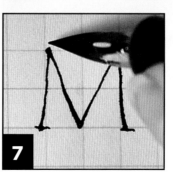

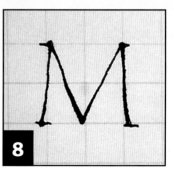

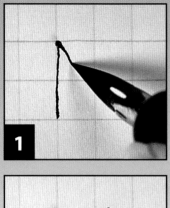
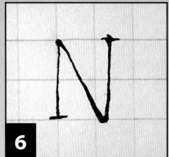
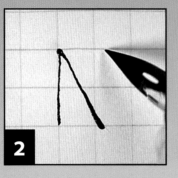
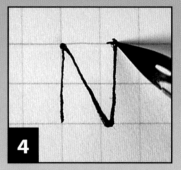

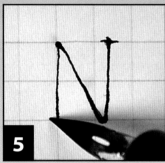

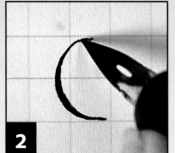
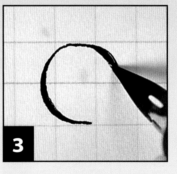
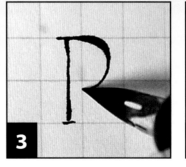

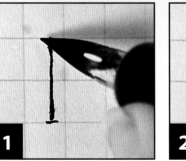
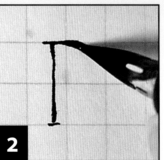
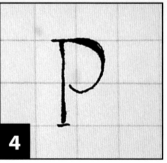

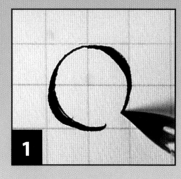 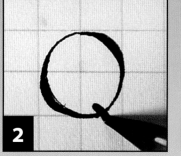 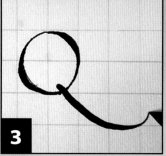

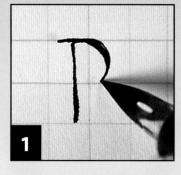 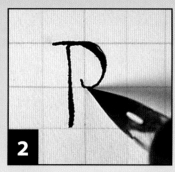 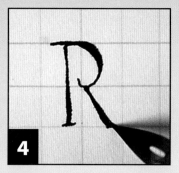

 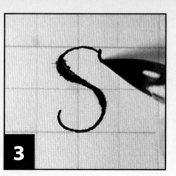

 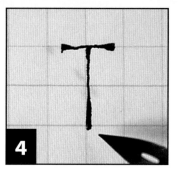

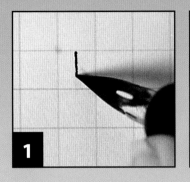
1

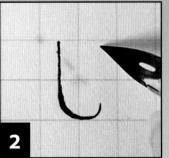
2

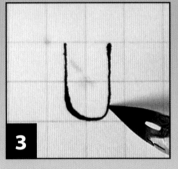
3

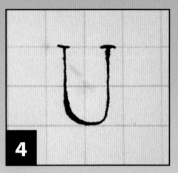
4

1

2

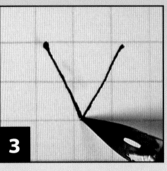
3

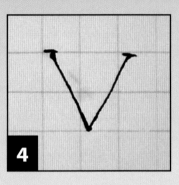
4

1

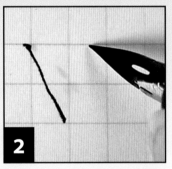
2

3

4

5

6

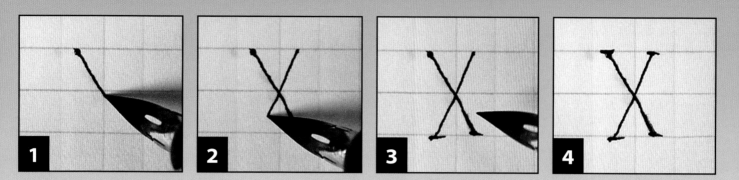

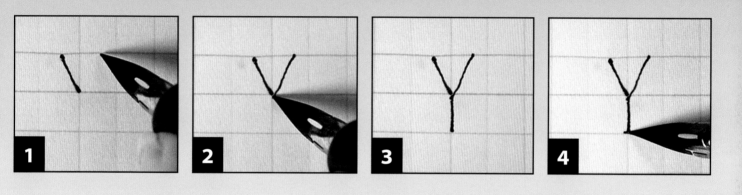

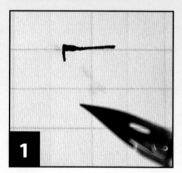
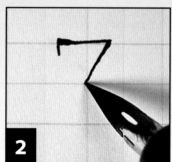
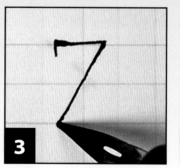
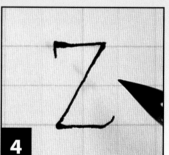

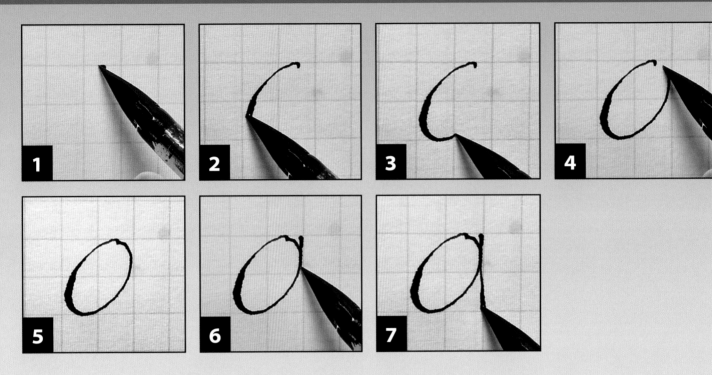

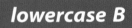

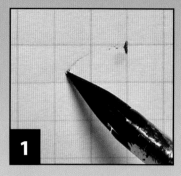

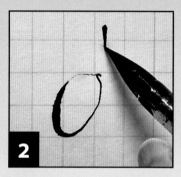
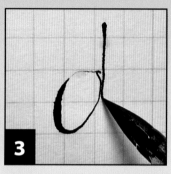

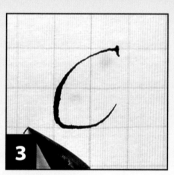

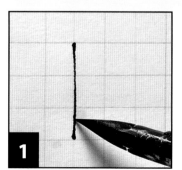
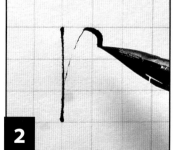
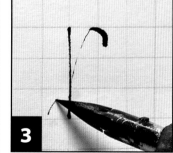
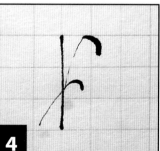

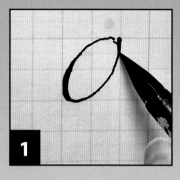
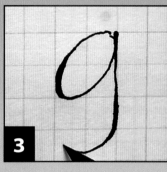
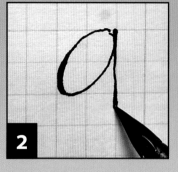
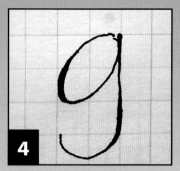

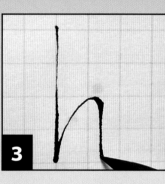

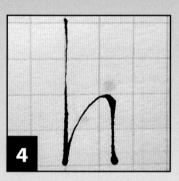

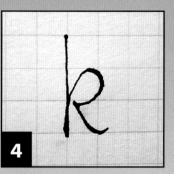

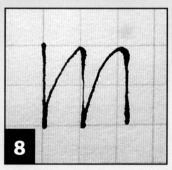

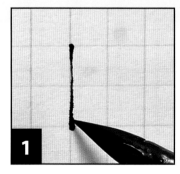

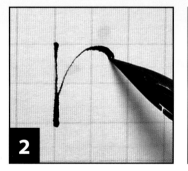

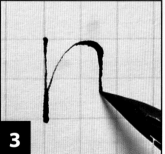

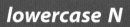

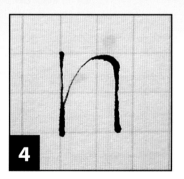

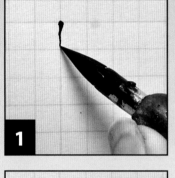
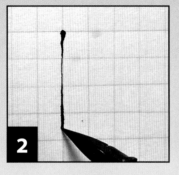
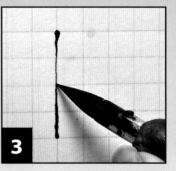
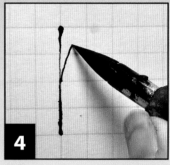

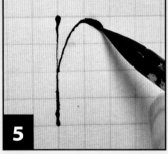
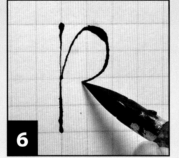
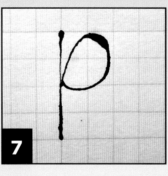

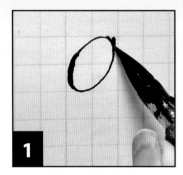
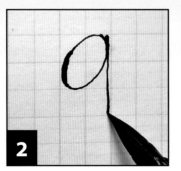

 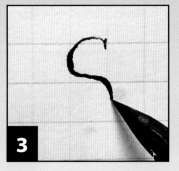 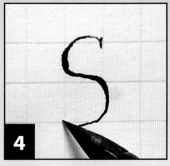

 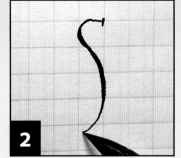 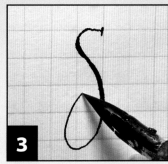

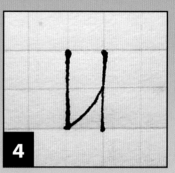

Casual *lowercase V*

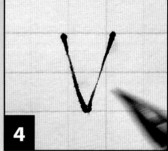

Casual *lowercase W*

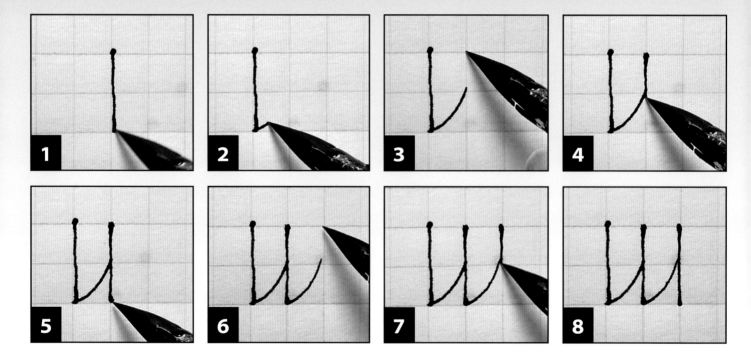

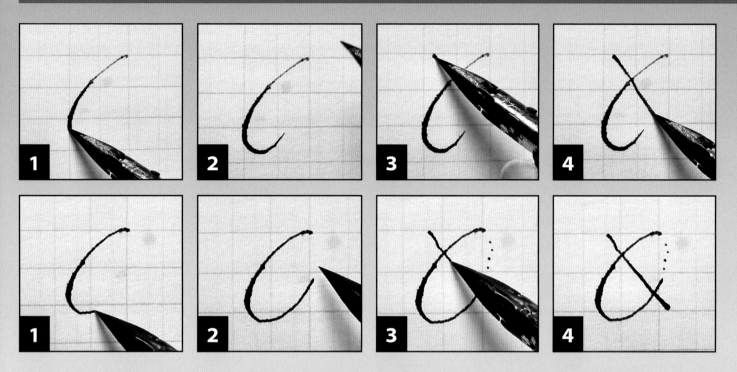

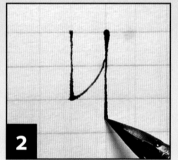
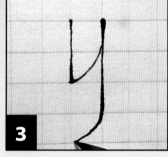
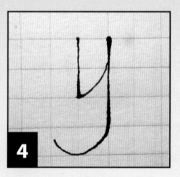

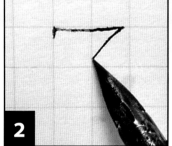
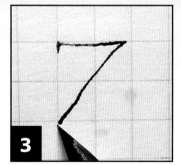
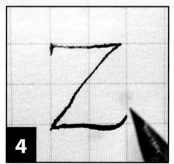

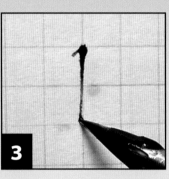
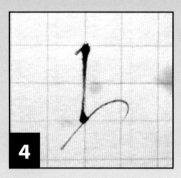

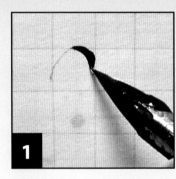
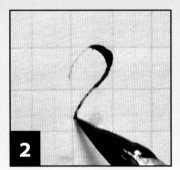
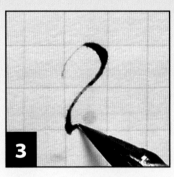
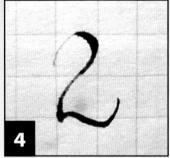

1

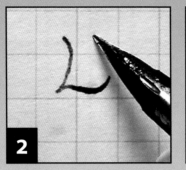
2

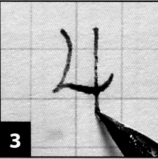
3

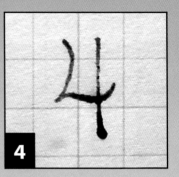
4

1

2

3

4

1

2

3

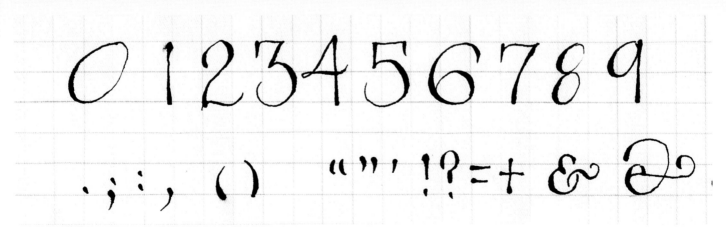
4

1

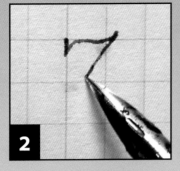

2

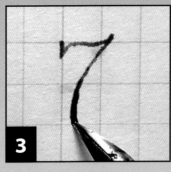

3

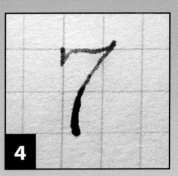

4

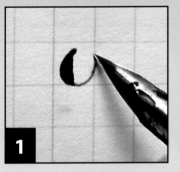

1

2

3

4

1

2

3

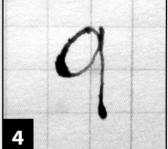

4

The Projects

Uncial Project: Knotwork

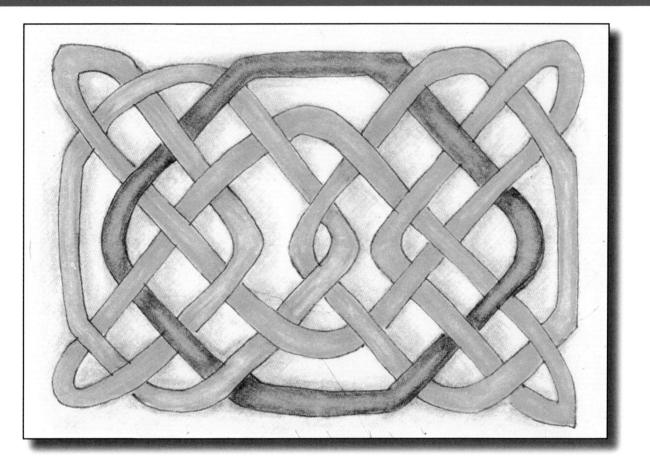

MATERIALS

- Grid paper to create the knotwork
- Canson Foundations 4 x 4 or 8 x 8 (8 x 8 boxes per inch is the smaller grid and is helpful for very detailed knotwork. 4 x 4 is perfect for beginners.)
- Pencil, mechanical or 2hb
- Eraser, white magic or kneaded
- Permanent marker, Pigma Micron or Prismacolor marker
- Watercolor paper, Bristol, or cardstock on which to transfer your newly created knotwork
- Saral transfer paper graphite for white or light color paper and white for black or dark papers
- To make your own transfer paper: On the back of the paper with your knotwork, cover with graphite using the side of a pencil point. Put this paper down on top of the paper you are transferring to. Trace your knotwork and it will transfer. Using a red ballpoint pen will help you see where you have traced.
- Once your artwork is transferred to your paper you can add color using watercolors, colored pencils, or watercolor pencils.

During the Middle Ages, monks studied textiles, mosaics, metalwork, and manuscripts from other countries for inspiration for their knot designs. Some knots were a single strand that made up a whole border and had no end. Monks competed to see who could make the fanciest knot. If you like knotwork, check out the Book of Kells and other instructional books on creating intricate knotwork.

MAKING A SIMPLE KNOT

Knots are created on a grid.

For the small knot, we are using a grid of 4 x 4 blocks, which are divided into 4 x 4 smaller blocks.

Put a dot in the center of the smaller 4 x 4 blocks.

Draw an oval around the small dot in the center of each block.

Finish the oval on the inside of the box as shown in the diagram.

Connect the ovals from the top box to the diagonal lower box.

Knotwork has a pattern of under/over, and you will need to decide where to start the over and under pattern as in the diagram.

The final figure shows a variation, going straight across the top and not connecting to the center ribbon.

Variations are fun, so try your hand at them. Use grid paper and trace until you feel comfortable.

MAKE A BOOKMARK

Transfer your knot onto a nice piece of paper. Once you are happy with the knot, you can ink it in with permanent marker. I use Pigma Microns or the new fine-point Sharpie. Once inked, the lines will not move if you decide to color in with watercolor. I used colored pencil to color this bookmark. Back your white paper with a coordinating color cardstock.

1. Knot a larger grid. Draw 4 x 6 rectangles. Keep lines light. Put a dot in the center of each box line.

2. Connect those center dots to give you diagonal lines. Connect the diagonal dots to form a diamond in each square.

3. On the outer boxes, create an arch all the way around the rectangle box as shown in red.

4. Once you have completed the arches, you will create blocks, which will stop your ribbon and redirect the lines. Create a block at the center top and bottom center sides and in the middle.

 On the block lines, continue the lines over the points as shown in blue. Think of these lines as ribbon and imagine you are weaving them on the grid.

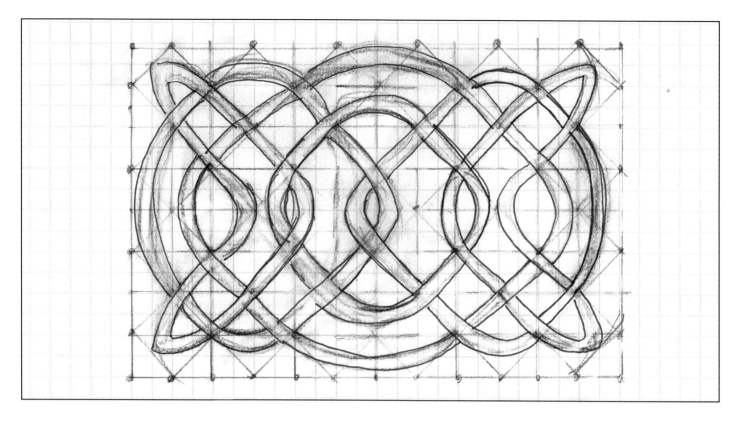

5. Draw your lines light so you can erase them! I have made them dark so you can see them here. Continue connecting the double lines or ribbons.

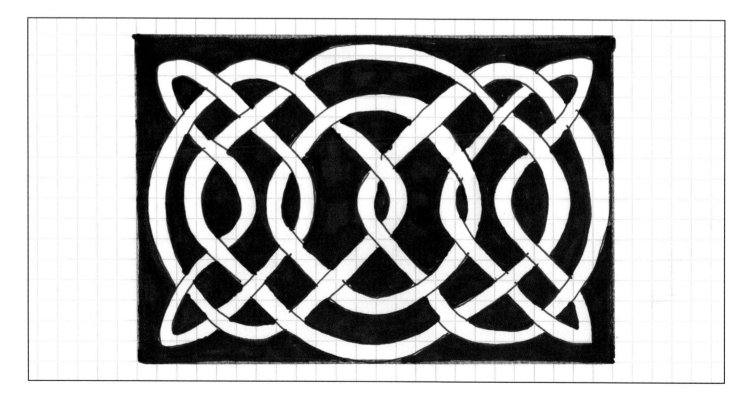

6. Once you have them connected, you will need to weave them. Remember the lines go over and under. Never have two over or two under next to each other. Have fun! You will get the hang of this. Trace if you need to, especially when you are beginning. I use vellum paper found in the cardstock area or Denril found in the art section. These can be lettered on without buckling like tracing paper.

Uncial Project: An Irish Blessing

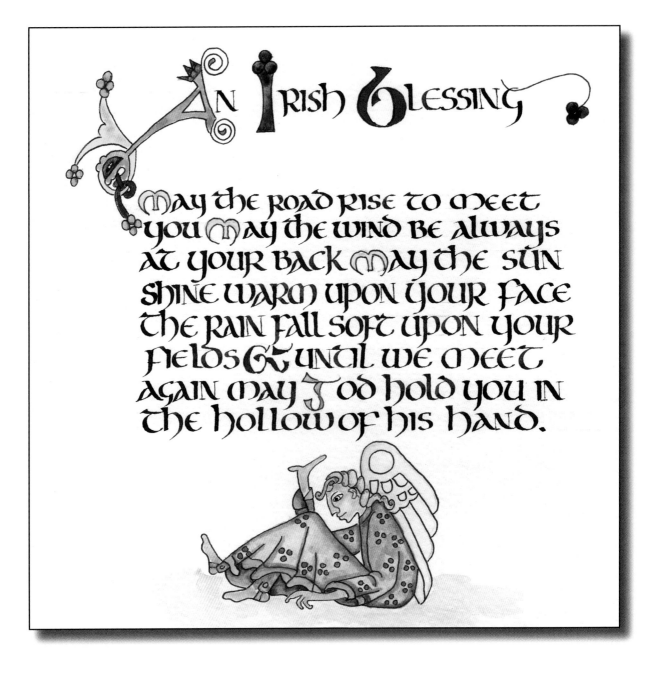

MATERIALS

- Watercolor pan set or tube watercolor
 (Prang watercolor or Winsor & Newton Cotman set)
- Colored pencils (Derwent or Prismacolor)
- Watercolor pencils (Derwent or Crayola)

Or use whatever you have on hand.

1. Letter your blessing.

 Practice writing the blessing again. Make it yours. Practice makes perfect! Use this exercise to practice your uncial hand.

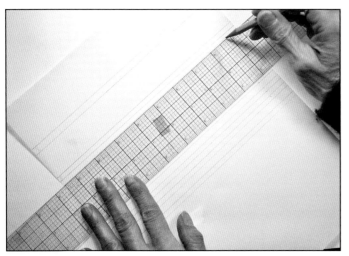

2. Use a grid ruler to measure your guidelines.

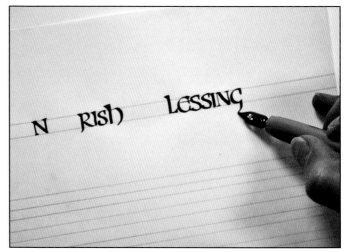

3. I have used fun Irish capitals. Check out *Celtic Design: Illuminated Letters* by Aidan Meehan (Thames and Hudson, 1992) for more ideas.

 If you are using drawn capitals, allow space to incorporate them. Draw in pencil, and when you are happy with the layout, go over the pencil lines with a permanent marker.

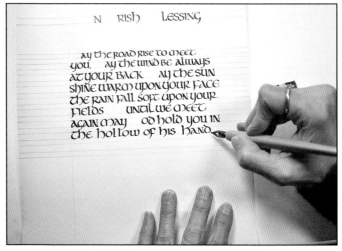

4. Allow the ink to dry before adding artwork and erasing guidelines.

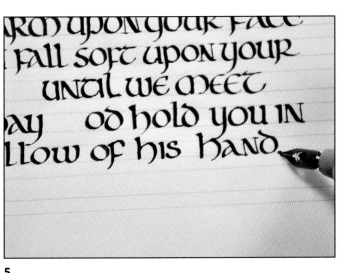

5.

6.

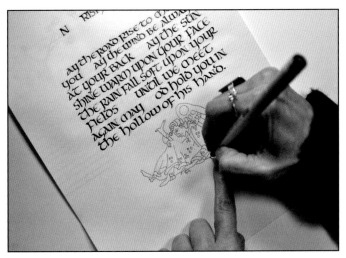

7.

8.

9.

10.

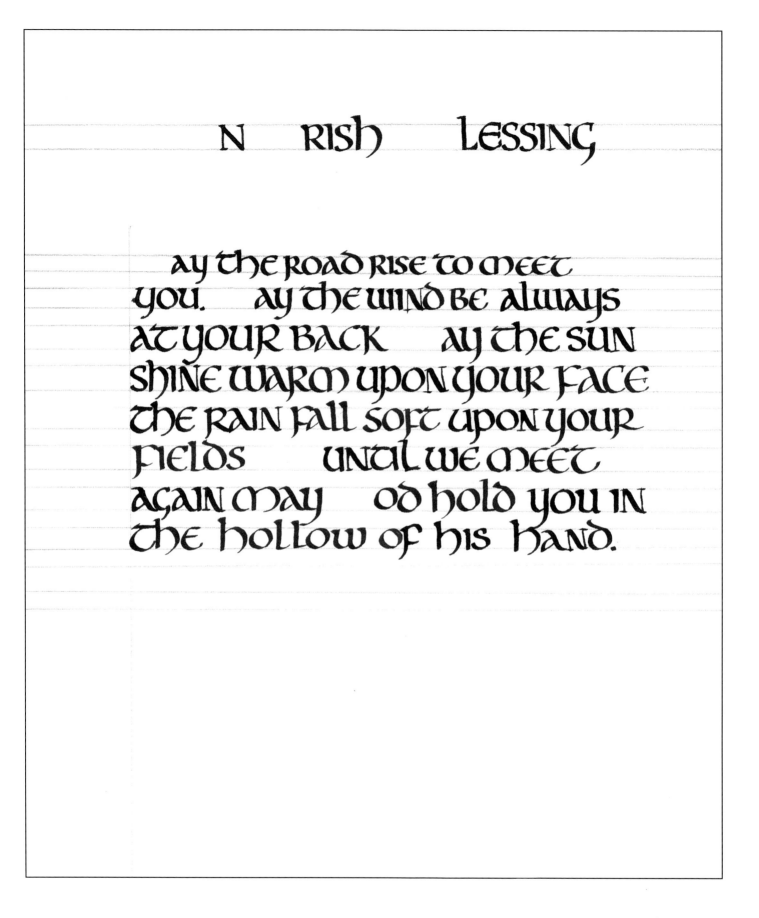

AN IRISH BLESSING

May the road rise to meet
you. May the wind be always
at your back May the sun
shine warm upon your face
the rain fall soft upon your
fields Until we meet
again May God hold you in
the hollow of his hand.

11. Trace the layout or create your own. Either way, have fun and enjoy the process.

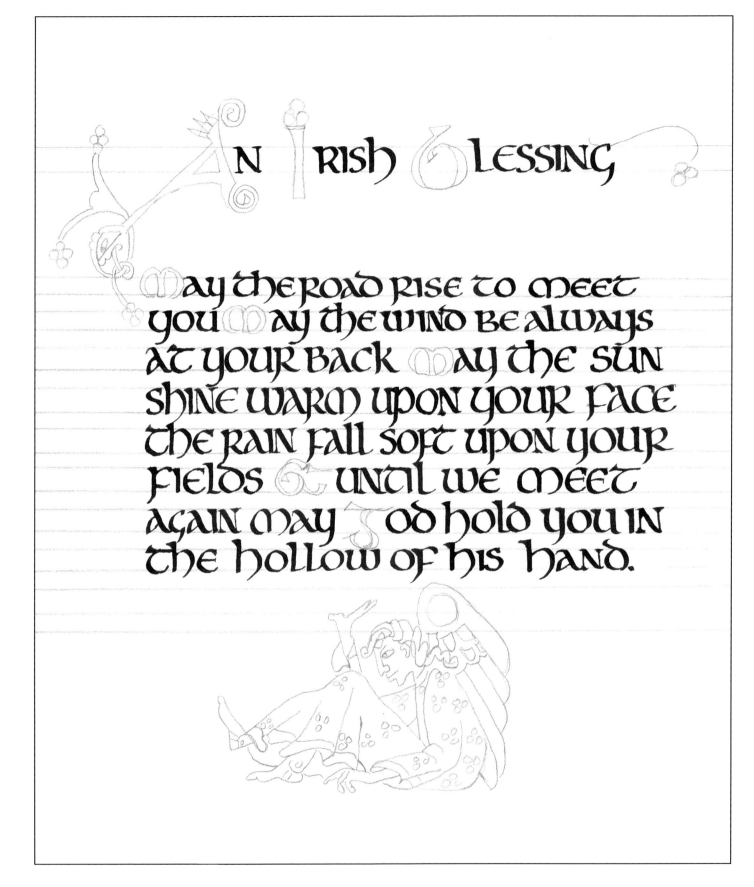

AN IRISH BLESSING

May the road rise to meet you May the wind be always at your back May the sun shine warm upon your face the rain fall soft upon your fields & until we meet again may God hold you in the hollow of his hand.

12. Here's the layout with artwork added, ready for outline with permanent marker or micron pen.

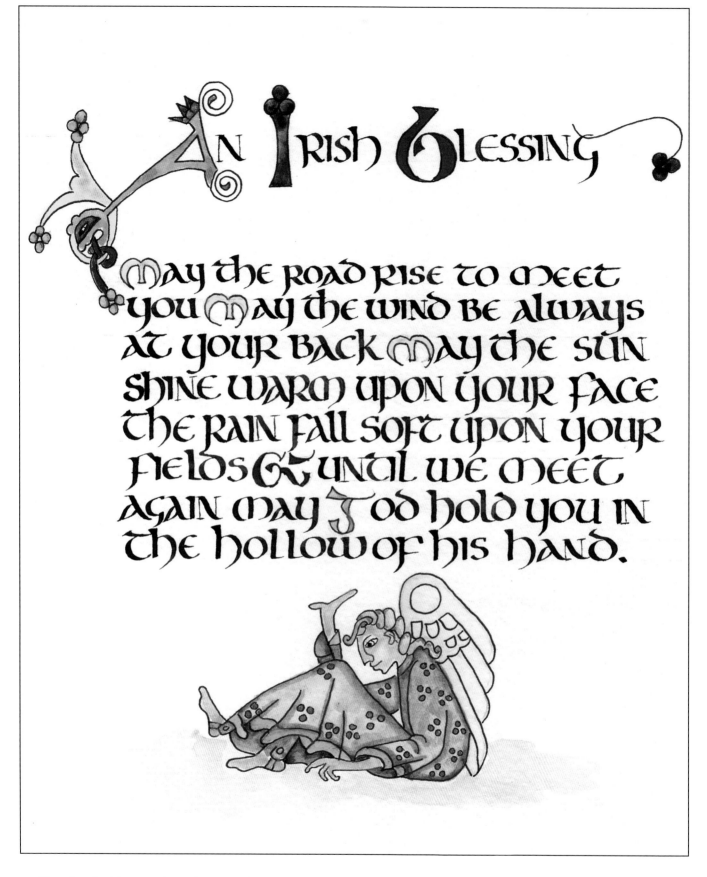

AN IRISH BLESSING

May the road rise to meet you May the wind be always at your back May the sun shine warm upon your face The rain fall soft upon your fields & until we meet again may God hold you in the hollow of his hand.

13. To color the blessing, I used watercolor paper and watercolor to complete.

Gothic Project: Seasons Greetings

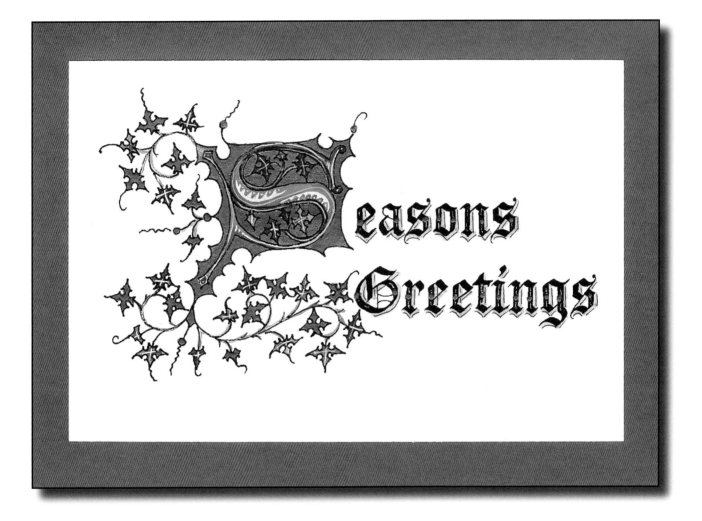

MATERIALS

- Watercolor paper
- Gold gouache or acrylic
- White gouache or Dr. Ph. Martin's Bleedproof White
- Pencil
- Eraser
- Permanent marker
- Paintbrush
- Watercolor in green, blue, and red
- Red cardstock

For our Seasons Greetings, we will create a beautiful verse with vines and leaves of blue and red enhanced with white work or white details. Illuminated letters have gold, making the page illuminated or brightly shine. You can add color making it a decorated letter.

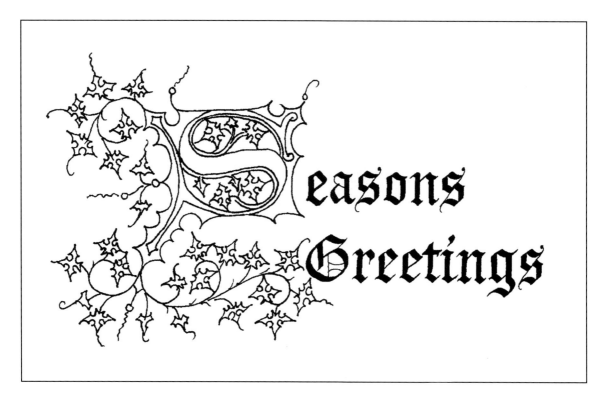

1. Copy the illuminated letter onto a piece of watercolor paper or other nice paper. You can trace or use the graphic transfer method: use a pencil to dirty the back of the paper with the letter **S** on it. Lay the side with the graphite or pencil scribble on it down and trace the letter. The pencil scribbles on the back will mark the clean paper. I like this method as it is easier to erase than using sacral graphite paper.

 Once the letter is on the final paper you are going to use for this project, trace over the pencil markings with a permanent marker.

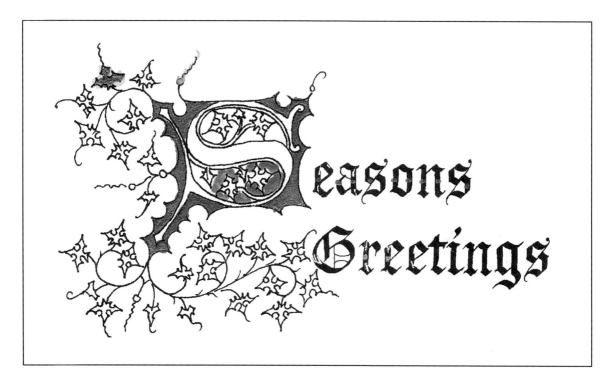

2. Using a gold paint, either watercolor or acrylic, fill in the areas to be gold first before adding color.

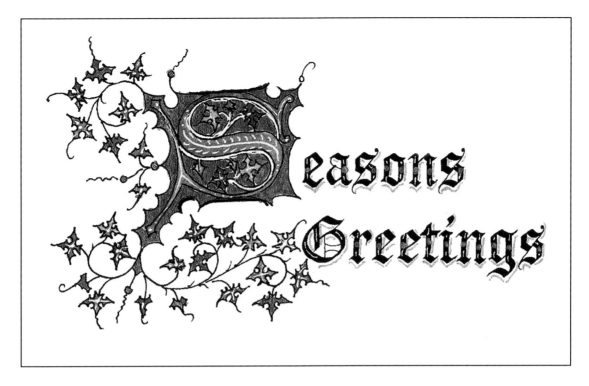

3. Color in the vines with two colors, either blue, red, or green and a few in the gold.

Color in the capital **S** using any of the colors you wish. Let the colors dry.

Practice lettering season's greetings. Once you are pleased with your lettering, add it to the page. Let dry.

Once everything is dry, you can add detail to the vines, capital, and the black letter.

Using white gouache or Dr. Ph. Martin's Bleedproof White, add highlights to the leaves, adding interest to the **S**, and let dry.

Add a dot of gold to the center of each letter, and let dry.

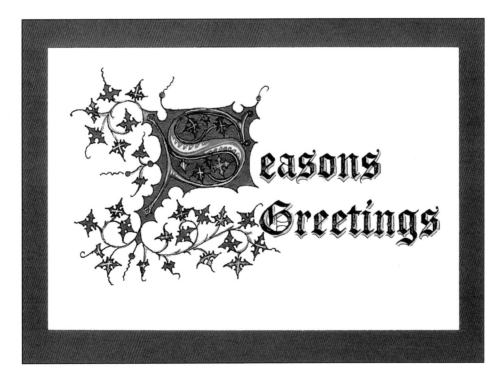

4. After the gold has dried, add a line of white coming out from the gold on either side of the gold dot.

If you put down lines for lettering, erase your lines once everything is dry. Don't be impatient! Mount your card onto colored cardstock for a card or to frame.

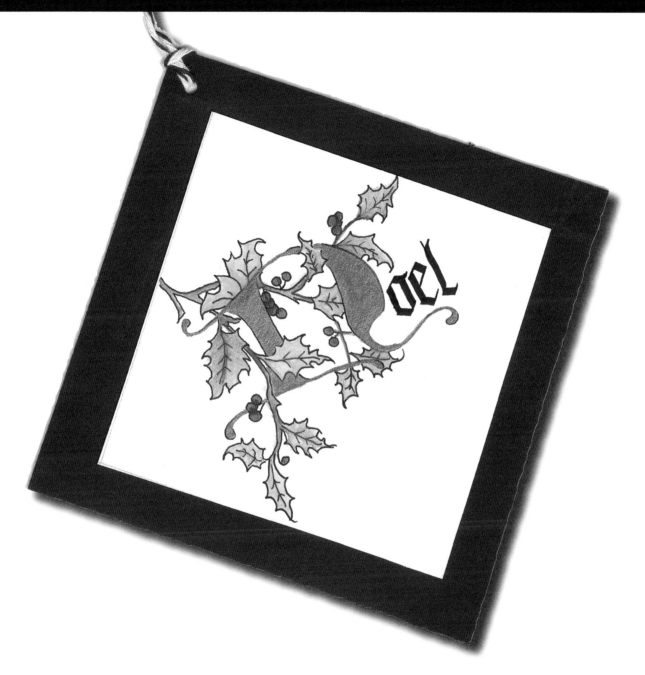

MATERIALS

- Watercolor paper
- Gold gouache or acrylic
- Pencil
- Watercolor pencils and water brush or paintbrush
- Cardboard or mat board
- String

Lombardic capitals are used here, but you can use whatever you wish. Add holly to create a unique gift tag. Create one-of-a-kind initials for gift giving or display.

2. Transfer the **N** and holly onto watercolor paper.

Color the Lombardic capital **N** in gold—use the same gold as in the last project.

3. For this project use watercolor pencils. They will help you make the tight leaves of the holly.

Color in the holly and berries.

Blend light green, yellow, and dark green for the leaves. For berries use red and burgundy or purple for highlights and lowlights.

Once you have completed coloring the leaves and berries, use a wet brush to hydrate the penciled watercolors on the paper. With the water lightly scrub the color to lift and move. Do the greens and then the red berries to keep the colors from mixing. This is a favorite technique when learning to add color to your lettering.

You can add the year under the Noel.

Lay down lines for the year and do not erase the lines until you are sure everything is dry!

Foundational Project: Leaf with Verse

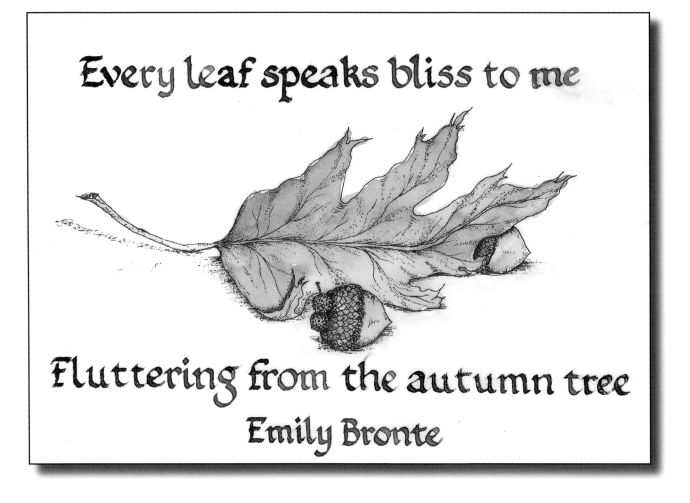

Every leaf speaks bliss to me

Fluttering from the autumn tree

Emily Bronte

MATERIALS

- Vellum paper
- Guard sheet
- Watercolor paint
- Paintbrush
- Graph paper
- Cardstock

You can find vellum paper in the cardstock or translucent paper collections. Check for the Darice or Recollections brand. Do not use tracing paper—it will cockle. I use Neenah UV/Ultra II Translucent printing paper.

Use a guard sheet. Oils from your hand can create spots that will not accept ink or water. Keep water to a minimum; do not flood the leaf with water.

There are different weights of stock, and all work well.

1. Transfer the leaf onto vellum paper using a photocopier or by tracing it.

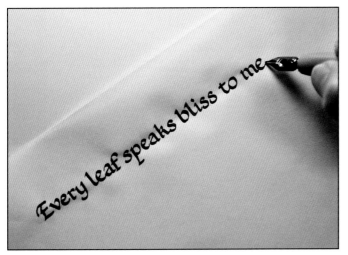

2. Practice the Emily Brontë quote on graph paper.

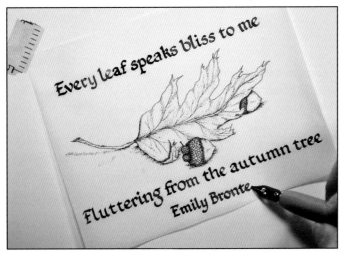

3. Once you are pleased with it, let it dry.

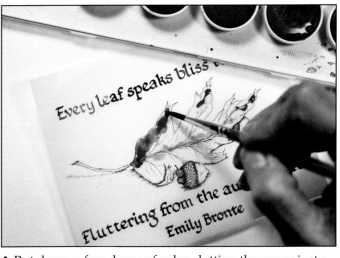

4. Put down a few drops of color, dotting the paper just a little. This is a fall leaf, and we want it to blend and not have one color dominate the leaf.

Start with red in a few spots, then green and yellow.

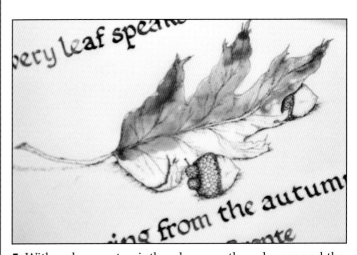

5. With a clean wet paintbrush, move the color around the leaf. If you need more color, you can drop it in.

Let it dry, and remember it will look different when dry.

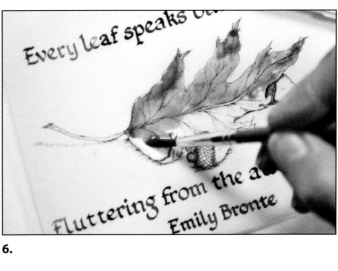

6.

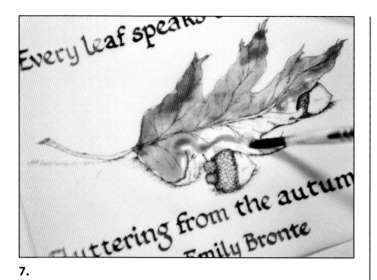

7.

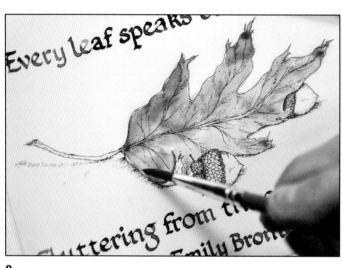

8.

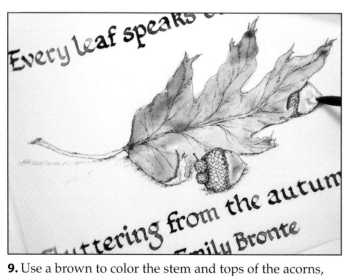

9. Use a brown to color the stem and tops of the acorns, move the color around keeping a light (sun) spot in front.

Color the nut of the acorn in greens, browns, and yellows.

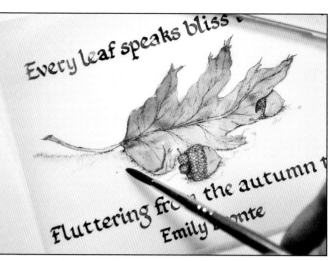

10. Do not forget to paint the shadows; using dirty water from cleaning the brush will do the trick.

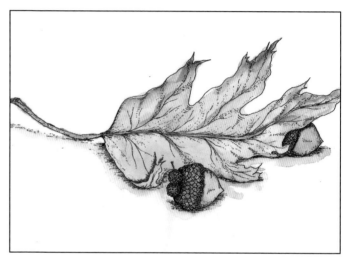

11. I like to find leaves and acorns to work with, and I consult reference materials for inspiration. Have fun playing with color.

When your leaf is totally dry and you are happy with it, you can begin to letter the quote.

The paper is translucent, and you can trace the poem onto the vellum. Tracing will give you confidence in lettering on projects and helps to learn centering and creating projects on your own.

Once this is dry, you can mount the leaf on cardstock. Try different colors and notice the effects of different backgrounds. Celebrate your achievement!

MATERIALS

- 5" x 30" sheet of paper cut from a sheet of 22" x 30" watercolor paper
- 15" x 17" sheet of black paper Canson Mi-Teintes for cover (available in large sheets at local art stores)
- French curve or lid of can to create line
- White acrylic paint craft or Golden acrylic paint
- Cheap brush or chip brush
- Bone folder or stylus

An accordion folded sheet of paper housed inside an origami cover is a fun and exciting way to create a distinctive way to show of your skills. This project also showcases a unique way of lettering a poem without using lines.

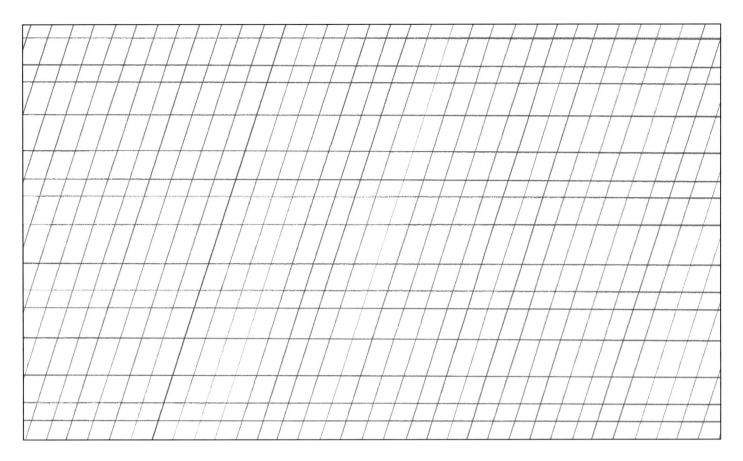

1. Use the italic grid to write your poem. Practice helps you gain confidence before committing the poem to good paper.

I used to stare up at the sky trying to see where the snowflakes were born. I could do it for hours. Well, minutes. But it was always the waiting that was the most fun. Anonymous

2. Practice lettering the "Snowflakes" quote.

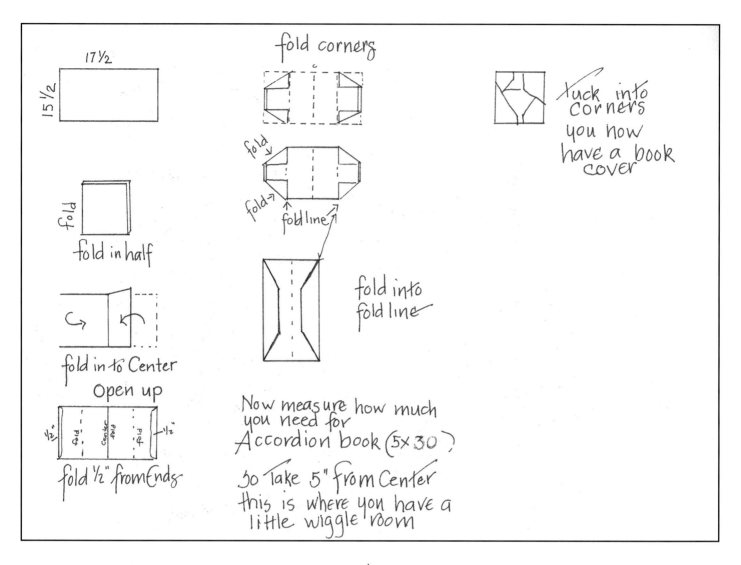

fold corners

17½

15½

fold

fold in half

fold in to Center

Open up

fold

Center

fold

½"

fold

½"

1½"

fold ½" from Ends

fold

fold

fold line

fold into
fold line

Tuck into
corners
you now
have a book
cover

Now measure how much
you need for
Accordion book (5×30)

So Take 5" from Center
this is where you have a
little wiggle room

3. Cut down the full sheet of paper to 5 by 30 inches.

Score and fold the paper at 4¼ inches until your paper is completely folded.

A sheet 30 inches long will give you seven pages.

Lay the paper with the wrong side up. Place your French curve or any tool to create a rounded up-and-down pattern at the bottom of your paper. Using a bone folder or stylus, depress the lines into the paper. Continue all the way across the paper.

Fold your paper into an accordion.

Lay your paper so that the opening (cut end) is to the right.

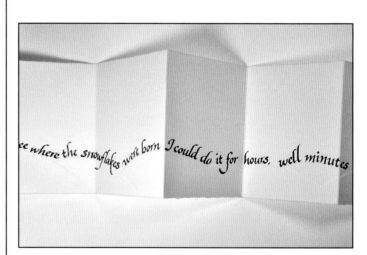

4. Lay out the quote on the length of paper.

Write the quote out in pencil onto the paper following the rounded guideline. The poem is written out on six of the sheets with the last sheet to tuck into the cover.

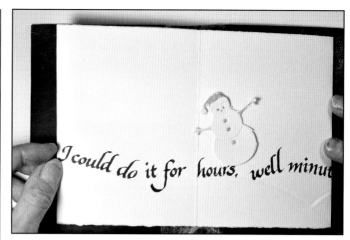

5. This gives a happy, playful feel to the quote. We are not using any other guidelines but the fold in the paper to letter on.

Let the letters dry before proceeding.

You can let the quote stand on its own, or use chalk pastels to color in the sky. Perhaps you want to add a snowman or snowflakes to make this your own creation.

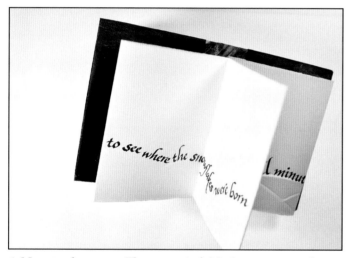

6. Now to the cover. The cover is folded to create pockets to hold your book and a snowflake or two.

Now fold in the wing—bring the four corners into the first fold line.

Now fold into the center at the first fold line.

You will not meet at the center because you folded the flap on the end.

Flip it over.

7. Lay your accordion paper across the cover.

Fold up the bottom toward the center without creasing, using the accordion paper for position (approximately 4 inches).

Bring the top of the paper down to give you approximately 5¼ inches in the center for the placement for the accordion book.

Tuck the top into the bottom fold.

Once you are comfortable with the position of the paper, crease your paper.

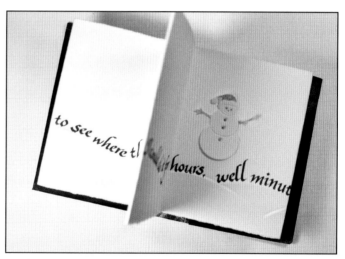

8. This is a very forgiving cover and will give you pockets for lots of snowflakes or snowmen. Have fun decorating your book.

You can create these little books with different themes to give instead of traditional cards.

Casual Pen Project: Sunflower

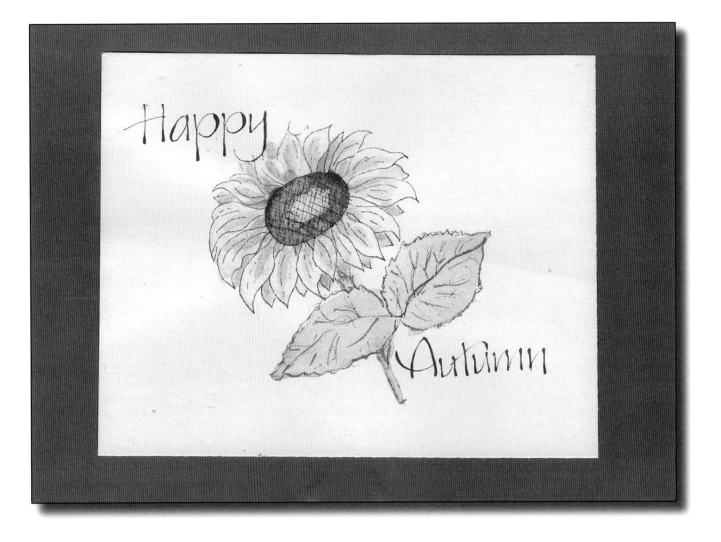

MATERIALS

- Watercolor paper or vellum
- Pan or tube watercolors

This fun project introduces watercolor and calligraphy to create a personal card using any sentiment. Use watercolor from this project to letter your sentiment.

1. Draw or transfer the sunflower onto watercolor paper or the vellum paper.

2. You'll need watercolors, pan or tube, light yellow, dark yellow, ochre, brown, light green, dark green, and red and orange for highlights.

3. Take the lightest yellow you have and color in the outer layer of petals. Use your darker yellow and place this darker yellow in the petals in shadow behind the front petals.

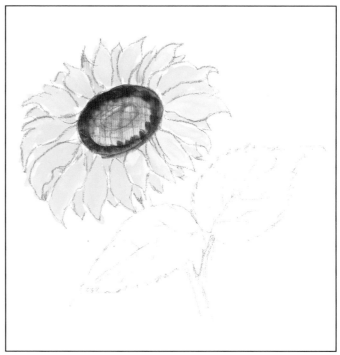

4. For the center, add a light covering of brown, and go over with a second layer of brown around the edge of the center.

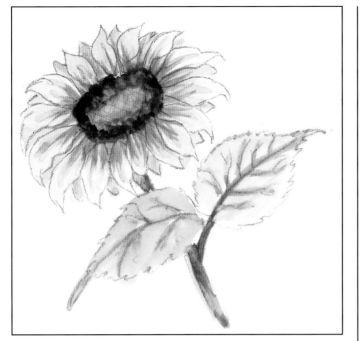

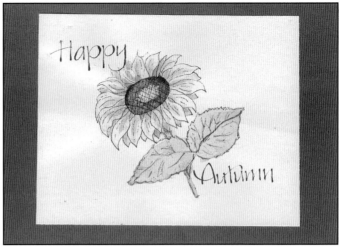

7. Add a verse or sentiment to make a beautiful birthday card or a Happy Autumn greeting.

5. While the center and petals are drying, paint a light green over the leaves. Using ochre, pull small strokes from the center of the flower out into the petals. Go over the stem and define the leaves with the darker green. Into the center, define the center with ochre over the brown, adding depth to the center.

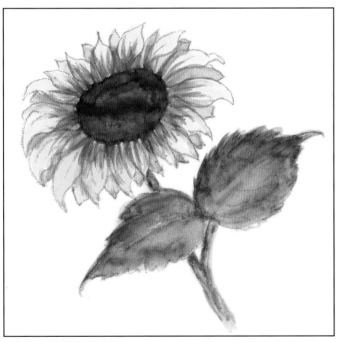

6. For the final steps, blend the leaves, allowing for shadow under the flower. Fill in the center, creating interest. Make every flower unique and fun to create.

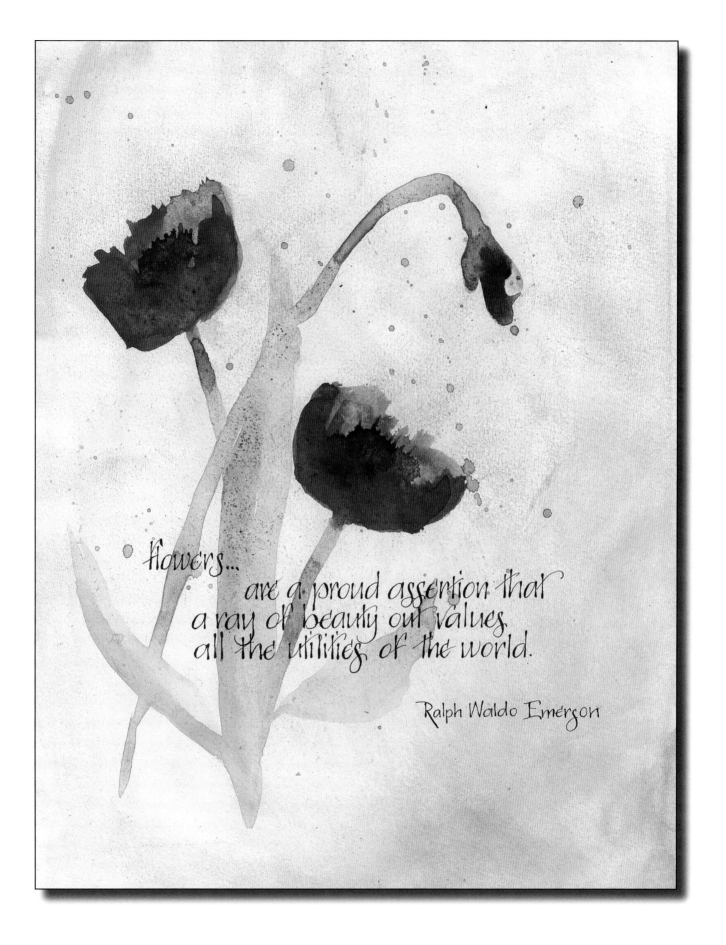

flowers...
are a proud assertion that
a ray of beauty out values,
all the utilities of the world.

Ralph Waldo Emerson

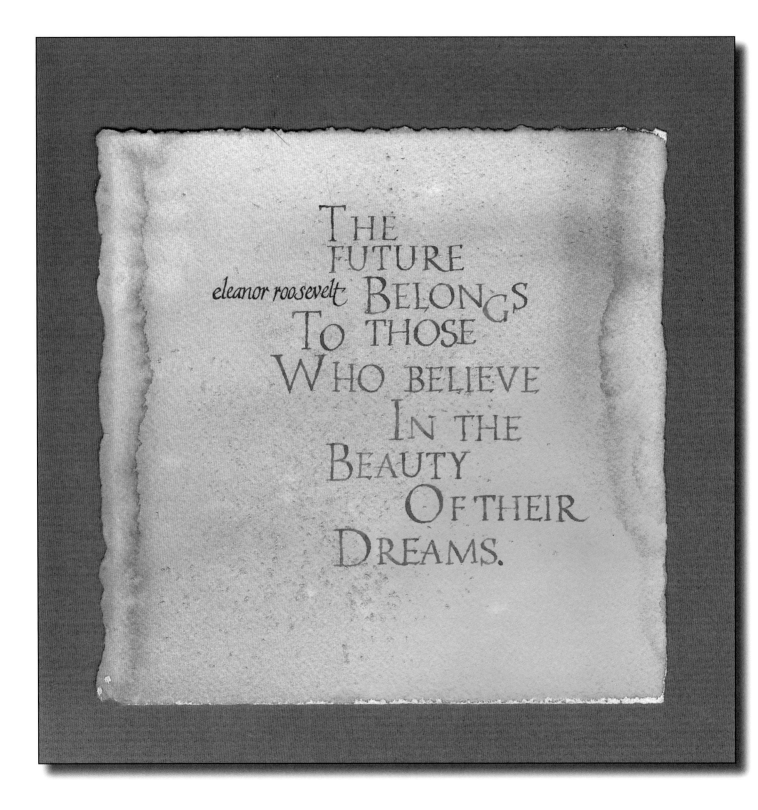

THE
FUTURE
eleanor roosevelt BELONGS
To those
Who believe
In the
Beauty
Of their
Dreams.

Watercolor Backgrounds

MATERIALS

- Dr. Ph. Martin's Radiant Concentrated Water Color or tube or pan watercolor
- Watercolor paper
- Spray bottle or paintbrush
- Paper towel
- Table salt or kosher salt
- Plastic wrap

This is a great way to enhance the tone of your lettering without introducing additional artwork.

Here I have used a light blue and fuchsia Dr. Ph. Martin's Radiant Concentrated Water Color on prewet watercolor paper. You can use tube or pan watercolor.

Wet watercolor paper with a spray bottle or a paintbrush or run under the faucet. Wet both sides of the paper so that the paper does not curl or buckle.

Place watercolor in three places around the paper. Add a second color in two to three places around the paper,

spritzing with water to help it blend if needed. If you dampen the area too much, use a paper towel to lift water and from the area. Play with small pieces of watercolor paper and see what you get. Use other colors that blend, but never more than three colors or you will make mud.

I put these away for poems or card sentiments. This is fun and a creative way to jump-start your creative process. You can try adding table salt and kosher salt to the wet watercolor and let it dry. See how the salt pulls the color from the area. Once dry you can brush the salt away.

Another technique is to add plastic wrap on top of the wet watercolor. Pull a piece of plastic wrap larger than the paper, wrinkle it up, and place it on the wet paint. The wrinkles in the plastic are what create the crystal-like patterns, so do not smooth out the wrinkles.

Set aside to dry overnight, and once dry remove the plastic wrap.

This can be done using salt and alcohol resist techniques with really interesting results and can be lettered on once dry.

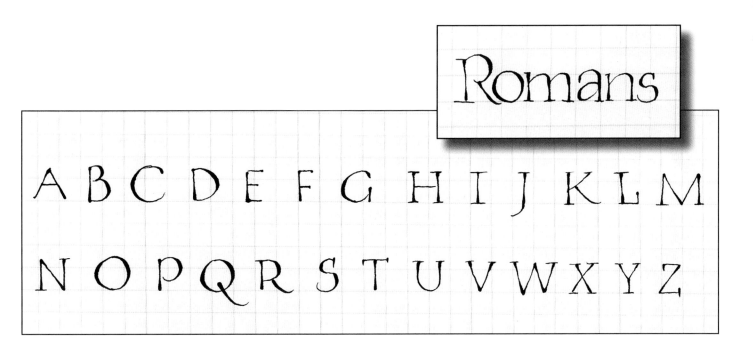

Pangrams for Practice

32 silly sentences with almost every letter

Forsaking monastic tradition, twelve jovial friars gave up their vocation for a questionable existence on the flying trapeze.

No kidding—Lorenzo called off his trip to visit Mexico City just because they told him the conquistadores were extinct.

Jelly-like above the high wire, six quaking pachyderms kept the climax of the extravaganza in a dazzling state of flux.

Ebenezer unexpectedly bagged two tranquil aardvarks with his jiffy vacuum cleaner.

Six javelins thrown by the quick savages whizzed forty paces beyond the mark.

The explorer was frozen in his big kayak just after making queer discoveries.

The July sun caused a fragment of black pine wax to ooze on the velvet quilt.

The public was amazed to view the quickness and dexterity of the juggler.

We quickly seized the black axle and just saved it from going past him.

Six big juicy steaks sizzled in a pan as five workmen left the quarry.

While making deep excavations we found some quaint bronze jewelry.

Jaded zombies acted quaintly but kept driving their oxen forward.

A mad boxer shot a quick, gloved jab to the jaw of his dizzy opponent.

The job requires extra pluck and zeal from every young wage earner.

A quart jar of oil mixed with zinc oxide makes a very bright paint.

Whenever the black fox jumped the squirrel gazed suspiciously.

We promptly judged antique ivory buckles for the next prize.

How razorback-jumping frogs can level six piqued gymnasts!

Crazy Fredericka bought many very exquisite opal jewels.

Sixty zippers were quickly picked from the woven jute bag.

Amazingly few discotheques provide jukeboxes.

Heavy boxes perform quick waltzes and jigs.

Jinxed wizards pluck ivy from the big quilt.

Big Fuji waves pitch enzymed kex liquor.

The quick brown fox jumps over a lazy dog.

Pack my box with five dozen liquor jugs.

Jackdaws love my big sphinx of quartz.

The five boxing wizards jump quickly.

How quickly daft jumping zebras vex.

Quick zephyrs blow, vexing daft Jim.

Sphinx of black quartz, judge my vow.

Waltz, nymph, for quick jigs vex Bud.

Sources

M ost items can be purchased at local arts and craft stores. For specific items you may want to use these suppliers or browse their catalogs.

PAPER AND INK ARTS

Paper and Ink Arts
www.paperinkarts.com

John Neal Bookseller
www.johnnealbooks.com

Scribblers
www.scribblers.co.uk

CALLIGRAPHY GUILDS

The International Association of Master Penmen, Engrossers and Teachers of Handwriting (IAMPETH)
www.iampeth.com

Cyberscribes, an internet calligraphy discussion group
www.calligraph.com/cyberscribes
www.cynscribe.com

Calligraphy and Lettering Arts Society (CLAS)
www.clas.co.uk

Society of Scribes and Illuminators (SSI)
www.calligraphyonline.org

ALABAMA

Birmingham Calligraphy Guild
PO Box 660323, Birmingham, AL 35266
www.birminghamcalligraphy.org

ARIZONA

Calligraphic Society of Arizona
PO Box 27695, Tempe, AZ 85285
www.calligraphicsocietyofarizona.org

ARKANSAS

Calligraphy Guild of Arkansas
917 W 7th Street, Little Rock, AR 72201
calligraphyguildofarkansas.blogspot.com

CALIFORNIA

Central Coast Creative Arts
796 Arlington Street, Cambria, CA 93428
artistsofcambria.com/workshops.html

Friends of Calligraphy
PO Box 425194, San Francisco, CA
 94142-5194
www.friendsofcalligraphy.org

Pacific Scribes
PO Box 3392, Santa Clara, CA 95055
www.pacificscribes.net

San Diego Fellow Calligraphers
PO Box 500911, San Diego CA 92150-0911
www.sdfconline.com

Sea Scribes—Monterey Bay Calligraphy Guild
PO Box 2581, Monterey, CA 93942
www.montereybay.com/directory/sea-scribes.html

Society for Calligraphy—Southern California
PO Box 64174 Los Angeles, CA 90064-0174
www.societyforcalligraphy.org

COLORADO

Colorado Calligraphers' Guild
PO Box 102672, Denver, CO 80250-2672
www.coloradocalligraphers.com

Summit Scribes
10032 Pinedale Drive, Colorado Springs, CO 80920
summitscribes.org

CONNECTICUT

Mysticalligraphers
PO Box 267, Mystic, CT 06355
www.calligraphyconnecticut.org/Mystic.htm

FLORIDA

Coastal Calligraphers Guild
PO Box 48216, Sarasota, FL 34230-5216
coastalcalligraphersguild.org

Gulfcoast Calligraphy Guild
5889 Greenfield Street, Pace, FL 32571-7323
gulfcoastcalligraphyguild.wordpress.com

Scribes of Central Florida
PO Box 1753, Winter Park, FL 32790-1753
www.scribesofcentralflorida.com

South Florida Calligraphy Guild
PO Box 16891, Plantation, FL 33317
southfloridacalligraphyguild.org

GEORGIA

Atlanta Friends of the Alphabet
PO Box 682, Decatur, GA 30031
www.friendsofthealphabet.org

Atlanta Penablers
3330 Piedmont Road, Suite 18, Atlanta,
 GA 30305
atlantapenablers.com

IDAHO

Idaho Inkspots Calligraphy Guild
PO Box 88, Idaho City, ID 83631
www.orgsites.com/id/idahoinkspots/

ILLINOIS

Chicago Calligraphy Collective
PO Box 316592, Chicago, IL 60631
chicagocalligraphy.org

INDIANA

Calligraphy Guild of Indiana
PO Box 30495, Indianapolis, IN
 46230-0495
calligin.org

**Kentuckiana Calligraphy and Paper Arts
 Guild**
916 Brookwood Drive, New Albany, IN
 47150
kcgonline.blogspot.com

Michiana Calligraphy Guild
PO Box 11513, South Bend, IN 46601
www.michianacalligraphy.com

IOWA

Iowa Scribes
3712 Wenig Road NE, Cedar Rapids, IA
 52402

KANSAS

Kansas City Letter Arts Exchange
14832 Goddard Street, Overland Park, KS
 66221
kclax.tumblr.com

LOUISIANA

Louisiana Calligrapher's Guild
18690 Magnolia Estates, Prairieville, LA
 70769-3216
www.louisianacalligraphersguild.org

New Orleans Lettering Arts Association
PO Box 9400, Metairie, LA 70055
www.neworleanscalligraphy.org

MAINE

Casco Bay Scribes
14 Roosevelt Street, South Portland, ME
 04106
cascobayscribes.blogspot.com

MASSACHUSETTS

Cape Cod Calligraphers Guild
12 High Street, Orleans, MA 02653
capecodcalligraphers.com

**Masscribes—New England Calligraphy
 Guild**
PO Box 67132, Chestnut Hill, MA 02467
www.masscribes.org

MICHIGAN

Michigan Association of Calligraphers
PO Box 2229, Birmingham, MI 48012-2229
micallig.org

Pen Dragons Calligraphy Guild
1029 Essex Circle, Kalamazoo, MI 49008
www.pendragonscalligraphy.org

Valley Scribes
1800 Deacon Drive A8, Saginaw, MI 48602

MINNESOTA

Colleagues of Calligraphy
PO Box 4024, St. Paul, MN 55104-0024
www.colleaguesofcalligraphy.com

MISSOURI

St. Louis Calligraphy Guild
PO Box 16563, St. Louis MO 63105
stlcalligraphyguild.org

MONTANA

Big Sky Scribes
1122 Garfield Street, Helena, MT 59601
www.bigskyscribes.org

Bridger Mountain Scribes
515 West Cleveland Street, Bozeman, MT
 59715
www.bridgermountainscribes.org

Great Falls Scribes
1320 16th Street S, Great Falls, MT 59405
www.bigskyscribes.org

Missoula Calligraphers Guild
PO Box 3448, Missoula, MT 59801-3826
www.bigskyscribes.org

Queen City Scribes
1122 Garfield Street, Helena, MT 59601
www.bigskyscribes.org

Yellowstone Calligraphers Guild
1001 Senora Avenue, Billings, MT 59105
www.bigskyscribes.org

NEW MEXICO

**Escribiente—Albuquerque's
 Calligraphic Society**
PO Box 30166, Albuquerque, NM 87190
www.escribiente.org

Southwest Calligraphy Guild
390 Watson Lane, Las Cruces, NM 8805
web.nmsu.edu/~mquinone/

NEW YORK

Genesee Valley Calligraphy Guild
66 Belcoda Drive, Rochester, NY 14617
gvcalligraphy.org

**Greater Rochester Penmanship &
 Calligraphy Club**
175 Mildorf Street, Rochester NY 14609

Island Scribes
PO Box 1043, Baldwin, NY 11510-1043

Society of Scribes NYC
PO Box 933, New York, NY 10150
www.societyofscribes.org

NORTH CAROLINA

Carolina Lettering Arts Society
PO Box 2234, Fairview, NC 28730
www.carolinaletteringarts.com

Coastal Calligraphers
216 NE 59th Street, Oak Island, NC 28465
www.carolinaletteringarts.com

Mountain Scribes
PO Box 250, Black Mountain, NC 28711
www.carolinaletteringarts.com

Triangle Calligraphers Guild
215 Wintermist Drive, Cary, NC 27513
www.trianglecalligraphersguild.com

OHIO

Calligraphy Guild of Columbus
PO Box 14184, Columbus, OH 43214
groups.yahoo.com/group/
 Calligraphy_Guild_of_Columbus/

Greater Cincinnati Calligraphers Guild
9467 Montgomery Road, Cincinnati, OH
 45242
www.cincinnaticalligraphy.com

Guild of the Golden Quill
PO Box 1221, Dayton, OH 45401-1221
www.daytoncalligraphyguild.blogspot.
 com

Marietta Calligraphy Society
60674 Somerton Highway, Barnesville,
 OH 43713

Scripts & Scribes of Summit County
PO Box 1348, Akron, OH 44309-1134
www.neohiocalligraphy.org

Western Reserve Calligraphers
PO Box 40275, Bay Village, OH 44140
www.neohiocalligraphy.org

OKLAHOMA

Calligraphy Guild of Oklahoma
2435 S. Peoria, Tulsa, OK 74114
www.calligraphytulsa.com

Sooner Scribes
PO Box 188, Oklahoma City, OK 73101
www.soonerscribes.com

OREGON

Calligraphers' Guild of Ashland
PO Box 304 Ashland, OR 97520
www.roguepens.org

Capital Calligraphers
PO Box 2294, Salem OR 97308-2294
www.capitalcalligraphers.org

Coast Calligraphy Guild
PO Box 5848, Charleston, OR 97420
coastcalligraphy.blogspot.com

Portland Society for Calligraphy
PO Box 4621, Portland, OR 97208
www.portlandsocietyforcalligraphy.org

Valley Calligraphy Guild
2684 Chad Drive, Eugene, OR 97408
valleycalligraphyguild.com

PENNSYLVANIA

**Calligraphers Guild of Northeast
 Pennsylvania**
106 Robert Road, Shohola, PA 18458
www.facebook.com/
 CalligraphersGuildOf
 NortheasternPennsylvania

Calligraphy Guild of Pittsburgh
5700 Fifth Avenue #34B, Pittsburgh, PA
 15232
cgofp.wordpress.com

Philadelphia Calligraphers' Society
PO Box 1372, Southeastern, PA 19399-1372
www.philadelphiacalligraphers.org

TENNESSEE

Memphis Calligraphy Guild
PO Box 13708, Memphis, TN 38187-0308
www.calligraphyguild.com

Nashville Calligraphers Guild
1637 Stewarts Ferry Pike, Hermitage, TN
 37076
www.nashvillecalligraphersguild.org

TEXAS

Capital City Scribes
PO Box 5427, Austin, TX 78763
www.ccscribes.com

Fort Worth Calligraphers Guild
PO Box 101732, Fort Worth TX 76185
www.fortworthcalligraphersguild.com

Houston Calligraphy Guild
PO Box 421558, Houston, TX 77242
www.houstoncalligraphyguild.org

San Antonio Calligraphers' Guild
PO Box 291232, San Antonio, TX 78229
www.sanantoniocalligraphy.com

Texas Lettering Arts Council
PO Box 3126, Coppell, TX 75019
www.txlac.org

**Kaligrafos, The Dallas Calligraphy
 Society**
PO Box 831118, Richardson, TX 75083
www.kaligrafos.com

Waco Calligraphy Guild
PO Box 8470, Waco, TX 76714-8470
www.orgsites.com/tx/
 wacocalligraphyguild/

UTAH

Utah Calligraphic Artists
PO Box 1086, Draper, UT 84020-1086
www.utahcalligraphicartists.com

VERMONT

The Vermont Study Group
13 Barber Farm Road, Jericho, VT 05465

WASHINGTON DC

Washington Calligraphers Guild
PO Box 3688, Merrifield, VA 22116
www.calligraphersguild.org

WASHINGTON

Nib 'N' Inks
PO Box 12354, Olympia, WA 98508-2354
www.nibninks.com

Peninsula Scribes
PO Box 1794, Sequim, WA 98382
peninsulascribes.wordpress.com

Rain Writers Calligraphers of Northwest Washington
PO Box 29508, Bellingham, WA 98228-1508
rainwriters.blogspot.com

Scripts & Scribes
24210 East Maxwell, Liberty Lake, WA 99019
www.facebook.com/ScriptsandScribesWA

Society for Calligraphy & Handwriting
PO Box 3761, Bellevue, WA 98009-3761
calligraphysociety.org

Tacoma Calligraphy Guild
2009 South 12th Street, Tacoma, WA 98405-3019
tacomacalligraphyguild.com

Windwriters
661 Ranch House Lane, Ellensburg, WA 98926

Write On Calligraphers
PO Box 277, Edmonds, WA 98020-0277
writeoncalligraphers.homestead.com

WEST VIRGINIA

Charleston Calligraphers Guild
RR4 Box 334, Hurricane, WV 25526
www.wvcalligraphy.com

Huntington Calligraphers Guild
RR4 Box 334, Hurricane, WV 25526
www.wvcalligraphy.com

WISCONSIN

Cream City Calligraphers
PO Box 1468, Milwaukee, WI, 53201
www.creamcitycalligraphers.com

CANADA

Alphabeas Calligraphy Guild
20025 36 Avenue, Langley, BC V3A 2R5
alphabeas.blogspot.com

Bow Valley Calligraphy Guild
PO Box 1647, Station M, Calgary, AB T2P 2L7
www.bvcg.ca/

Calligraphers Guild of Manitoba
214 Thurlby Road, Winnipeg, Manitoba, R3C 1Y3
calligraphersguildofmanitoba.blogspot.com

Calligraphic Arts Guild of Toronto
56 Neilson Drive, Etobicoke, ON M9C 1V7
www.neilsonparkcreativecentre.com

Calligraphy Society of Ottawa
PO Box 4265, Station E, Ottawa, ON K1S 5B3
ottawacalligraphy.ca/

Edmonton Calligraphic Society
Suite #119, 14032–23 Avenue NW, Edmonton, AB T6R 3L6
edmontoncalligraphicsociety.ca/

Fairbank Calligraphy Society
PO Box 5458, Victoria, BC V8R 6S4
www.fairbankcalligraphysociety.com

Hamilton Calligraphy Guild
PO Box 57144, Jackson Station, Hamilton, ON L8P 4W9
www.hamiltoncalligraphyguild.com

Kelowna Calligraphers' Guild
233 Dalgleish Court, Kelowna, BC V1X 7A4
groupspaces.com/KelownaCalligraphersGuild/

La Societe des Calligraphes de Montreal
PO Box 204, Snowdon Station, Montréal, QC H3X 3T4
societedescalligraphes.org

Lettering Arts Guild of Red Deer
PO Box 242, Red Deer, AB Canada T4N 5E8
www.lagrd.ca/

Regina Calligraphy and Paper Arts Group
170 Parker Avenue, Regina, SK S4S 4S1
www.facebook.com/#!/groups/194071997356410/

Royal City Calligraphy Guild
87 East Tree Drive, Breslau, ON N0B 1M0
royalcitycalligraphyguild.blogspot.com

Warmland Calligraphers of the Cowichan Valley
PO Box 2, Duncan, BC V9L 1M3
members.shaw.ca/warmlandcalligraphers/

Westcoast Calligraphy Society
PO Box 18150, Vancouver, BC V6M 4L3
westcoastcalligraphy.com

Wheatland Calligraphy Guild
PO Box 3445, Melfort, SK S0E 1AO
www.cityofmelfort.ca/Directory/Wheatland+Calligraphy+Guild/

Glossary

Ascender The portion of a letter that rises above the waist-line, as in the upper stem of the minuscule **b, l,** and **h.**

Baseline Writing line, real or imagined, wavy or straight, on which the body of the letter sits.

Body height or x-height Height of letters between the waistline and baseline, without their ascenders or descenders.

Calligraphy From the Greek words *calli* (beautiful) and *graphein* (to write). Believed to have been first used in the early seventeenth century, it usually refers to beautifully formed letters written directly with a pen or brush. However, the word is often used more generally to include not only writing but also lettering and illuminating.

Capital height The height of a capital letter. Some hands have a separate line height for capital height and another height for ascenders.

Carbon ink Made of fine particles of carbon suspended in water, gum, and various additives. Carbon pigment was used in cave painting. (Ink made from soot is carbon ink.)

Descender The portion of a letter that falls below the baseline; the lower stem of the minuscule **j, p,** and **q.**

Dip pen Pen whose nib must be dipped into an ink supply or have ink or paint brushed onto it, as distinct from one that carries its own ink supply, such as a fountain pen or broad-edge marker.

Counter Fully or partially enclosed space within a character. The inside of the **O** is the counter.

Cross stroke Mark made horizontally left to right or right to left. The letters **f** and **t** have a cross strokes at the waist.

Divider Inverted **V**-shaped device, which looks like a compass. Calligraphers use it to measure, compare, or duplicate exact distances, such as spaces between writing lines and spacing in illumination.

Entrance stroke The little stroke that begins a letter is the entrance stroke.

Exit stroke A nineteenth-century word for a small stroke to finish off the stroke of a letter. Also known as a serif.

Gouache Watercolor with chalk or other additives for opacity, which help in keeping clean strokes, unlike the translucent watercolor.

Guard sheet A thin sheet of paper placed under your hand while writing to keep the writing paper clean and free from smudges. Normally a different color from the paper you are lettering on.

Guidelines Lines marking any and all of the writing lines, baseline, waistline, capital line ascender, and descender line. Used during lettering to keep writing precise.

Gum arabic Dried exudation from bark of various species of acacia tree found in Africa, Asia, and Australia. It is a binder for the color particles—a glue that holds the fluid and helps move fluid or ink off the nib. Use sparingly as it will crack or rub off if you use too much.

Hairlines The thin lines of a letter.

Inks The word ink comes from the Greek word *inkauston* (to burn in) and possibly refers to the coloring process of early baked tiles or the way iron gall inks burn into the page due to their acid content.

Pigmented ink The coloring matter in pigmented ink is finely ground insoluble particles that are suspended in a medium of glue or gum and water. Other additives

could include preservatives, fragrance, and shellac for shine. Pigmented ink is lightfast and rarely used in fountain pens as it tends to clog.

Dye ink Water and dye used in fountain pens and is fugitive.

Waterproof ink Ink containing enough shellac so that it dries impervious to water. India ink is an example.

Semi-waterproof ink Ink that is moisture proof but not impervious to water.

Non-waterproof ink This ink is readily dissolvable in water when dry and will bleed or smudge if touched with any moisture.

Majuscule Any script where all the letters are of approximately equal height. Uncial is a majuscule hand and has no uppercase letters. It also refers to uppercase letters.

Minuscule Scripts containing letters with ascenders and descenders. Lowercase letters.

Nib The end of the pen that meets the writing surface. Can be detachable or cut from the shaft as in the reed pen or quill pen.

Nib width The width of any given broad-edge nib. Used to measure the letter height when determining weight. Each hand is written with a nib height that is determined by the nib width.

Pen From the Latin word *penna* (feather), any number of hundreds of writing instruments that deposit ink on a writing surface.

Pen angle In broad pen writing, the angle at which the nib edge meets the paper in relation to the writing line. A steep angle is approximately a 46- to 90-degree angle and a natural angle is 30 to 45 degrees. The relationship between the edge of the nib and the baseline.

Reservoir Small piece of metal attached to the upper side or underside of a nib. It holds a supply of ink and regulates the ink flow.

Slant The slope of the letters from the vertical. Although any script maybe slanted, slant is a characteristic of letters written with speed.

Slant lines Lines that are later erased to help the calligrapher keep letters at the intended slope.

Spacing Distance between strokes (inter-letter spacing). Space between letters in a word (inter-word space). Inter-linear space is the space between the lines of writing.

Stick ink High quality of carbon ink. Made in China since the third century B.C.

Stroke Any mark made with the pen nib.

Waistline The upper boundary of the body height of a letter.

X-height The body height of a letter.

Practice Page

Practice Page

A
X
D
A
X
D
A
X
D
A
X
D
A
X
D

C-2 5-5-5 5° Slant line Italic

Practice Page

Practice Page

A
X
D
A
X
D
A
X
D
A
X
D

C-2 5-5-5 5° Slant line Italic

Practice Page

Practice Page

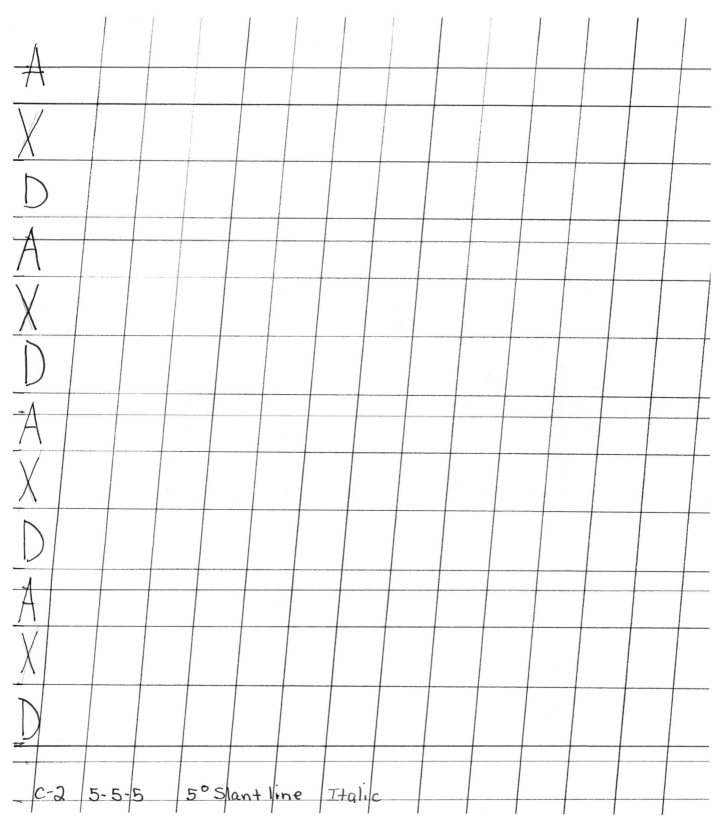

A
X
D
A
X
D
A
X
D
A
X
D

C-2 5-5-5 5° Slant line Italic

Practice Page

Practice Page

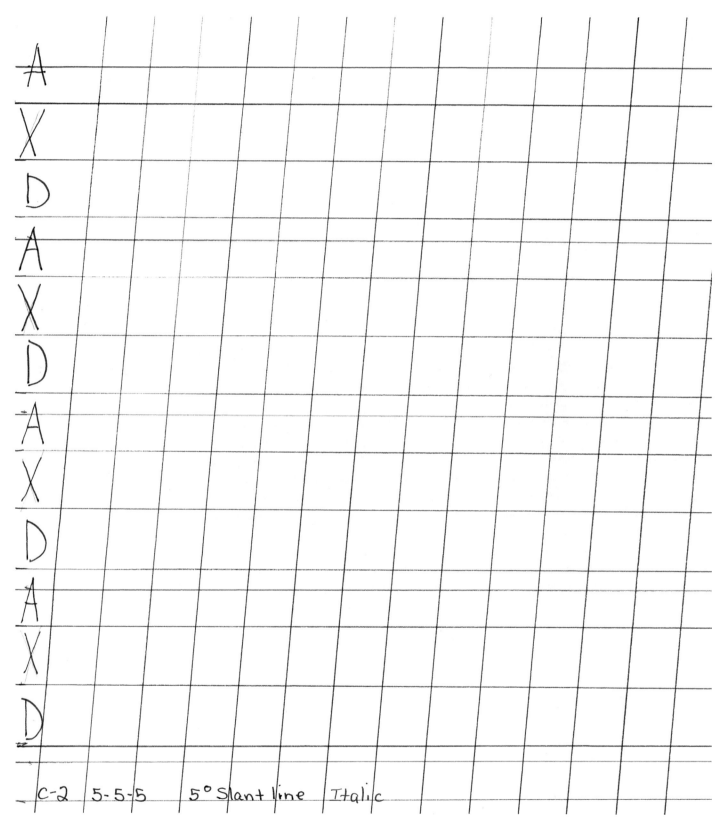

A
X
D
A
X
D
A
X
D
A
X
D
A
X
D

C-2 5-5-5 5° Slant line Italic

Practice Page

Practice Page

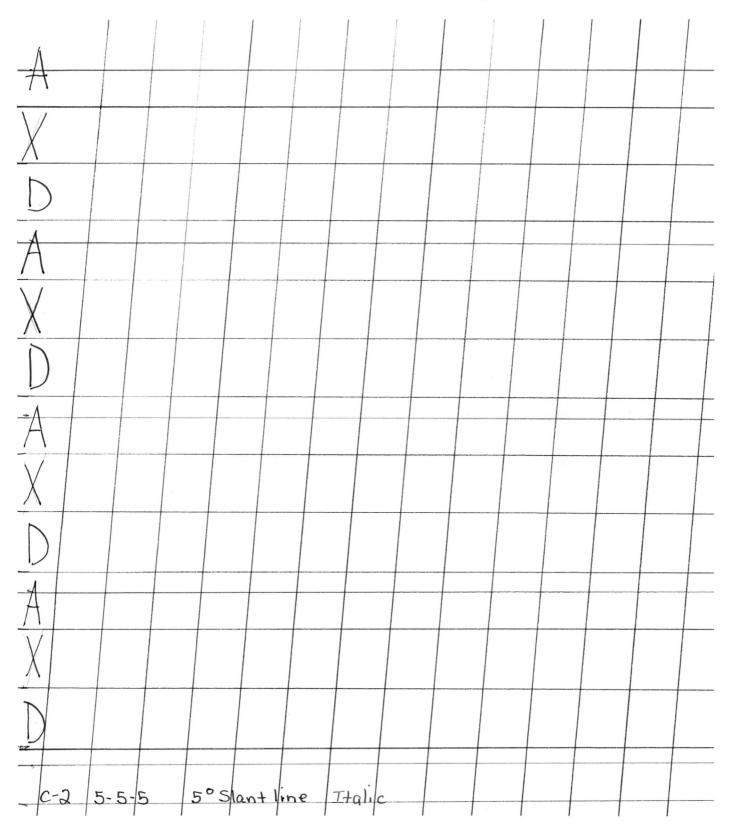

A
X
D
A
X
D
A
X
D
A
X
D

C-2 5-5-5 5° Slant line Italic

Practice Page

Practice Page

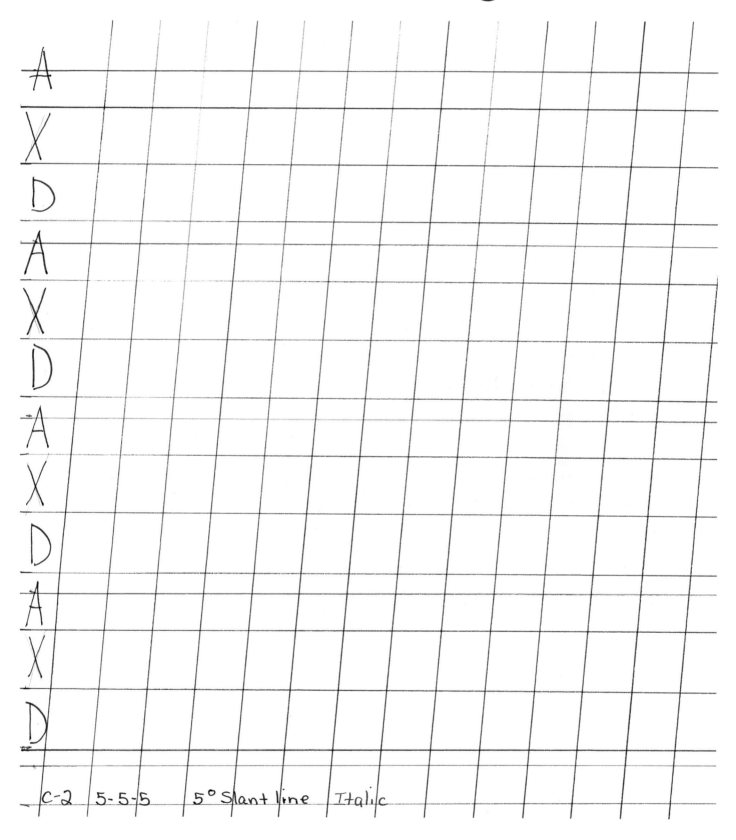

A
X
D
A
X
D
A
X
D
A
X
D
A
X
D

C-2 5-5-5 5° Slant line Italic